To Marcia & Jack,

Merry Christmas, 1986 —

Love,

Claudine

The Art of Queena Stovall
Images of Country Life

American Material Culture and Folklife

Simon J. Bronner, Series Editor

Associate Professor of Folklore and American Studies
The Pennsylvania State University at Harrisburg

Other Titles in This Series

The Art of Queena Stovall
Images of Country Life

by
Claudine Weatherford

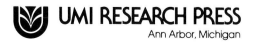

UMI RESEARCH PRESS
Ann Arbor, Michigan

Produced and distributed by
UMI Research Press
an imprint of
University Microfilms, Inc.
Ann Arbor, Michigan 48106

Library of Congress Cataloging in Publication Data

Weatherford, Claudine, 1945-
 The art of Queena Stovall.

 (American material culture and folklife)
 Revision of thesis (Ph.D.)—George Washington
University, 1985.
 Bibliography: p.
 Includes index.
 1. Stovall, Queena. 2. Folk artists—Virginia—
Biography. 3. Country life in art. I. Title.
II. Series.
ND237.S794W43 1986 759.13 [B] 86-11426
ISBN 0-8357-1765-8 (alk. paper)

To my family, Bud and Gary Weatherford, and Timothy Wyant; and to the memory of my mother, Bert Weatherford, who, like Queena, provided me with a courageous, creative, and energetic role model for my life and work.

Contents

List of Plates

Color Plates

Preface

In January 1979, I drove from upstate New York to central Virginia to meet ninety-two-year-old Queena Stovall. When I arrived at the Wigwam—her farm home in Amherst County—she was sitting in the center of a spacious kitchen, hands crossed on top of the cane between her knees. She was laughing and chatting, surrounded by doting family and friends. Outside an ice storm damaged powerlines, leaving her house without electricity. But such events rarely fazed Queena; inside there was plenty of wood to fuel her Majestic stove, every room had kerosene lamps, and the homemade dandelion wine—stored under a bed in the guest room—produced a rosy glow on her visitors' faces.

A few months earlier, I had seen slides of Stovall's paintings while taking a folk art class in Cooperstown, New York. My instructors, Louis C. and Agnes Halsey Jones, whetted my interest as they recounted their visits to Queena's farm and talked about the value of her paintings—begun at age sixty-two—to the study of American folklife. Because of my interest in women who become self-taught artists late in life, the Joneses suggested that I visit Queena; they contacted the Stovalls and arranged for an introduction. In the years since, Stovall's paintings have become the pivotal component of my study. Through her paintings it was possible to penetrate her intimate circle of friends and family on the one hand, and her wider community on the other. As my project took shape, Stovall's perception of traditional rural life became the warp and the perceptions of those she portrayed became the weft of a tapestry that takes tangible form in close to fifty paintings that she produced during her career as an artist.

American folklife represents an integral part of American cultural history. Segments of our society that are slower to change and are loyal to tried-and-true customs provide a window into past time—a view of the day-to-day activities and attitudes of a large portion of our population. But traditional culture is difficult, sometimes impossible, to reconstruct through conventional sources because people living in a traditional manner usually do

not leave written records. There are no receipts for the sorghum molasses sold or bartered; there are few diaries left by slaves' children who continued to work long hours for white families after emancipation; and there are only scant records by participants describing the cultural and social function of religious rituals. Information about American folklife and its meaning must be gleaned from those who still participate in or remember a traditional lifestyle. As a painter of her rural community, Stovall became a conservator of American folklife.

The significance of her artistic legacy extends beyond her paintings to include sketches, notes, and the material culture she reproduced on canvas—all carefully saved and available for study. Stovall, eager to explain her mission as an artist and the techniques she developed, spent hours talking to people interested in her work. This rich collection of information allows for an unparalleled view of a twentieth-century art form devoted to scenes of country life in America.

Stovall and her art figure prominently within a category of older women painters of rural themes who have become well known and appreciated during the twentieth century: Anna Mary Robertson Moses ("Grandma Moses"), Clara McDonald Williamson ("Aunt Clara"), Clementine Hunter, and Edna West Teal among them. But Stovall's interest in the detailed artistic documentation of actual people and identifiable places sets her apart. Her paintings, distinct and individual in their style yet widespread in their popularity, offer a creative and informative contribution to an understanding of the relationship among art, nostalgia, and public appeal.

While Stovall's position as an insider—a native of the area she recorded—offered a unique advantage, her reputation and popularity spread beyond the community's boundaries. A gifted painter, Stovall was discovered early in her career. In particular, two professional artists, Grant Reynard and Pierre Daura, encouraged Stovall to exhibit and sell her work. During the last thirty-five years, Stovall's paintings have been exhibited countless times: in New York City at the Kraushaar Gallery, the Museum of American Folk Art, and the IBM Gallery of Science and Art; in Cooperstown, New York at the Fenimore House Museum of the New York State Historical Association; in Williamsburg, Virginia with the Abby Aldrich Rockefeller Folk Art Collection; and throughout the South at various museums and art centers.

This book is about identifying and evaluating a specific type of material culture—paintings of everyday, rural scenes—for the purpose of reconstructing American folklife. Specifically, my goal is to analyze the usefulness of Stovall's pictures to the study of folklife in the Blue Ridge Piedmont of Virginia. Stovall's work is useful for the study of traditional life in two ways: the paintings reflect the folk history of a rural community, but as importantly, they also illuminate Queena's own life, a creative force within

that community. As such, given the self-taught quality and traditional subject matter of her paintings, her work provides a useful forum for views on folk art. Broadly speaking then, this study combines folklife study with artistic biography.

Tradition—a term used extensively in this study—is a key ingredient in the concept of folklife, and thereby, folk art. Tradition, however, is an imprecise word; it is often used differently by scholars outside the discipline of folklore. A major source of confusion results from the use of the word tradition to describe a national or even international scale legacy of style and techniques—as in a fine arts tradition. This use of the word, favored by art historians, refers to old, established stylistic and technical practices spanning a wide area. But as applied to folk art, "tradition" represents a shared aesthetic, and the informal, yet structured, systematic transmission of forms, materials, and processes of manufacture within a folk community.[1]

Keeping this concept in mind and applying the methods of American material culture and folklife research, I utilized Stovall's paintings in two ways: first, as historical documents to be "read" for information about folk technology and everyday events in the lives of rural Virginians, and, second, as an aid to people interviewed (referred to as narrators) who remember living the life that Stovall portrayed. The validity of the paintings as historical documents was determined by comparing the content of her paintings with oral history, folklife writings, and literary works on the traditional life of the rural South. Aspects of the paintings which were different from the comparative sources have been explained, for the most part, in terms of Stovall's artistic development and aesthetic sensibilities.

As a tool for field research, Stovall's pictures evoked rich and powerful narrative from Amherst County people who saw reproductions. One advantage of exploring a contemporary topic is the amount of extant information available: many of Stovall's contemporaries in the community are still alive, and portions of the cultural landscape remain intact. By showing individuals from Stovall's community prints of her work, I learned a great deal about the meaning of daily and seasonal events in the life of country people: for example, which events are considered to be more significant and why; differences between the way blacks and whites are affected by the labors of farming; and the romanticization of life in the past.

Regardless of ethnic identity or socioeconomic position, most narrators affirmed the accuracy of Stovall's depictions. Whether her pictures are about hog butchering, burying the dead, or baptizing the living, most people who looked at them said "yes, that's it, all right." Similarly, written descriptions of traditional life occurring elsewhere in the South generally agreed with Stovall's pictures. But as reassuring as uniform agreement might be in declaring the paintings a valuable source of historical information, the more

intriguing data came from the points of disagreement—the differences between Stovall's perception and the community's collective perception. It is the differences, inconsistencies, and contradictions between the perceptions of the artist and her community that forced my attention in this study.

Information within the various topics of the study is arranged chronologically. In this way Stovall's life and the development of her art are aligned with the influences on her art and the effect of her creativity on her community through time. My goal has been to juxtapose these separate factors—her life, art, and community—to expand the basis on which explanations and interpretations can be made.

Forty-nine Stovall canvases exist. One of these is an unfinished painting. Portions of two others reveal modifications by Stovall's sons made at her request. The unfinished and altered paintings, and her sketches, are included in my investigation because Stovall's hand could be clearly distinguished from her sons' and, for the purpose of historical documentation, the completion of a person, place, or object in a painting is not always necessary.

Along with the paintings and sketches, a major source of information comes from about fifty-five hours of taped and untaped interviews with thirty-six people. I selected these people on the basis of four criteria: (1) individuals portrayed by Stovall, (2) close friends and family members, including, of course, Queena herself, (3) Stovall's employees, and (4) other individuals in Amherst County who directly experienced the replacement of traditional patterns by a modern lifestyle. Of the fifty-two individuals identified as persons portrayed in her canvases, twenty-one people were alive and available for interviews at the time of my field research. In addition, fifteen qualified individuals who were not portrayed were interviewed.

Many of the interviews reflect a structured approach. I compiled a list of questions based on the scenes that Stovall painted. The responses to those questions revealed degrees of agreement or disagreement between the scene depicted in a painting and the scene recalled by the narrator. Next, I showed the narrator prints of Stovall's pictures. It was during this second stage of the interview that most of the complementary information was collected.

Other interviews, however, were less structured and more spontaneous. For example, I left my tape recorder on as I helped the Stovalls prepare dinner and while we ate together. These times were particularly worthwhile for recovering family anecdotes and lore, often left undiscovered by tightly organized interviews. During one summer, I spent weekends with Hobart Lewis, the subject of "Basket Maker." We agreed that I would help with his gardening in exchange for his recollections about Queena and traditional life in Amherst County. Although I asked Hobart many planned questions, some of the most useful material emerged while we puttered on his property doing chores. Guided by his own pace and sense of what was important, I gained many insights from his unique point of view.

Throughout this study I have been concerned with the censorship, selectivity, and potential for falsehood in the information collected from those interviewed. How can a Northern white woman like myself be sure that the people interviewed—many of whom were Southern blacks—are telling me the "truth?" And, if they were not telling the truth, what *were* they telling me? I found the words of historian Lawrence Levine reassuring:

> [That] folkloristic documents are not perfect sources should hardly surprise historians whose quest by its very nature engages them in an incessant struggle to overcome imperfect records. They have learned how to deal with altered documents, with consciously or unconsciously biased firsthand accounts, with manuscript collections that were deposited in archives only after being filtered through the overprotective hands of friends and relatives, and with the comparative lack of contemporary sources. The scholarly challenge presented by the materials of folk culture is very real, but it is neither unique nor insurmountable. [2]

To meet this "scholarly challenge," I repeated key questions, asking the same narrator for the same information in different ways and at different times. I made an effort to get to know the people I consulted during my field research. Only during a later stage of my investigation did I seek sensitive information—about a specific racial relationship, how Queena Stovall was thought of as an employer, or the reactions of individuals to their portrayals. I asked the more sensitive questions after an individual understood my goals and, hopefully, trusted my discretion. There were instances when a narrator requested that the source of information remain anonymous, a common situation in oral history collecting. Hence, I have left passages of confidential information unidentified to honor confidentiality.

The other facet of the issue of falsehood and censorship is what the people I interviewed wanted me to hear and why. Early in my collecting, I sensed that most of those interviewed were expressing the same message expressed by Stovall in her paintings. The message can be stated this way: "life wasn't always a bowl of cherries back in the good old days, but it's more satisfying and productive to remember the pleasant aspects than to dwell on the misery." People tended to respond first to the reflection of country life's pleasures that the paintings provided. But a fuller picture of country life— including its drawbacks and privations—appeared during a second level of investigation: a level of closer scrutiny of the paintings, and of more detailed, penetrating questions asked of the narrators. In my view, Stovall and the members of the community that she portrayed were keenly aware of the negative aspects of traditional, rural life. Stovall and her family, friends, and neighbors, however, generally were optimistic people; they were people with spirit and ingenuity, people who made the best out of bad situations. This is what I think they wanted me to understand.

In addition to the oral histories that I collected, there are close to ten hours of interviews recorded by faculty or students in the Cooperstown Graduate Program. Louis and Agnes Halsey Jones are to be credited for the taped interviews with Queena on November 3, 11, and 14, 1972, and a former student of the Joneses, Robert Sieber, for the interviews on May 28 and 31, 1974. In addition, about five hours of interviews with Queena were taped by Jack O'Field, who produced a television film on Queena for the Public Broadcasting System in July 1978.

Because of the chronological emphasis of the study, there are areas of unevenness. Material from public and personal archives and from newspaper and magazine articles provided bridgework to connect the sequential data. Information from three archives became particularly important: the New York State Historical Association Folk Art Archives (NYSHAFA), the Randolph-Macon Woman's College Art Department Archives (R-MWCAD), and the Stovall family papers (SFP).

Following the down-to-earth approach practiced by many folklorists, I have used first names and nicknames for most of the individuals referred to in the text. I decided, however, to use last names when discussing Stovall's work as an artist, or when referring to the individuals she portrayed. Within the venerable sphere of serious creativity, I think a crucial element of dignity and respect can be transmitted through the use of last names.

When using the published and unpublished material of other field workers, I remained loyal to their text and punctuation. Personal letters have been quoted verbatim without correcting or pointing out errors in spelling or other fine grammatical points. I have exercised more editorial license with the narrative that I collected. For example, when the same topics came up several times I often merged the conversations when clarity and understanding would be enhanced. Other editorial liberties included the use of brackets to insert words which facilitate the reading and comprehension of a quotation. Speech patterns were transcribed as closely as possible. If a person said "hog butchering" one time and "butcherin' " another, the terms were conveyed as such. But in all cases I have tried to avoid misleading representations of those interviewed, and strived to retain the inflection and syntax of their personal styles whenever possible.

This book was made possible by the unstinting generosity of countless individuals. First and foremost, I wish to thank the Stovall family, particularly Queena herself, who participated in many hours of interviewing before she died in 1980. Robert K. Stovall, Queena's son, provided inestimable advice and expertise on the reproduction of his mother's paintings. And Queena's other children as well as members of her extended family offered invaluable help: Louis Basten, Rosalie Basten, Annie Laurie Bunts, Dr. and Mrs. Powell G. Dillard, Jr., Judy Fairfax, Narcissa Kelley, Mary White Lewis, David Hugh and

Barbara Stovall, James S.D. and Hazel Stovall, and Margaret Stovall. On one occasion when I discovered Queena's letters from her husband written early in their marriage, I asked one of Queena's daughters if she knew about them. "Well," she said, "whatever they say, they're history now. Why don't you borrow them for your project? Return them whenever you want to." As I carefully tucked the letters, brittle from age, into my satchel, I marveled at the family's undaunted courage in the face of scrutiny and willingness to share its intimate past for the sake of historical enlightenment.

During the years of my research, many individuals allowed me to photograph their Stovall paintings. Several owners are family members and mentioned above; in addition, Carrington-Dirom-Basten Company, Inc., Mr. and Mrs. William R. Chambers, C. Tad Holt, and Mrs. T. Suffern Tailer were most generous with their time and paintings. The production of color plates for this book was made possible through the extraordinary generosity of Rosalie D. Basten, Mr. and Mrs. S. Allen Chambers, Jr., Mr. and Mrs. William R. Chambers, Edwin Dillard, and Mrs. John D. (Narcissa) Kelley. I wish also to thank Francis F. and Stephen P. Goldman of the Rock Creek Institute, in Washington, D.C., who provided administrative support for the Queena Stovall project.

In addition, I am grateful for the cooperation I received from other individuals from Lynchburg and Amherst County, Virginia, who participated in my research. Hobart Lewis and his family and Lucille Watson deserve a special note of thanks. Others whose help was greatly appreciated are listed under "Interviews" in the book's bibliography. Their contribution was essential, and working with them was a pleasure. Also, I extend my appreciation to the staff and associates of the Maier Museum of Art and Randolph-Macon Woman's College—especially Ellen Schall—who welcomed my efforts and offered assistance. I gathered much useful data from the taped interviews with Queena Stovall by Jack O'Field (July 1978) of Bowling Green Films, Inc. (based in San Diego, California), which are in the collection of the Lipscomb Library at Randolph-Macon Woman's College. Antoinette Kraushaar took time from a busy schedule to locate records of the exhibition and sales of Stovall's works. Had it not been for Louis C. and Agnes Halsey Jones, professors emeriti in the folk culture program in Cooperstown, New York, I would never have met Queena Stovall nor had the opportunity to study her art. They gave me full access to the folk art archives of the New York State Historical Association and the use of their private library on several occasions. I am also indebted to the Jones's student, Robert Sieber, who spent a week with the Stovalls in 1974 photographing paintings and interviewing Queena.

I am particularly grateful to Simon J. Bronner, associate professor at Pennsylvania State University, who recommended that my manuscript be published, and skillfully and efficiently provided editorial advice. My thanks,

especially, to John Michael Vlach, associate professor at George Washington University, who guided my study from the stage of conception to the finished product. His sincere and enthusiastic approach as a teacher and his ability to sustain my sense of humor during discouraging moments were most welcomed. In addition, James O. Horton, Clarence C. Mondale, Phyllis M. Palmer, Gerald E. Parsons, Jr., and Robert T. Teske were very generous with their time and expertise. Fellow graduate students provided an incalculable amount of emotional support and helpful comments on the text; among them were Olivia Cadaval, Jim Deutsch, JoAnn King, Catherine Hiebert Kerst, Leslie Sayet, Nancy Solomon, and Tara L. Tappert.

Long-term research projects frequently engulf the writer's close friends and family. To those who shared my enthusiasm when work went smoothly and tolerated my grumbles during the bottlenecks, I extend unqualified appreciation. A complete list of names would take pages; an abbreviated list must include Ann Bassetti, Mary E. Case, Jane Greif, Nancy Kassner, Kathie McCleskey, and V. Spike Peterson. Finally, I am especially grateful to my spouse, Timothy Wyant, whose companionship and cheerful disposition sustained me throughout; to my brother, Gary Weatherford, who from my childhood taught me about the rewards of curiosity and learning; and to my mother and father, Bert and Bud Weatherford, who never wavered in their encouragement and support.

A Country Woman

Emma Serena Dillard Stovall, called "Queena," was born on December 21, 1887, at her family's country place four miles south of Lynchburg, Virginia. Her life spanned many decades: she witnessed decisive social, political, and economic changes in her community and throughout the nation. At the time of her birth, Thomas A. Edison had already demonstrated his incandescent light bulbs, yet forty percent of the nation's population lived on farms in houses lit only by oil lamps. The South was still recovering from the bitter years of Reconstruction and twelve states of the fifty were yet to join the Union. In 1890, when Queena was three, the Seventh Cavalry—General Custer's former unit—slaughtered several hundred Sioux Ghost Dancers and their families at Wounded Knee. By the time Queena died, automobiles, airplanes, space flight, computers, and nuclear energy were familiar products of human technology. Moreover, the Civil Rights Acts irreversibly changed her world—inexpensive farm labor all but disappeared, her grandchildren attended integrated schools, and young blacks called her "Queena" instead of "Mrs. Stovall."

One of a Dozen: 1887-1908

According to family lore, soon after Emma Serena was born, her name was changed to "Queena," as it had been for her namesakes, two maternal aunts. As the story goes, younger children considered "Serena" unpronounceable, transforming the sounds into "Queena."[1] "I think I was the seventh...of twelve," Queena recalled.[2] "We, as twelve children, were raised real close together—I mean we just got along without any trouble"[3] (plate 1). "The Dozen Dillard," as they were known in those days, grew up in a world saturated with southern customs.[4]

A growing and prosperous town, Lynchburg had a population of about eighteen-thousand people in the late 1890s when nine-year-old Queena moved with her family to a big house on Federal Street. At that time many of

Lynchburg's inhabitants—largely of Afro-American, English, and Scottish descent—worked in factories and warehouses or at jobs along the James River. Edward King, a Northern journalist visiting Lynchburg in the 1870s, observed the "rafts and flat-boats, steered by barearmed and bareheaded negroes...and quarrymen...blasting and chiseling blocks for building purposes."[5]

After a look at the commercial area—within walking distance of Queena's Federal Street home—King offered his impressions of the city's working-class ethnic population:

> The Northerner is at first amazed by the mass of black and yellow faces...colored mammas smoked pipes in doorways of shops, where colored fathers sold apples, beer, and whiskey; colored damsels, with baskets of clean linen in their stout arms, joked with colored boatmen from the canal; colored draymen cursed and pounded their mules; and colored laborers on the streets enveloped one in a cloud of suffocating dust as he hastened by. Toward the water sloped other streets lined with roomy tobacco warehouses; half-way up the hill a broad and well-built business avenue crossed at right angles, and there, at last, one saw white people, and the ordinary sights of a city.[6]

Queena may well have walked past this same scene—absorbing impressions of the black community—as she accompanied her mother and their cook to the outdoor markets. There were other circumstances, aside from shopping excursions, in which white children, like Queena, of middle- and upper-class families were exposed to Afro-American culture: for example, visits to slaves', and later servants', cabins, or through close enduring relationships that developed between white families—especially the children—and black domestics.[7] An old friend of Queena's said "we called them colored servants. Every household had a black cook....They became really members of the family."[8] In my opinion, Queena's image of blacks—transferred to canvas later in her life—rested on a foundation of these early experiences.

Along with observations of "the mass of black and yellow faces," Edward King's discerning eye recorded the culturally elite aspects of Lynchburg. "'Old Lynchburg'...once the wealthiest city in the United States, in proportion to its population...stands in the centre of a region richly supplied with educational institutions....the growth of families in which the hereditary love of culture and refinement, and the strictest attention to those graces and courtesies which always distinguish a pure and dignified society, are preeminently conspicuous."[9] Through birthright Queena benefited from Lynchburg's wealth, dedication to culture, and high regard for refined social "graces and courtesies."

Queena's parents, Ella Nathan Woodroof and James Spotswood Dillard, were "very well-to-do, among our wealthy people. What we called 'first families' in those days."[10] Born to educated, affluent, land-owning families, Ella

and James moved easily in Lynchburg's "dignified society." Queena's maternal descendants are traced from an Englishman, Richard Woodroof, who had settled in Pamunkey Neck (King William County) by 1696. Members of the Woodroof family gradually moved to western Virginia, and in 1770 David Woodroof—an officer in the Revolutionary War, a vestryman, and a town trustee—purchased several hundred acres in Amherst County. Queena's grandfather, Pitt Woodroof, continued to own land and at least one plantation house throughout his career as a circuit riding Methodist minister.[11]

Lineage on her father's side is less clear, but it seems likely that Queena descended from George Dillard, an Englishman, who settled in the Rappahannock River region in 1650. By the second quarter of the nineteenth century, it seems probable that members of the family lived in Campbell County, near Lynchburg. Thomas Dillard, a lawyer and graduate of William and Mary College, lived on a plantation near Lynchburg.[12] Family property in Amherst County increased through the purchases of Queena's older brother, David Hugh Dillard. Queena was able to participate in country life primarily because family property was made available to her by members of the Woodroof and Dillard families.[13]

Queena idolized her mother, Ella, whose dignity and refined tastes— sustained through hard times—provided her daughter with a lifelong role model. Queena's mother was well educated and well traveled. She was raised by an older brother who sent her to Stewart Hall, a private girls' school, and Virginia Female Seminary [now Mary Baldwin College]. "[Ella] got a medal for music and 'belles lettres'," Queena said proudly. "That was for writing . . . she loved to write."[14] In keeping with the ideal expectations for a "southern lady,"[15] Ella married well, produced six sons and six daughters, and managed a large house that "everybody loved to come [to] because she was charming." Descriptions of Ella fit the idealized image of Southern upper-class antebellum women summed up in the late nineteenth century by Thomas Nelson Page:

> Her life was one long act of devotion . . . to her husband, devotion to her children, devotion to her servants. . . . The training of her children was her work. She watched over them, inspired them, led them, governed them. . . . She reaped the reward . . . their sympathy and tenderness were hers always, and they worshipped her.[16]

As for child rearing, "[Ella] really trained us how to behave," Queena said. "I don't know how she managed to make us so good. Every last one of Mama's children have high ideas."

Ella combined her upper-class savoir faire with a practical knowledge of rural life gained during her residence at Brookfield. "She taught me a great deal about country living," Queena said. "She loved it too." Queena's early experiences at the Brookfield farm marked the beginning of a memory bank,

fundamental in the choice of her painted themes later in life: "It was the only thing I knew...things I had seen and done and lived."[17]

Queena was about nine years old when her father died at age forty-eight. Socially distinguished, James Dillard was a member of a prominent family considered important to the progress of central Virginia. According to Queena, he "was a top Mason, high as you could go." His appreciation for painting and literature represents an early artistic influence in Queena's life. She recalled that her father "always loved poetry and art and those things. I've got a Dutch scene Mama said my father had bought."[18]

Ella Dillard expressed another perspective on her husband's cultivated preoccupations. She once told a granddaughter that James "was the most lovable, the sweetest, the most romantic person... [but] she said 'those type are never successful in a business way.' So he was a dreamer, romantic and all."[19] Ella's attitude toward her husband was affirmed following his sudden death when it became evident that insufficient income had been left to support the family.[20]

Queena's mother—widowed at age forty-two—moved her twelve children from Brookfield to 115 Federal Street, a large house owned by the Dillard family in the Federal Hill area of Lynchburg. "I reckon Mama's the one that had the hardest time," Queena reflected.[21] Proud and independent, Ella resolved to support her family without handouts, refusing offers of assistance from her late husband's affluent friends. Queena recalled that "they all went to give her some money, but I know she didn't take any."[22]

Although "Mama wasn't trained to work, to leave us to go out to work," Ella arrived at a solution which allowed her to stay at home with her children while making an income: the family residence on Federal Street became a boardinghouse.[23] Ella joined the ranks of Southern "women of all classes [who]...ran millinery shops and bakeshops, inns and boardinghouses."[24] But her boarders were usually handpicked from her own social circles. "It was the same as if they [the boarders] were just really visitors in your home, [people] that she knew and all. We remained friends always ever afterwards."[25] Among the boarders were young women whose parents—residing out of town, in the country—wanted their daughters to attend Lynchburg schools under the protective eye of a virtuous and cultivated matron.

Ella's children, too, benefited from the advantages of an urban school system. "That's where I got my education," Queena proudly recalled, "at the Lynchburg schools." Her first teacher "was just mighty good, mighty strict, but mighty good. You'd have a morning teacher, and then you'd have somebody come in for arithmetic and geography," providing a broad exposure to subjects and different instructors. Queena remembered high school as a time of lighthearted fun and boy-girl antics: "That was a mighty foolish time"[26] (plate 2).

Aside from the foolishness, high school offered Queena her first opportunity to take formal art classes. Two watercolors completed during this period have remained in the family (plate 3). These early art classes, however, left Queena uninspired. Assignments—often based on still lifes—were unimaginative and spiritless. "I never cared for still life," Queena said, adding another time; "I wanted action, I reckon."[27]

In addition to her high school drawing and painting classes, Queena came in contact with art through her mother's artistic hobbies. "She really did have talent in painting," Queena claimed; "she painted china."[28] Like many women in the nineteenth century who decorated household goods,[29] Ella painted vines of ivy and violets on her cups and saucers. Robert K. Stovall, Queena's youngest son, recalls his grandmother's pleasure from decorating: "One thing I remember distinctly is grandmother making watermelon rind pickles. She'd sit on the back porch, cut them into inch and a half squares, then would sit there with a paring knife and sculpt a design on each piece of pickle—a spray of ivy or a bunch of grapes. She would can the pickle, [and] put those designs so they were facing outside."[30] Ella's preoccupation with painting extended beyond creative approaches to domestic tasks. While living at Pedlar Farm, in Amherst County, during the 1930s and 1940s, she tutored a young art student who eventually became a well-known painter in central Virginia: "It was Miss Georgie Morgan Mama had taught art to in the country," Queena recalled.[31] Georgia Morgan gained local prominence as an art professor and for her paintings of Amherst County landscapes.

But Queena's exposure to art at home and at school failed to ignite her artistic energy for many years. In the meantime, she enjoyed her youth and prospered as a student.[32] During her senior year of high school Queena accepted a job in a Lynchburg office, thus helping to pay her own way, following the example of her strong-minded mother. "I was supposed to have graduated in February and I didn't want to. That class, you know, [is] never in on the big doings like the June graduates. I wanted to be a June graduate, and I wanted to work."[33] Although her secondary education was essentially completed, Queena always regretted that once employed she found it impossible to finish the last semester of high school. In spite of Queena's future goal to get married and have children, she echoed the sentiments of other Southern women who desired more education but were often unable to fulfill their aspirations.[34] "I'd always think that I was going back to school, even if I was fifty years old. I was going to college, but I never did go."[35]

Marriage, Family, and Life in the Country: 1908-1923

Around 1907, while working at the railroad ticket office in Lynchburg, Queena met her future husband, Jonathan Breckenridge Stovall (Brack), a man fourteen years her senior from nearby Halifax County. Queena recalled:

He came in there one day at lunch time ... to buy a mileage book. ... So I got up to sell him a
mileage book. When I punched him [procedure for customer identification in the mileage
book] I looked at him—I was just nineteen then—and I punched in "middle age" and
"stout"! He said he fell in love with me right then, and, of course, it hurt him terribly. He was
thirty-three then. ... So one day I went over to the bank to take in money for a deposit and
there was Brack, waiting for me I guess. ... He said, "I think as many mileage books as I
bought from you, you could at least speak to me." So I did. That was enough.[36]

At age twenty, Queena's attention focused on her wedding plans and the
promise of domestic fulfillment. On September 24, 1908, the local newspaper
reported: "An interesting social event was the marriage last night of Miss
Emma Serena Dillard ... and Mr. Jonathan Breckenridge Stovall ... in the front
parlor of the spacious old home of the family, Eleventh and Federal
Streets. ... The vows were said beneath a beautiful bell ... of goldenrod and
ferns, goldenrod predominating."[37] In retrospect, Queena laughed about the
decorations: "[I] didn't have allergies then!"[38]

In keeping with Southern cultural custom, Ella Dillard was pleased that
another of her six daughters had gotten married. Having grown up during the
post-Civil War period when "war created a generation of women without
men,"[39] Ella took great pride in her daughters' marriages. Indeed, Queena and
Brack were considered a good match. A local newspaper stated, "The bride is
one of the most charming young ladies of Lynchburg. ... Mr. Stovall is ... one of
the best-known young businessmen of Lynchburg."[40] When Queena married
Brack his position as vice-president of the Hughes Buggy Company seemed
secure; it was a thriving local Lynchburg business, and well suited to Brack's
flair for selling. Although Brack's family lacked the social prominence of the
Woodroofs and Dillards, he was clever, humorous, well read, and a master
storyteller. Queena described her husband as a "wonderful character."[41]
Friends remembered him as "the most entertaining and witty man. ... he
delighted us with his stories."[42]

Early in their marriage, Brack's attitude toward Queena—based partly on
the difference in their ages—was reminiscent of nineteenth-century
patriarchal relationships common between husbands and wives.[43] Brack's
letters from a buggy trade show in Atlantic City in 1911 begin with "My Dear
Little Girl," instructing Queena to "be sure and write me and tell me how you
are getting along."[44] After seven years of marriage, Brack's letters to Queena in
1915 remained adoring. But at the same time, he appeared more cognizant of
her adult status. He refers to her as "Old Sweetheart" and such a "brave little
woman."[45]

By this time, Queena had given birth to four children and was pregnant
with her fifth: Brack, Jr. ("Bug"), Narcissa, Annie Laurie, Judith Victoria
("Judy"), and Mary White. "After we were married," Queena reflected, "I had
my children right fast—about four or five of them."[46] In addition to mothering,

she managed a house, a farm, and hired help: "See, Brack was traveling most of all those early days in marriage, and so I had everything to look after, to do. Brack always said I had to have a cook for all those children, which I did."[47] Reflecting further Queena said, "You can't do anything when you got four, five, or six children and still having them. So you just do best you can do." Such comments about the weight of a wife's duties echo the sentiments of many Southern women who "experienced the shock of sudden transition from the life of a carefree, sought-after girl to one circumscribed by matronly responsibilities."[48]

Queena's responsibilities became more onerous when the buggy company went broke in 1913, leaving the Stovalls with little money after Brack paid off creditors using the firm's remaining thirty-six hundred dollars.[49] Automobiles were gaining popularity at the expense of horse and buggies—one of many changes to come in Queena's traditional world. "[I] didn't think a buggy and wagon would *ever* go out," Queena said. "How things do change!"[50]

In desperate need of a salary to support his growing family, Brack took a job as a shoe salesman, which required traveling for weeks at a time through small towns and rural areas in southwestern Virginia and North and South Carolina. Much to his dismay, he spent many weeks during the year on the road away from Queena and the children. Exchanging letters almost daily during certain periods, Queena and Brack exhibited remarkable perseverance and devotion toward one another in spite of stressful circumstances. Virtually every surviving letter contains reassuring passages: "I have been in a hack all day today...I am working just as hard as I know how for you and the babies dear and long so much for the time when I can hold you all in my arms again.... I thank the good lord every night and all of the time for the wonderful woman he gave me."[51] Both Queena and Brack found time to send presents and thoughtful items to one another. "It was nice of you to send the hankerchief & candy," Brack wrote. Occasionally, he sent a ham to Queena: "I hope that meat got there all OK for it will mean so much to you this summer."[52]

Yet Brack also wrote apologetic letters which expressed the strain of separation:

> For darling every minute I spend away from you is an absolute misery for me. For I just think of and long for you and the babies all of the time. Life is not worth liveing as...we are now and it is nothing but the absolute need of bread and meat that keeps me out hustling for you and the babies. I am pretty sick and tired of being away from home and believe me darling as soon as I can possibly figure it out I am going to kiss the road good bye.[53]

Brack's absences were made more tolerable for Queena because she stayed with her mother during the winter months. Around 1906, Ella designed and built a house at 1 Denver Street in Lynchburg, conveniently located next

door to her generous, protective son, David Hugh Dillard.[54] The house was located at the end of the street on a bluff overlooking the James River. An inconspicuous backyard which sloped out of sight enabled Queena to keep in touch with country pleasures. "I had a garden spot there," Queena said. And a daughter added, "she had a cow, chickens and pigs...but she hid them on a bluff." Queena laughed as she remembered, "I put them down the hill a little bit."[55]

Raising children virtually alone and on a fluctuating income (Brack worked on commission) drew upon Queena's ingenuity and her knowledge of country resources. Beginning in 1913, Queena rented a farmhouse in Amherst County during the spring and summer. Over the next few years, her self-sufficiency gradually increased, as she gardened and raised animals to help feed the family while Brack was away and money was short.

Sometimes Brack's job was profitable, offering encouragement about the future potential of his job. "I had the best week last week I have had so far," Brack wrote, "and things are looking better everyday now."[56] On the whole, however, Queena steeled herself for less heartening reports, especially after shoe sales plummeted with the start of World War I. His hopes for success dashed, Brack wrote: "Looks like things will never take a turn for dad anymore. When you get a good line war comes on & knocks the spats out of trade."[57] Several months later the situation appeared even more grim. "I have had no luck at all today. Worked three towns but could not get an order."[58]

Queena besieged Brack to return and find a job closer to home. She made her position on travel clear on more than one occasion, which prompted defensive rebuttals and promises to reunite the family:

> About coming home, you know dearest there is nowhere on earth I had rather be than with you but I have just got to make good with this business & make a new home for you & the babies & I am working as hard as I possibly know how to. . . . If we were living in Spartanburg or Greenville [S.C.] I could be home every Friday or Saturday sure & go back out Mondays. I am so anxious to succeed darling for it means so much both for you & I."[59]

In the fall of 1914, Queena and the children moved from Virginia to Sumter, South Carolina, in an effort to end the long periods of separation and make it easier for Brack to spend weekends at home. But the relocation proved unsatisfactory and by March 1915, Queena—pregnant with her fifth child—was once again living in Amherst County.

Returning to Amherst County with a new agenda in mind, the next few years proved to be a watershed in Queena's life. She matured as a country woman, expanded her knowledge of traditional rural activities, and increased the amount and type of contact she had with her black neighbors. Queena added a crucial layer of information about traditional rural life—the people and their behavior—to her storehouse of images. This information increased

the potential themes for her later paintings. Caring for several children and running a farm left scant time for artistic outlets. But Queena's appreciation for creativity and her photographic eye provided a means of registering special people and places in her mind until she started painting many years later.

Several of those special people came into Queena's life because she needed to hire help for a variety of circumstances. "I am glad you will get a midwife," Brack wrote, "don't take any chances darling with yourself."[60] It must have been comforting to know that Nancy Lewis—"Aunt Nanny" as locals referred to her—would be available during and after the delivery of Queena's fourth daughter. Nancy—an ex-slave—worked as a "mother of the sick" while raising a large family of her own.[61] She and her children lived near Elon in a log house built by her husband before his death in the late nineteenth century. Nancy's youngest son, Hobart Lewis, worked for Queena from childhood onward, and may well have been the youngster whom Brack mentioned in a letter: "Make that colored boy work the garden [soil] good for it will pay wonderfully in the end."[62] Bearing children without doctors and growing a large garden brought Queena closer to neighboring blacks who later became subjects for her paintings.

Queena's repertoire of farm scenes, as expressed years later in her paintings, increased after the move back to Amherst County from South Carolina. Brack and Queena decided to invest seriously in building a farming business. "I believe if we can get 500 hens," Brack wrote, "they will make us a liveing & we can gradually run them up to 1000 & I know they will take care of us and make us some money too."[63] Brack's optimism and scheming continued, and he cast about for a place to sell their farm produce: "I am certain we could make a country store pay."[64]

Queena assiduously set about the task of making their farming venture a success, combining her increasing experience with Brack's advice and directives. "Keep close track on the hens," her husband warned, "& try to make them pay their way. Figure on them as close as you can and see if you think we could make a liveing out of them."[65] Queena's fascination with raising pigs and curing hams—the theme of five later paintings and countless dinner party favors—may have begun with Brack's suggestion, "if you get a chance you might buy us a small pig."[66] Continuing a tradition that began during the 1860s when women ran plantations and businesses while their husbands fought in the Civil War, Queena took charge of the Stovalls' farm, accruing knowledge and competence within and beyond the domestic side of rural life.

Still, country life was lonely at times. The Stovalls had hoped that Ella Dillard would stay with Queena at the farm, to help with the children and provide companionship in a manner common among women within Southern kinship networks. Ella, however, finally freed from the responsibilities of

child-rearing, often had commitments in Lynchburg, or traveled as she had before her marriage. It would have salved Brack's conscience to have "Mrs. D." spend more time in Amherst County with Queena, but other forms of family assistance were not so desirable.

When Queena considered turning to the Dillards for financial help, Brack discouraged her from relying on her prosperous brothers. "Darling you know how bad it is to be going to the family for help all the time & if we can just work through ourselves it will be so much better."[67] Brack's attitude—perhaps based on a threat to his pride during a time when he was struggling to support his family—unwittingly promoted Queena's independence and self-assurance.

To make matters worse, news arrived in June 1915 that Brack had quit his job over a disagreement regarding commissions. The Stovalls had exactly five dollars in the bank. He promptly found a new job, but the demand to travel did not cease. He worked for the duration of his career as a salesman with the Jamesway Agricultural Equipment Company. By now Queena had adjusted better to the periods apart, gaining confidence and self-reliance from living in Amherst County. During the late 1910s, her sixth child was born, closely followed by a seventh; she called her sons William and James (Billy and Jim). And Queena persevered, keeping the dream of a family farm alive until the early 1920s.

In 1923, Queena and her family moved back to Ella's Denver Street house. Ella traveled more frequently and began spending her winters in Florida, leaving the house in Queena's capable hands. Besides taking care of the house while Ella was away, Queena remembered other factors prompting the return to Lynchburg. She decided, after an amusing incident, that her children required an urban—and more urbane—education not offered at the one-room schoolhouse near their farm in Elon. As a daughter retold the story, one Saturday night during bath time two of the Stovall daughters, Judy and Narcissa, "ran water, put [their] bathrobes on and got in the tub," taking the name of their new clothing literally. Daughter Judy recalled, "Mama said then she was afraid she better bring us to town."[68]

Return to Lynchburg: 1923-1945

Queena lived in Lynchburg for the next twenty-three years. Like many of her friends and family, she struggled through the Great Depression years, then watched her sons leave home to serve in World War II. During this period, Queena's achievements and recognition as a loyal and able wife, a loving mother and aunt, and a generous and wise friend crystallized into a respected matriarchy. Queena's strong character, self-confidence, and stability fortified her for changes which would occur throughout the next two decades. She

experienced motherhood's sorrows and joys in new ways, adjusted to an ailing husband and mother who required care and compassion, and reinstated lingering desires to embellish her life artistically.

Shortly after the move back to Denver Street, Queena's seven-year-old son, Billy, died. The child's death—presumably from pneumonia—was the first in the Stovall family and deeply saddened Queena. Her daughter recalled, "I remember Mama crying [and] that really got me. I was ten years old. Mama said that was the hardest death of all, the death of a child."[69] But before the end of the decade, Queena had two more sons: David Hugh (Dave) in 1923, and Robert Kelville (Bobby) in 1927.

Aspiring to emulate her mother who had twelve children, Queena was disappointed when major surgery became necessary, ending her childbearing years in her early forties. She once told a journalist, "I don't know a thing in this world except raising children and having a happy home—and enjoying it!"[70] Her love and enjoyment of children extended to her brother's offspring, who lived next door at 3 Denver Street. David Hugh Dillard and Queena were always close in age and spirit, and their adjoining property on Denver Street allowed a complementary relationship to blossom. David Hugh's prosperity as a businessman contrasted with Queena's precarious financial condition; Queena countered with a willingness to provide a respectable, stable extension to David Hugh's family. Eventually, she assumed Ella Dillard's role as matriarch, providing a hub around which the family rotated. Following Ella's example, Queena graciously engineered large family gatherings, offered advice and support, and kept an eye out for those in need of help.

Queena's nieces and nephews spent a considerable amount of time sharing meals and congregating at the Stovall home. One niece remembers frequent breakfasts of "country sausage and buckwheat cakes" as well as "Aunt Queena's" empathetic attitude: "She was always with you."[71] For example, Queena believed, "children shouldn't have to go to school on their birthday." Her own children remember: "Mama was always home. She was a great listener, planned parties, [would] make candy, never fussed about abuse [to the furniture]—preferred us to bring our friends home."[72]

Queena's sympathetic, permissive approach was balanced by a firm sense of a son's or daughter's role in the family network. When she needed help at home, even grown offspring were called to the task and expected to respond obediently. Queena wrote to her daughter Annie Laurie in the fall of 1933, requesting she return home from Roanoke because "with 'Daddy' and 'Bug' [Brack, Jr.] both away, I'll have to have you to help me."[73] A more serious matter prompted Queena to implement a family decision to bring Annie Laurie home immediately to care for an ailing aunt. "Margaret was taken suddenly ill with a heart attack and they had to get trained nurses with her.... She worries over the expense and kept saying you ... could do just as

well. [Your uncles] thought it best to send for you ... that you could manage Margaret better than anyone else."[74] Along with familial duty, however, Queena encouraged her children to be independent thinkers.

Occasionally, Queena's promotion of independence backfired. Once a daughter cleverly ducked from view for several weeks, provoking Queena to write to another daughter, "your Daddy has been out every weekend but ... I haven't seen 'hide or hair' of Judy. I reckon she figures she would have to stay if she came out."[75] Through it all, Queena's children and nieces and nephews adored her—as she had adored her own mother and her mother's family—reinforcing an enduring matriarchal structure.

When Queena returned to Lynchburg in the 1920s she became a member of Rivermont Presbyterian Church located close to the Denver Street house. She sustained her membership for a lifetime, attending services—despite the distance—after the family moved back to Amherst County in 1945.[76] Indications of Queena's unwavering belief in Christianity were evident not only from steady church attendance, but also in her blessings before meals, family prayer sessions, and unabashed admissions that God had an enormous influence on her life and art. Asked for an explanation of her artistic talent, Queena credited higher orders. "It's the Lord. The Lord wanted me to paint those pictures, now that is the truth."[77]

Kathleen Massie, Hobart Lewis's daughter, clarified my understanding of the extent to which faith (in the scriptural and general sense) and imagination, inventiveness, and hope were necessary ingredients for surviving the insecurities of rural life. As Kathleen expressed it, Queena—along with others who lived by farming—had to have "a lot of imagination, a lot of faith." Kathleen further explained:

> I think all of the old people have a lot of imagination because they didn't have many facts. They had to use their imagination in order to make even a garden. They didn't have [a] guarantee. They had seed and a hoe to work with, and no guarantee that they were going to make a garden survive. You take seed, a little dry, hard bean, a little dry, hard pea, a little dry, hard corn. Up comes a living green sprout, a vine. It blooms [into] a pod, or what have you. Something to eat. [Those were] days when nobody could do that much alone. You had to have faith or imagination when you plant that thing. You got to have it.[78]

In my opinion, Queena's belief in Nature's promise to produce food from "a little dry, hard corn or bean" came from a source of faith and imagination beyond organized religion. At times Queena revealed a fanciful imagination, suggesting her romantic curiosity about nonconventional beliefs. Her son Bobby often said, "Mother was a romantic." Perhaps in part it was the romantic side of her personality that led to spiritual exploration. A niece recalls that "Queena believed in spirits at 1 Denver. [She had] a ouija board."

But curiosity and imagination did not continue unrestrained. Queena "gave [the ouiji board] up when she was told [it] was evil."[79] To be sure, Queena did not rank her romanticism, imagination, or intuition with her faith in traditional Christianity. But her eagerness to penetrate below dogmatic layers indicates, I think, a certain daring, a romantic curiosity, which became evident in her artistic growth.

Queena's frugal and practical domestic management—first honed during those early years in Amherst County—continued through the 1930s, helping to diminish the hardships imposed by the Depression. Queena still raised pigs and sheep in the backyard at Denver Street, out of the sight of city inspectors, and a garden provided ample vegetables for the family. Brack's steady employment—coupled with Queena's careful budgeting—permitted household improvements, a sign of greater economic security.[80]

A sign of Queena's interest in refinement was her love for antiques. Although her mania for collecting reached a peak when she moved back to Amherst County in the mid-1940s, Queena's interest in old things was evident during her residence at Denver Street. A special place was designated for antiques, called "the 'antique' room."[81] Around this time Queena also joined "The Antiquarians," a women's club in Lynchburg devoted to the research of early American collectibles.[82]

Even during earlier years when the Stovalls counted every penny, Queena maintained her taste for stylish fashions. "Mama got a new hat every year, no matter what,"[83] Bobby Stovall said. As the children grew older and her financial concerns eased, Queena's priority for "looking mighty pretty" resurged, providing a channel for her creative urges. She wrote to a daughter,

> I have just finished making me a spring suit. It is real pretty and I did a mighty good job on it. Won't wear it until I can get hat & shoes to wear with it. I am making Mary White a suit too. I ordered a lovely piece of seersucker ... to make for you. It won't come until Feb. 10th & I will make it right after that & send it to you.[84]

And like her mother and many nineteenth-century women, Queena spent hours painting floral or fruit designs on tinware and furniture. Large elegant dinners were never complete without artfully rendered, personalized place settings, such as mugs or cups with an individual logo which matched a trait peculiar to the guest. Local black neighbors, hired to help cook and serve the dinner, wore special fancy uniforms made, of course, by Queena. With more time to spend on creative projects, her artistic talent gradually came to the forefront.

By the mid-1930s, Ella Dillard's health began to show serious signs of deterioration. She had spent her summers at a sumptuous plantation-style farmhouse located between Pedlar Mills and Pleasant View, about seven miles

from Elon. Ella cherished her life in the country, and it fell upon Queena to keep the farm running when her mother became unexpectedly ill. In 1935, after living in Lynchburg for more than a decade, Queena returned temporarily to the country. She spent the summer and early fall at Pedlar Farm, responding as a dutiful daughter to her mother's wishes. Queena—once again on her own—wrestled with the challenges of managing the indoor and outdoor tasks of a farm.

Letters from that summer indicate Queena's reaction to the responsibility, and her expectations of those around her—family members and black employees—to whom she looked for help and cooperation. Four "rough and tough" boys were under her charge: "you never saw such appetites," Queena wrote.[85] Accustomed to the help of at least a hired cook, Queena became aggravated by the behavior of an employee on whom she depended: "I have to cook 3 big meals a day and it has just about put me through as I have no help. I let Marthy go as I didn't think she was much good."[86] Subsequently, the cook was rehired, revealing Queena's inclination toward forgiveness and also her practical attitude about reevaluating the situation. A few weeks after Marthy was "let go," Queena wrote, "I have the colored girl Martha that Mamma had to help me."[87]

With another stint of rural experience stored away, Queena prepared to return to Lynchburg in the fall of 1935. As a final gesture of daughterly devotion, Queena "canned up so much nice 'stuff', tomato juice, catsup, corn, peaches, etc.—about 125 cans for Mamma."[88] Reveling in her work, the pleasures of country living outweighed the strains.

A few years after the summer at Pedlar Farm, Brack retired because of a bad heart. It would be the first time in twenty-seven years that the Stovalls would live under the same roof free from Brack's travel schedule. This arrangement, however, lasted only until Queena assumed greater responsibility for Ella's welfare. By the 1940s, Ella's advancing age and precarious health warranted great concern among her sons and daughters. Queena and her brother David Hugh Dillard worried about Ella's isolation at the Pedlar Farm, which was a fair distance over country roads from Lynchburg.

As a result, David Hugh remodeled a small farmhouse, called the "Wigwam," on a portion of his property in Amherst County, where Ella and Queena lived[89] (plate 4). "I would come and stay with [Ella] because I had learned to live in the country too," Queena said. Brack spent weekends at the Wigwam, but continued to live at the Denver Street house with the Stovalls' unmarried daughters, who were working in Lynchburg. Following Ella's death in 1945, Queena told David Hugh, " 'I'd like to come out here and eat up this good garden we had planted.' He said 'why don't you sell your place in town and come on out here and have this place?' So that's what we did"[90] (plate 5).

"A Full-blown Painter": 1945-1980

Queena's return to Elon in the 1940s completed a full circle, beginning and ending in the country; the last arc would include an unimagined artistic harvest. A convergence of three factors explains the occurrence—relatively late in her life—of Stovall's career as an artist. First, Queena had been exposed to artistic influences through her father's appreciation for art and literature and her mother's hobbies. Stovall, like her parents, took pleasure in reaching beyond utility. Her creative and artful approach to ordinary tasks—making clothes or decorating a dinner table, for instance—laid a foundation for future accomplishments. Second, she had a lot to say about country life based on repeated experiences and a love for interesting, picturesque people and places in Amherst County. The weight of these unexpressed perceptions demanded an outlet—such as the diaries kept by women in the nineteenth century—which was provided to Stovall by the opportunity to paint pictures. Third, the existence of a loyal, supportive extended family fostered Stovall's work as an artist. Stovall's nuclear and extended family encouraged her to oil paint. And the availability of the Wigwam on a permanent basis provided an inspirational setting in which to paint; there she was surrounded by the folklife and Blue Ridge landscape expressed on her canvases.

In the fall of 1949, Queena's brother, David Hugh, his wife, Rosa, and his daughter, Rosalie, were having dinner at the Wigwam with the Stovalls. "All the family would come and eat Thursday nights' and Sunday nights' dinner and supper with us," Queena said.[91] Queena had just painted a rocker which caught David Hugh's eye. Admiring his sister's skill and artistic inclination—and ever alert to ways to reciprocate for the care given to their mother—David Hugh proposed a plan. Queena recalled the episode:

> I had just finished a rocker for my son. It was right good. Rosalie . . . had been taking lessons out at the college under Mr. Daura. Davie Hugh said, "Queena, why don't you go out and take lessons?" Well, I couldn't afford lessons, when I didn't think I could do anything with art lessons but Davie Hugh said that at least it would get me out of the kitchen two days a week. I didn't think much about it till next day when Davie Hugh and Rosalie came down to the house. Rosalie told me that they had been talking it over and had decided that if I would agree to take lessons, Davie would pay the tuition and start me out. I told them I was real excited and would love to be out there with Rosalie, but didn't think I could do anything. Rosalie bought me my case and paints and Davie enrolled me.[92]

Queena attended three or four sessions of an art class taught by Pierre Daura at Randolph-Macon Woman's College. Daura's eye quickly recognized Stovall's impressive grasp of subject matter and her ingenuity at solving technical problems. He recommended that she abandon the class in favor of painting on her own, her own way. Around Christmas, the paintings of Daura's

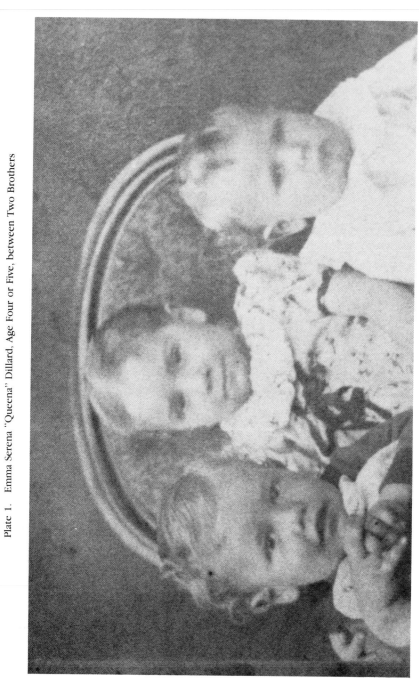

Plate 1. Emma Serena "Queena" Dillard, Age Four or Five, between Two Brothers

Plate 2. Queena Dillard as a Teenager

Plate 3. Queena Dillard, Untitled Watercolor, ca. 1905
3″ × 6″.
(*Photo by author*)

Plate 4. The Wigwam, Elon, Virginia
(*Photo by author*)

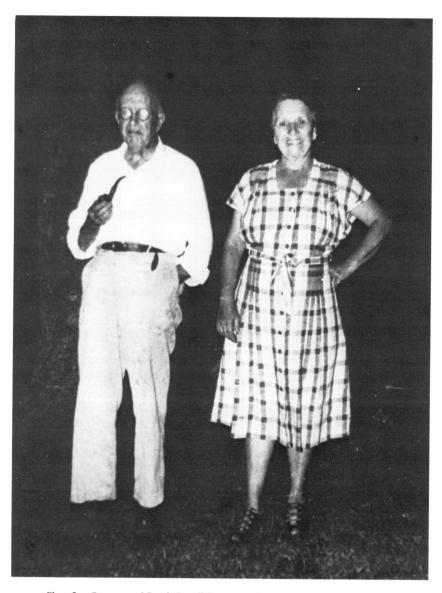

Plate 5. Queena and Brack Stovall Returning from a Day of Gardening at the
Wigwam, Early 1950s
(Photo by Robert K. Stovall)

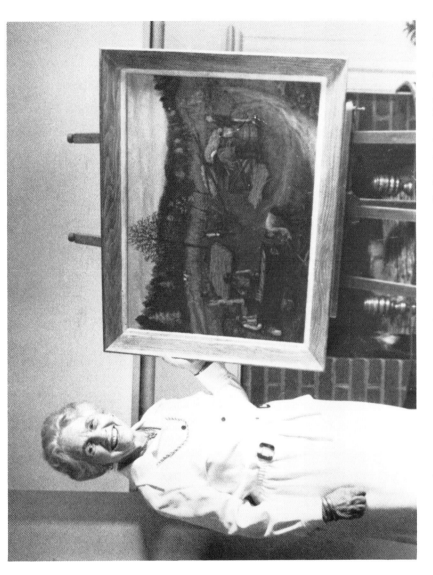

Plate 6. Quena Stovall ca. 1975, Standing next to Her Painting, "Making Sorghum Molasses" (*Photo by author*)

students were put on display at Randolph-Macon Woman's College. He placed a bench in front of "Hog Killing"—Stovall's first painting—recommending that viewers pause and study it closely[93] (color plate 1). Daura continued to inspire and guide Stovall's work over the next fourteen years, building a friendship which lasted for the remainder of their lives.

Nineteen fifty and 1951 were banner years for Stovall. After the positive response to "Hog Killing," she set forth with enthusiasm, and produced twenty-nine of her forty-eight known completed canvases in less than two years. But, generally, she did not sacrifice her daily and seasonal chores, twice-weekly family dinners, frequent entertainment of friends, or regular church attendance for more time to paint. Bobby Stovall recalls his mother's attitude:

> I think she said one time, she didn't have time for such foolishness.... and this is a quote, "There were cows to be milked, and chickens to be fed, and hogs to be taken care of, and the garden that needed weeding and planting." Her work day was basically from sunup to sunset.[94]

As a result of her commitment to farming, few of Stovall's paintings have a date of July or August, two of the busiest months on a farm.[95]

Around Christmas in 1950, Grant Reynard, a professional artist from New Jersey, on a lecture tour in Lynchburg, encountered Stovall's first six or seven paintings. Reynard (a friend of Queena's daughter-in-law, Margaret Stovall) reluctantly agreed to look over the paintings, anticipating the worst: amateurish works by "a sweet little old lady" that would require more tact than honest criticism.[96] But Reynard was overwhelmed by what he referred to as "the great event" of his visit. He found himself on his hands and knees on the living room floor, looking at the paintings that leaned against the sofa and chairs. Soon after, Reynard wrote to Stovall, "I have never seen an artist in all my travels and in teaching and observing artists for all these years whose work was so thrilling and surprising in it's character and originality. You are a full blown painter."[97] In time, Reynard, along with Pierre Daura, would become important influences on Stovall's work.

Even though Reynard's and Daura's recognition flattered Stovall, she was not prepared for the prices people were willing to pay for her paintings. "Come, Butter, Come" became the first work bought by a museum. Recollections about the sale of "Come, Butter, Come" indicate the Stovalls' surprise at the offers. Their son Bobby recalled:

> When the man came down to talk to them about the painting—from the Oglebay Institute up in Wheeling, West Virginia—they were negotiating. Talking about a price. "Mr. Stovall, we're prepared to pay two-fifty." And Daddy thought he meant $2.50. Daddy said, "Hell's bells that just about covers the cost of the canvas and brushes." He could not believe that anybody would pay $250 for a little sixteen-by-twenty inch picture, painted by this little old lady in Amherst County. You know, $250 back then—I remember his social security check was $13, so you can imagine what $250 would have looked like.[98]

This early encounter introduced Stovall to the economic potential of her paintings.

Besides an appreciation for the paintings' artistic contribution, Reynard realized their market potential when he wrote, "the only progress you have to make is in the doing of more paintings. . . . just go ahead as I told you at the time of my visit and *paint* and draw and *paint* and *paint* the things that you know and love, the life around you that you feel and see."[99] Since he sincerely believed in Stovall's art, he took the initiative to seek out trustworthy, reputable channels to bring it to the public's attention. "I have been showing your work to artists and to people who know the dealer and publicity game and have had many suggestions about what we should do about them."[100]

Within a few months, Reynard had arrived at a way to let Queena's "work burst upon New York."[101] He wrote:

> I took your eight paintings in to show them to Miss Kraushaar who is head of the Kraushaar Gallery in New York, one of the oldest in the city, of the highest high class order, and one of the few remaining honest art dealers in the city. Miss Kraushaar liked the paintings very much. . . . What [she] wants to do is this. She wants to go at it quietly, easily, showing your work to interested people but no big splurge at first, no one man show right now, until she sees how it takes on. . . . I think she has very healthy ideas about it all.[102]

Stovall trusted Reynard's advice on managing her work. Not only was he an experienced artist, he also shared her religious values: "I look for no rewards of any kind here," Reynard wrote. "My satisfaction is in seeing a fine Christian person and her fine work find the people who shall appreciate it. . . . I only thank God that He has enabled me to help along a little in this work which you are doing."[103]

By mid-July 1951, six paintings had been accepted on consignment by Antoinette Kraushaar. Other paintings soon followed as Stovall's enthusiasm for the opportunity mounted. Approximately twenty paintings were exhibited by Kraushaar between 1951 and 1955. Prices for the paintings ranged from $175 to $450.[104]

That Stovall's introduction to the marketplace was guided by two relatively cautious, conservative individuals—Reynard and Kraushaar—partially explains the restrained success Stovall's art experienced in the commercial arena in the 1950s. "Miss Kraushaar," Reynard warned, "wants no cheap publicity, wants [the paintings] rather to be introduced gradually. . . . She wants you to agree to *avoiding any publicity put out without it being agreeable to the Kraushaar Gallery.*"[105] Reynard was firm in his opinion that Stovall keep her work "out of the class of amateur painting, or the 'just another primitive' class."[106] The low-keyed approach toward Stovall's work insisted on by Kraushaar, discouraged the kind of celebrity status gained by other self-taught painters of the mid-twentieth century.

By 1956, when Stovall's arrangement with the gallery ended, four

paintings had been sold by Kraushaar.[107] Stovall profitted from the arrangement in two ways: the sales of the paintings generated cash income after many lean years, and the prices set by Kraushaar established a market value, influencing future prices, especially when Stovall began selling her own works.[108]

Under Kraushaar's restrained promotion policy, local exhibitions were limited. One exhibition, however, did take place in the fall of 1952 at the Lynchburg Art Center.[109] This was the first local exhibition since Daura's exhibition of his students' work in 1949. But in spite of infrequent exhibitions, Stovall's reputation was kept alive through other means. Prior to the Art Center show, a local newspaper hailed Stovall for "becoming nationally recognized for her talents."[110]

In April 1956, Stovall had her first one-person show.[111] Of the thirty-one works shown, seven were borrowed from friends and family who purchased the works in the early 1950s and others—still in New York—were returned by Kraushaar.[112] Stovall was delighted when the exhibition generated brisk sales. The Lynchburg Art Center printed a small catalogue—the first devoted to Stovall's works—to accompany the thirteen-day exhibition. This exhibition drew a sizable audience from Lynchburg and elsewhere in Virginia, and important contacts were established. For instance, Leslie Cheek, then Director of the Virginia Museum of Fine Arts, attended the exhibition and Stovall's supper afterwards.[113] With typical élan, Queena entertained the out-of-town guests at the Wigwam where she prepared a lavish buffet supper. According to Queena's way of thinking, the exhibition was not complete without the chance to taste her smoke-cured ham, fresh spoon bread, and homemade dandelion wine, within the artful ambience of antique furniture, braided rugs, and Currier and Ives prints. For Queena, similar creative threads ran through the art of her pictures and the art of her life.

Stovall's confidence and desire to exhibit increased as her time for painting decreased. From the Lynchburg Art Center exhibition in 1956 onward, her artistic emphasis shifted from producing paintings to showing and selling them. In 1957, Stovall entered a painting for the first time in the Virginia 16th Biennial, a contest sponsored by the Virginia Museum of Fine Arts in Richmond.[114] Stovall's entry, "Swing Low, Sweet Chariot," was not selected for top honors, but was selected as part of a traveling exhibition destined for the Springfield Museum of Fine Arts in Massachusetts[115] (color plate 2).

Around this time there were indications that Stovall's social status and reputation as an artist became intertwined. In a letter responding to Stovall's painting on exhibition during the next Biennial, the 17th, Louise Daura commented, "I wish the *Lynchburg* [*News*] and *Advance* had reprinted the account [of the exhibition] so everyone here would realize how important

you are in the art world. They [residents of Lynchburg] know how important you are in the social world, and everyone loves you."[116]

Losing no momentum, Stovall next entered a juried exhibition in 1958 sponsored by the Mead Atlanta Paper Company and held at the Atlanta Art Center.[117] Stovall submitted "Baptizing—Pedlar River" (color plate 3). The painting was one of seventy-four works selected among over one thousand entered by Southern artists.

In 1959, Stovall again entered the (17th) Annual Virginia Artists Exhibition sponsored by the Virginia Museum.[118] In April, she received a telegram from the Museum announcing its decision to buy her entry, "Baptizing—Pedlar River."[119] The painting had been one of four selected for purchase out of the 154 entries in the competition.[120] As usual, Queena's family and friends rallied around her. A bus was chartered for over forty friends and family who rode with her to the awards ceremony in Richmond.[121]

In 1961, Stovall completed her monumental painting entitled "End of the Line" (color plate 4). The completion of this work—a work dedicated to her white friends as "Swing Low, Sweet Chariot" had been to her black friends— marked the beginning of the last phase of her painting career. Only three more works, painted by Stovall alone, would be completed. Along with dramatic social changes around her, Queena was challenged more and more by health problems. Her heart showed signs of weakness, and she suffered a slight stroke. In addition, cataracts slowly marred her vision, frustrating her painting efforts.

In 1963, Stovall entered a painting, for the third time, in the Virginia Artists Exhibition at the Virginia Museum of Fine Arts. Of the 1,549 art objects submitted, the jury selected 175 paintings, prints, drawings, sculptures, and craft items. This time Stovall's entry, "End of the Line," won a certificate of distinction, but was not bought for the museum's collection.[122] Shortly after Stovall's participation in the Virginia Artists Exhibition in 1963, she left to vacation in Europe with David Hugh, his wife, Rosa, and their daughter, Rosalie Dillard Basten. For three months, Queena traveled widely, as her mother once did, visiting museums and historical monuments across the European continent.

After fifteen years, Stovall's artwork was returned to the location where her artistic expression as a painter began. In February 1965, "thirty-one 'primitive' paintings by Queena Stovall of Elon" were put on exhibition in Main Hall at Randolph-Macon Woman's College.[123] Stovall was delighted that six paintings were sold as a result of the exhibition. Among them, Randolph-Macon purchased "Swing Low, Sweet Chariot" as part of the college's permanently displayed collection of American art.

Through her recognition as an artist, Stovall began to receive recognition for her civic contributions. In 1966, she was commissioned as a "Kentucky

Colonel," an honorary organization whose members have donated substantial time to civic activities. A friend—also a Kentucky Colonel—recommended her for the commission after learning of her paintings while attending an annual December "chitlin' " dinner at the Wigwam. In Stovall's view, her talent for making good chitterlings was as decisive in the honor as her talent for painting. "He must have been impressed with the good old-fashioned chitlings," she reasoned.[124]

From the late 1960s through the 1970s, Queena repeatedly experienced personal loss, and, after several aborted efforts at painting, decided to end her career as an active artist. Her eldest child, Brack, Jr., died suddenly in 1969.[125] A few months after Brack, Jr.'s death, Queena's brother—and close friend—David Hugh Dillard died, exacerbating her grief.

In November 1972, Louis C. Jones, folk art scholar and Director Emeritus of the New York State Historical Association (NYSHA), and his wife, Agnes Halsey Jones (also a folk art scholar) were traveling around the eastern half of the United States, sampling the country's folk art under the auspices of the National Endowment for the Humanities. While visiting a friend in Lynchburg, they learned about the paintings of a local artist, Queena Stovall. They became interested and spent several days interviewing Stovall and photographing her work.[126] Thus began a close friendship that lasted until Queena's death in 1980 and continues through her sons and daughters.

When the Joneses returned to Cooperstown, they convinced NYSHA to sponsor an exhibition of Stovall's works. Through the efforts of the Joneses and the NYSHA staff, forty-one paintings were located and borrowed for a major exhibition in 1974-75.[127] The paintings traveled from the Dillard Museum of Lynchburg College via the Abby Aldrich Rockefeller Folk Art Collection (AARFAC) in Williamsburg, Virginia, before they reached NYSHA's Fenimore House Museum in Cooperstown.[128]

By the late 1970s, Stovall was accustomed to seeing her name and photographs of her paintings in newspapers and magazines (plate 6). Her television debut took place through the efforts of Jack O'Field, owner of Bowling Green Films, Inc. In 1978, O'Field interviewed and filmed Stovall as part of a public television special on folk artists. During and subsequent to O'Field's filming, many of Stovall's works were brought together for a variety of local exhibitions in Lynchburg, Virginia, Greenville, South Carolina, and New York City.

Toward the end of her life, Stovall became more contemplative about her past: "Through it all it's been a peace and a happiness that I think few people have had. I've had a wonderful life."[129] Queena never lost sight of her affinity for country life: "I am a country woman," she often said. Gradually growing weaker, however, Queena retired from direct participation in the chores of the Wigwam. Still, her presence continued to be felt through her indomitable

spirit and desire to pass on the life she valued. "I teach Whitey [daughter Mary White] to do everything now, because she's really the head," Queena conceded. "I'm too old to take [an] active part. . . . she's beginning to learn about the garden, to plant things."

Two days before Queena died, she asked to see the bountiful half-acre garden Mary White tended.[130] Unable to walk the distance, Queena was driven to a spot where she could view hundreds of thriving tomato, squash, and bean plants recently mulched according to her instructions. Satisfied with the garden's progress, she returned to the farmhouse. Early in the morning on June 27, 1980, Queena died quietly in the bedroom where she had painted.

Queena is buried at the Presbyterian Cemetery in Lynchburg, about twenty miles from Amherst County and the Blue Ridge Mountains she admired. A small but meaningful event, symbolic of her association with country life, occurred during the burial service. Bobby Stovall recalled,

> It was during the service, while the minister was praying. It seems like it was late afternoon—I think the funeral was at four o'clock. I heard this rooster crowing. There we were, less than a half-mile from the expressway going around town and everything was very quiet, very still and a rooster crowed. To me it said something. It was rare for a rooster to crow in the city; it was rare for a rooster to crow in the afternoon. I thought it was very unusual. Someone told me that it was a sign of good luck.[131]

2

Phase I, 1949-1950: "American Food at Its Best"

There is a strong link between that table full of American food at its best and more than half of [Stovall's] paintings, which reflect the source, the labor, the folk technology which makes these victuals possible.[1]

In the fall of 1949, Stovall enrolled in Pierre Daura's art class at Randolph-Macon Woman's College, after her brother David Hugh Dillard paid for her tuition and supplies. Though she attended the course for only a short while, Daura's interest in her talent had a catalytic effect: she went on to produce slightly over one canvas a month throughout late 1949 and 1950. From the beginning Stovall chose her subjects as if she were making an entry in her diary. Since the continual chores of farming saturated her daily life, she gravitated toward the depiction of activities close at hand and ongoing at the Wigwam. Stovall's early works depict the getting and preparing of food in the country. Out of the thirteen pictures produced that first year, the majority represented subsistence related activities, such as raising, butchering, and dressing farm animals, processing dairy products, harvesting crops, and canning fruit.

"If I Thought I Could Do a Thing, I Could Do It"

Stovall's first painting, "Hog Killing," stands as a monument to the beginning of Stovall's artistic career, courageously pursued at an elderly age. Entering Daura's art class, she "was scared to death to be among college girls who were sketchin'."[2] Not yet aware of the full potential of her talent, she was uncomfortable in the classroom environment of young students "with sweaters and beads."[3] Rosalie Basten, her niece and fellow student, eased Queena's transition from the demands of gardening and cooking to those of academic assignments. "Rosalie told me that Pierre wanted us to paint a picture of what Christmas means," Stovall recalled.[4] Her initial reaction to the assignment was candid: "I just thought [that Christmas] was a lot of confusion."[5]

But after thinking it over, she decided that Christmas had a very specific meaning in her life, inextricably connected with seasonal chores: " 'Lord,' I said, 'the only thing Christmas means to me is hog killin'. Everybody in the country has got to have a little fresh meat.' "[6] With her personal vision in mind, Stovall began to draw a couple of hogs hanging from a tree. Years later she laughed, remembering an amusing exchange with Daura as he looked at her drawing: "When Pierre came around and saw it he told me to go home and finish it. Only thing he said was that I should have a prop under the limb that was supporting the weight of the hogs. I told him that I had one under it at home."[7] When Daura told the students to go home and complete their pictures, Stovall responded in astonishment: "I said to him, 'You mean paint by myself without you telling me what to paint?' And he said 'yes,' and so I came home and didn't go back for a month, until just before Christmas, when I finished the 'Hog Killing.' "[8]

In part, the decision to render hog butchering was based on her overall perception of the activity's rewards: "I think butcherin's a real treat."[9] But in spite of the enjoyment Stovall received from pigs as a subject, her depiction of hog killing did not represent an entirely pleasant, carefree occasion. Stovall expressed the onerous side of the job in a letter to Mary F. Williams: "The month of December in the country—what with hog-killing...and getting ready for Christmas—has almost put me back to bed again."[10] In fact, the weight of the task may well have placed it in the forefront of Stovall's mind, increasing its likelihood as a subject.

Having discovered a workable motif—pigs—Stovall began to express her ideas through additional paintings and other artistic endeavors. Using pigs repeatedly as a subject, she developed a common thread through several of her paintings, providing the same kind of continuity in her art as she had in her daily life. About "Cutting Out the Meat," her second painting, she said: "I just had to paint the next one...because that's what we did next after we killed the hogs."[11] The painting represents a ceremonial event—tasty hams, sausages, and cracklin' bread finally become available after months of slopping pigs, patiently watching them grow, and completing the arduous tasks of slaughtering, cutting, and curing the meat (plate 7).

In time, Stovall played out her visual notions regarding pigs by completing three more canvases on the topic: "Empty Pen," "Feeding Time," and "Full Litter" (plates 8, 9). Moreover, pigs represented a leitmotif in her wider range of artistic production created for family and friends. Stovall's pig motif dominated the table settings and decorated napkins she made for her celebrated chitterling dinners (plate 10). No small task, especially during a busy time of the year, she made a souvenir for every person who attended the dinners. "We always gave it the first Saturday in December," Queena said. "For years it was just the men, but after a while the wives started asking to

come.... We had 48 here for the last one."[12] In February, special friends received handmade valentines adorned with pigs wearing crowns.

Stovall made decisions about what she painted based on two dimensions in her life. In general, seasonal events or scenes of ordinary daily activities satisfied her desire for an overall record of her community. On a particular and personal level, however, she chose portrayals within those scenes which represented her commitment to and affection for her own family and farm. Hence, several of Stovall's paintings reveal the same two people—Brack Stovall, her husband, and Sally Mae McDaniel, her loyal and hard-working domestic. For Queena, Brack was a lifetime partner with whom she raised her children; Sally Mae was a source of steady help and companionship to meet the demands of the Wigwam. Both stand as symbols of an emotional and physical support system necessary for the kind of life Queena lived.

Brack appears in nine, possibly ten paintings—more than any other single individual.[13] "She was absolutely wild about him," James Davis recalled. "Nobody came in front."[14] Queena often talked about Brack during interviews: "He was a forceful person, a wonderful character. He believed in children, [but] not letting them take possession of everything. We took care of them and all that—what I mean is we didn't put the children first."[15] Although kind and loving parents, Brack and Queena's respect for discipline reflected the Southern social caste system; they incorporated a hierarchical structure within their family which clearly defined acceptable behavior and privilege.

"Mostly I remember Mr. Stovall," Davis said, "being in some kind of comfortable place with that crooked pipe in his mouth." Evidently, Queena Stovall envisioned her husband in a like manner. In "Brack and the Pickwick Papers," a pipe-smoking Brack is ensconced in his easy chair, absorbed in a book (plate 11). Usually wearing the same pants, sweater, and hat, Brack's easygoing style comes through clearly in her portrayals. "Although Brack wasn't a farmer," Stovall said, "I used to always put him in smoking a pipe."[16] In the paintings about pigs, he sits or stands overlooking the operation, or putters around the crib at feeding time. Always combining pleasure with his sense of duty, he's never so involved with chores that his pipe goes out and must be set aside.

Stovall's tribute to Sally Mae McDaniel is "Sally Mae's Favorite Breakfast" (plate 12). McDaniel appears in five other paintings, second in number to Brack.[17] During the ten-year period that McDaniel lived in a room off the kitchen at the Wigwam, Stovall depended heavily on her assistance. As expressed in "Favorite Breakfast," Stovall was gratified by McDaniel's appreciation for the bounty from the Wigwam gardens. Stovall said:

> We always raised sweet potatoes out here. Sally Mae was with us about ten years. After we'd dig 'em, she'd pick out the biggest ones and pick one for herself, just real big. She'd cook it the night before and in the morning heat it, open it up and put butter on it, don't you see.[18]

Plate 7. Queena Stovall, "Cutting Out the Meat", January 1950
18" × 24".
(Louis B. Basten, III, Lynchburg, Virginia; Photo from the collection of Robert K. Stovall)

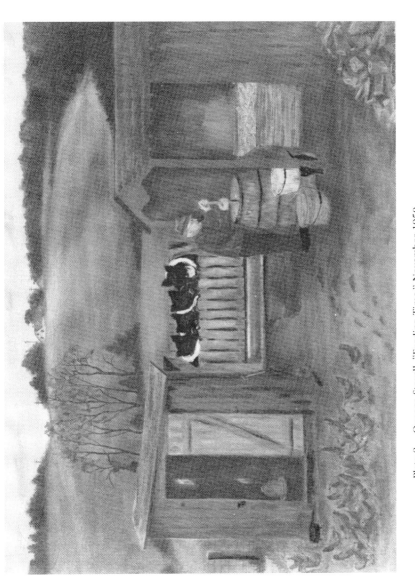

Plate 8. Queena Stovall, "Feeding Time," November 1950
19″ × 24″.
(*The estate of Queena Stovall, Lynchburg, Virginia; Photo from the collection of Robert K. Stovall*)

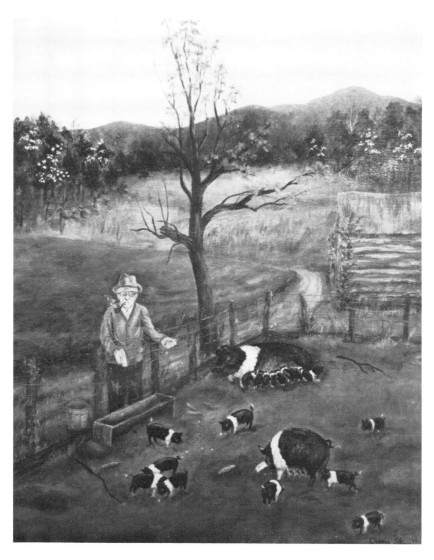

Plate 9. Queena Stovall, "Full Litter," November 1956
20″ × 16″.
(Robert K. Stovall, Lynchburg, Virginia; Photo by author)

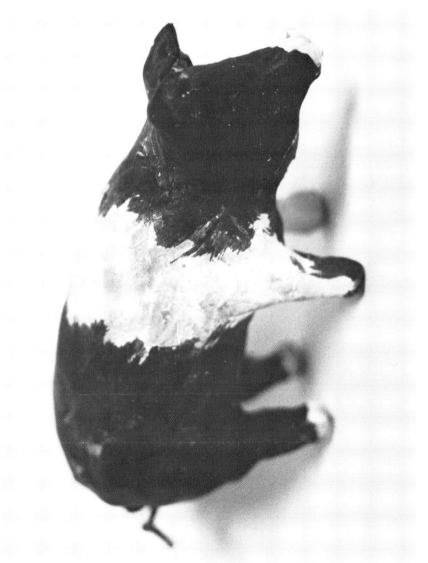

Plate 10. Queena Stovall. Clay Pig. 1960s
3¼″ × 6¼″.
(*Photo by author*)

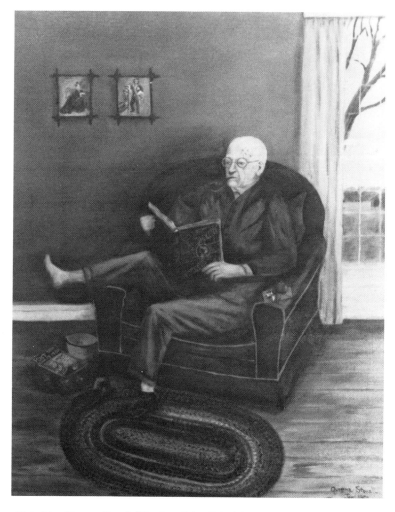

Plate 11. Queena Stovall, "Brack and the Pickwick Papers," January 1950
20″ × 16″.
(*The estate of Queena Stovall, Lynchburg, Virginia; Photo by author*)

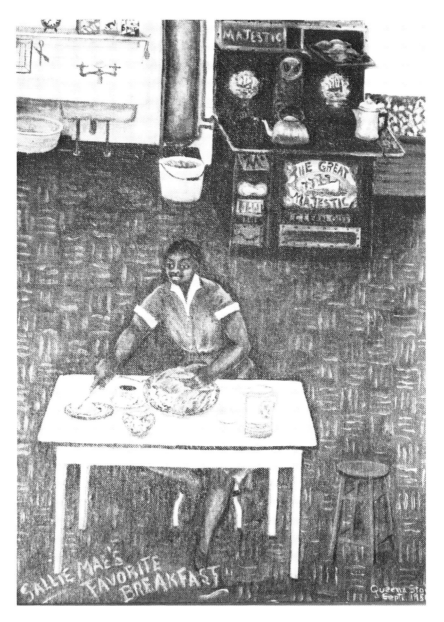

Plate 12. Queena Stovall, "Sally Mae's Favorite Breakfast," September 1950
16" x 12".
(The estate of Queena Stovall, Lynchburg, Virginia; Photo by author)

Plate 13. Queena Stovall, "Saturday Night Bath," April 1951
17″ × 23″.
(Mrs. T. Suffern Tailer, Southampton, New York; Photo by author)

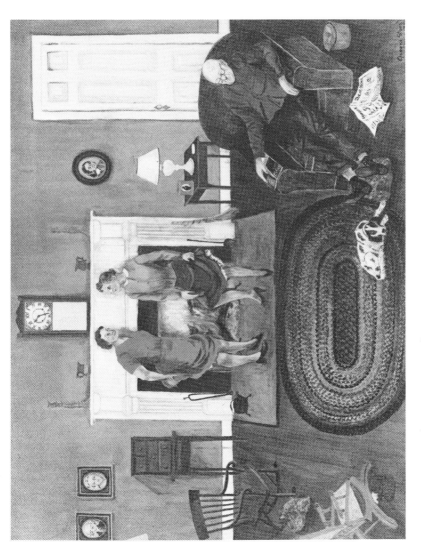

Plate 14. Queena Stovall, "Fireside in Virginia," December 1950
18″ × 24″.
(*Mrs. R. Cary Fairfax, Lynchburg, Virginia; Photo from collection of Robert K. Stovall*)

Plate 15. Queena Stovall, "Monday Morning," April 1950
19″ × 25″.
(*Mr. and Mrs. William R. Chambers, Lynchburg, Virginia; Photo by author*)

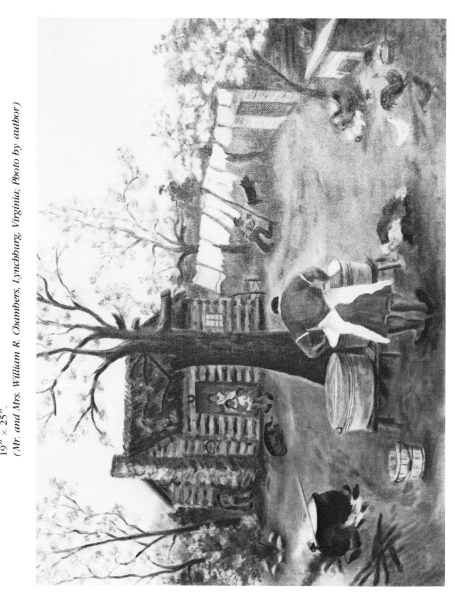

When I asked McDaniel whether she eats sweet potatoes for breakfast, she answered, "that's right. I still do. I like [to drink] buttermilk or a Dr. Pepper or something like that."[19] Close agreement exists between Stovall's document and McDaniel's expanded narrative describing the scene. But Stovall couldn't bring herself to render a modern detail—the Dr. Pepper!

Beginning Methods and Techniques

During this first painting phase, Stovall adopted a systematic process to transfer the image in her mind to her canvas. Deciding on a theme, she often observed the event firsthand, making a rough sketch. Between the sketch and the canvas, Stovall established an elevated perspective, characteristic of all her works. Also, through practice and experimentation, she began to define her criteria for a satisfactory painting.

From the start, Stovall went to the location of a scene and made a sketch in preparation for her painting. Often the scene took place only a few steps away. Hogs, for instance, were butchered at the Wigwam near the pig pens, just outside Queena's kitchen window. James Johnson, one of David Hugh Dillard's farmhands who helped to butcher Queena's hogs for many years, recalled: "[To] this very day, I remember how it was. Mrs. Stovall stood there at the window painting this picture."[20] Melvin Bailess, David Hugh's farm manager, said she would sit "on the steps and sketch while we were working with the hogs, hanging [them] up on the pole with their hind feet, you know, swinging down. We didn't know what was going on. We knew she was there doing something."[21]

Over the years, Stovall continued to make preliminary sketches: "In 'Swing Low' ["Swing Low, Sweet Chariot"] . . . I had gone up there to where the scene is and sketched the trees and layout."[22] Stovall sketched the setting, without the details, to "block out" a general idea of the landscape. She conceived of and added the specific contents of her pictures later, after the painting was begun.

An examination of Stovall's use of the word "sketch" reveals information about her level of ability to conceptualize and verbalize her artistic process. "I never learned how to sketch," Stovall said after several years as a painter. "I just don't know how."[23] Further, she said, "I didn't like to draw—couldn't draw really."[24] It seems that Stovall derived her sense of the words "sketch" and "drawing" from relatively brief experiences in art classes taken when she was a girl. She recalled a high school art assignment in which "all we ever drew was a prism or cube or something like that—just a nothing without any life to it."[25] As a student in Daura's class, Stovall was confronted once again with the frustrations of sketching: "The first thing he did in school, Pierre made us sketch about ten minutes. . . . we'd sketch those college girls . . . all in different

positions."[26] It seems to me that Stovall associated sketching with the use of inanimate objects out of context: "I have to paint somebody doing something," she said, "showing that they are working."[27] The class models—whether students, prisms, or cubes—did nothing but sit stiffly, waiting to be copied. Such lifelessness was foreign to Stovall's experience and contrary to her respect for "doing something." "I'm used to a busy life," she said, "of doing things. That's what I love."[28]

Although Stovall received some academic training in Daura's class, she did not remain a student long enough to associate the term "sketch" with more than drawing unmoving objects separated from an active context. The larger point is, I think, that artistic development from a naive to a highly trained artist entails not only improvement in eye-to-hand dexterity, but also the competence to articulate one's artistic process in fine art terms. When asked to describe her initial steps in a painting, she fell back on the term "sketch" because she knew no better word to describe her technique, but earlier negative associations prevailed. More extensive formal art training probably would have clarified and enhanced Stovall's art vocabulary.[29]

Characteristic of Stovall's paintings from the beginning is a slightly elevated perspective. She seems to have visualized her subjects from a position about two or three feet up, allowing her to step back and look into what she painted. As a result, one is left with a sense of observation rather than participation. When painting, Stovall separated herself from her subjects in order to translate familiar, everyday, routine aspects of her life into satisfactory artistic expressions. Unlike making sausages, planting a garden, or canning, she lacked experience in oil painting on canvas. It was necessary, then, to pull back, rise up, look hard and concentrate without the compromises of participation.[30]

During the first year, Stovall detected some shortcomings in her skills and began to experiment with ways to overcome them. While working on "Cutting Meat," she was confronted with her inability to depict the inside of a building. Bailess recalled—and Johnson agreed—that the cutting and trimming took place "inside a building, a big machine shed at her place where she lived. That's where we do the work, down there." The logic behind the location seems obvious since, he said, "it's so cold you couldn't stay outside."

Yet Stovall depicted the scene outdoors. She herself explained the discrepancy: "I put it outdoors because I didn't know how to show it indoors."[31] The difference between the actual and depicted settings indicates a conscious decision to change the surroundings of a scene because of her perceived artistic inability—a rare display of self-doubt—during an early stage of her career.[32] But ironically, in the end, the loss in accuracy regarding location enabled Stovall to enhance the description of the entire event. The spacious outdoor setting of "Cutting Meat" allowed her to illustrate more

activities related to this stage of preparation—portioning the lard—in the same space. These activities usually occurred in different areas: the hams were cut and trimmed in a shed, while the lard was cooked in a pot closer to the house.[33] Stovall's decision to relocate and concentrate these activities to fit on one canvas actually increased the painting's value as a historical document. One detail was sacrificed due to limitations in skill, but as a result more information about the event could be included.

Several of Stovall's canvases show signs of reassessment and modification. If Stovall didn't like something she had painted, she often changed it. For example, in "Saturday Night Bath" the boy sitting on the bench was brought forward, and the shed in "March Fury" was made smaller in size[34] (plate 13, color plate 5). Such trial and error represents experimentation and a growing sense of discrimination and fastidiousness in her art; she was learning to be self-critical, a necessary trait for any serious artist, and a vital part of her development.

Another example of her emerging artistic standards is the painting "Cutting Corn at the Foot of Tobacco Row Mountain." After successfully completing eight canvases, Stovall was confronted by an obstacle; her attempts to record the cutting and shocking of corn failed to meet her criteria and she abandoned the project.[35] In spite of repeated efforts, she could not get the road to lay down, a problem she subsequently faced with rugs in interior scenes. And Tobacco Row Mountain in the background continued to present an insurmountable challenge, a surprising disclosure since successful rendering of the Blue Ridge Mountains is seen in the background of many of her completed works. Perhaps most illuminating is her frustration with a feature of the actual setting which symbolized modernity and the encroachment of change on her beloved country life. At first documenting the scene authentically, she painted telephone poles along the side of the road. The poles, however, were eventually left out when Stovall decided that they looked too modern. As can be seen here and in other works, Stovall's emotional attachment to the past partly explains the emergence of aesthetic decisions which compromised the historical accuracy of her documents.

Nostalgia, Creativity, and Artistic License

Interviews with people from Stovall's community offered clues about her creative development. When the painted scenes were compared with my narrators' information about folk technology, it became obvious that Stovall's romantic attachment to the past, combined with her aesthetic sensibilities, influenced her art from an early stage. She made aesthetic decisions when her need to produce art outweighed her predilection to record. At times her artistic license resulted in the depiction of misleading information; at other

times, however, it merely underscored her veneration for her past heritage. About "Hog Killing," Stovall said:

> The way we killed was to get a big barrel and put rocks around under it, the barrel was propped up on a slant, then we put water in it, don't you see. The barrel was kept from burning by building the fire at the front. When the rocks were heated by the fire they were put into the barrel, making the water scalding hot. It didn't do so bad as I remember.[36]

But James Johnson's comments encouraged a closer look at the painting. "Let me check this," he said, studying a print of "Hog Killing," "because we didn't usually scald them in no barrel down there. That's the first way I started when I was growing up at home, see, with those wooden barrels, down in Goochland County." Melvin Bailess recalled that

> years ago it was a barrel. Used to be a barrel. You heated your rocks, put your rocks in there to heat the water, then take the rock out and scald your hog. But there [at the Wigwam] we had a big round pot.

Unlike the workers' recollection of killing hogs at the Wigwam, Stovall depicted the older barrel tradition in the picture.

Although Stovall claimed that she painted only contemporary farm life scenes of the Blue Ridge piedmont in the 1950s and 1960s, "Hog Killing" is only the first of several paintings which document the past along with, or instead of, the present. In "Hog Killing" the past is superimposed on the present, and, in fact, is visually and narratively more significant. She diminished the role of the "big, round" iron pot, a modern object, by rendering it small and leaving it slightly outside a triangular composition which takes the eye from the barrel up to the scraping platform, over to the scaffold, and back to the barrel. The picture, then, includes objects that are functionally redundant because either a barrel *or* an iron pot is used to scald hogs.

Why would Stovall tolerate a misleading and confusing description such as this? In my opinion, she was giving free rein to her sense of what makes interesting and satisfying art without letting go of her preference to record. The traditional custom of heating rocks in a wooden barrel suited Stovall's desire for liveliness as well as satisfying a love for color, texture, and atmosphere, seen repeatedly in her works. She preferred the artistic and narrative potential of the older barrel tradition: roughhewn slats, hot rocks steaming from contact with the water, and a crackling fire provided images with varied textures and vivid colors compared to a black iron pot. Futhermore, the barrel tradition required more activity. The workers had to maintain the fire constantly to control the rocks' temperature and, hence, protect the barrel from burning. This task required concentration. Johnson referred to the potential danger of the job:

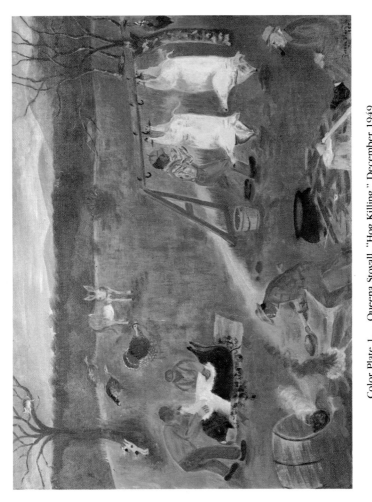

Color Plate 1. Queena Stovall, "Hog Killing," December 1949
18″ × 24″.
(*Louis B. Basten, III, Lynchburg, Virginia*)

Color Plate 2. Queena Stovall, "Swing Low, Sweet Chariot," October 1953
28" × 40".
(*Maier Museum of Art, Randolph-Macon Woman's College, Lynchburg, Virginia*)

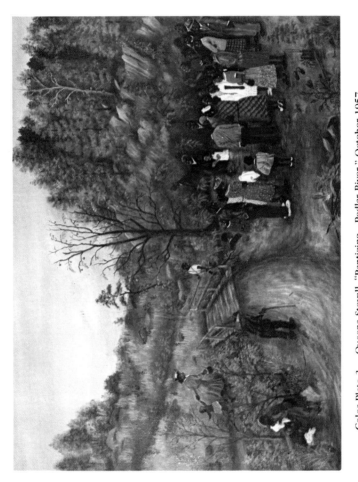

Color Plate 3. Queena Stovall, "Baptizing—Pedlar River," October 1957
26" × 34".
(*The General Endowment Fund, Virginia Museum of Fine Arts, Richmond, Virginia*)

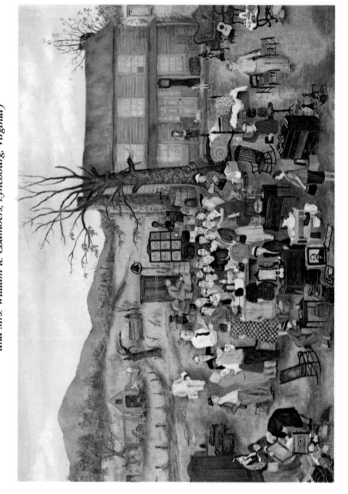

Color Plate 4. Queena Stovall, "End of the Line," December 1960
32" × 44".
(Mr. and Mrs. S. Allen Chambers, Jr., Washington, D.C. and Mr.
and Mrs. William R. Chambers, Lynchburg, Virginia)

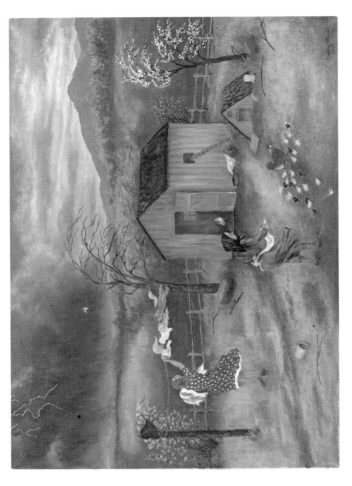

Color Plate 5. Queena Stovall, "March Fury," September 1955
20" × 26".

(Mrs. Harold G. Leggett, Sr., Lynchburg, Virginia)

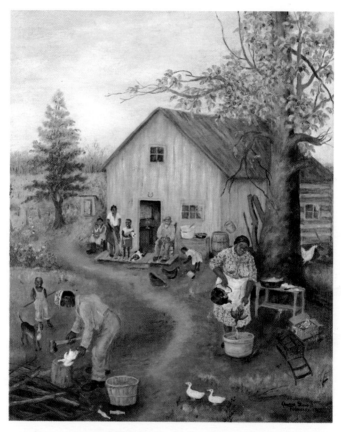

Color Plate 6. Queena Stovall, "Comp'ny Comin'," February 1967
24″ × 20″.
(Mr. and Mrs. David Hugh Stovall, Lynchburg, Virginia)

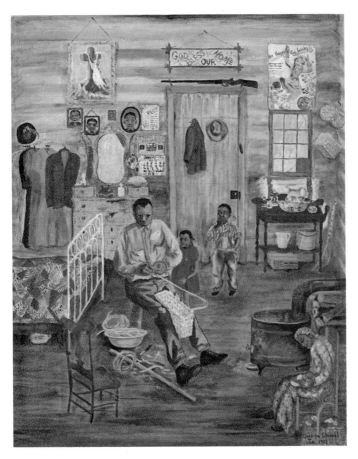

Color Plate 7. Queena Stovall, "Basket Maker," January 1951
20″ × 16″.
(C. Tad Holt, Lynchburg, Virginia)

Color Plate 8. Queena Stovall, "Peaches Are In," October 1950
20″ × 26″.
(Mr. and Mrs. S. Allen Chambers, Jr., Washington, D.C.)

It was just like you shooting a shotgun. Take a shovel and [lift] them in there. [There is] a crash. The whole barrel shakes. When cold water hit a rock, it throw a piece back out. You'd be surprised. You have to watch about that. That's kinda' dangerous.

Aside from the danger, there was at least one advantage to tending the fire. Allen Dempsey, who worked for Ella Dillard and Queena for many years, said "being around the fire keeps the odor back."[37]

One farmer shown a print of the painting remarked on its inaccuracy. "He commented at length on 'Hog Butchering' [*sic*]," wrote a colleague of mine. "Said the picture was all wrong—no way the pig would have been moved so far from the water [because] often it must be submerged more than once and it is too heavy to move around unnecessarily."[38] It seems to me, however, that the unrealistic distance allows for an unobstructed and more balanced distribution of components in the composition. Had Stovall represented the proximity more realistically, the scraping activity would be partially hidden by the barrel and fire, obscuring that part of the butchering process. Once again, Stovall made an aesthetic decision, this time sacrificing the accuracy of one part of the painting for the overall artistic clarity.

Symbols of the past continue to appear in Stovall's later paintings. The hearse, for example, in "Swing Low, Sweet Chariot" was included on a whim. "I put in one of those old, fancy draped hearses," Stovall said. "Long about that time, here come one through town. So I just kinda' put that in the picture and had it sitting there at the church." Actually, Stovall admitted that the funeral home director in the painting owned "a brand new shiny black one."[39]

Also, when depicting the interior of the Wigwam, Stovall rendered old family photographs instead of the numerous other pictures she owned. In three paintings, "Pickwick Papers," "Fireside in Virginia," and "Queena Cutting Brack's Hair," pictures of her parents and grandparents hang on the wall (plate 14). Based on Stovall's attraction to the splendor of the past and appreciation for her heritage, the allure of the pictures is understandable. In one, Ella Dillard wears an expansive Victorian gown and James, her husband, exhibits a regal Masonic uniform. Both their costumes and poses are representative of a bygone era.

Interpretations of the Meaning of Daily Life

Altogether, the paintings produced by Stovall during her first year as an artist contribute to a folklife sampler of her community. Under the guise of images describing the labor of food getting and preparation, Stovall's paintings offer data about traditional attitudes and behavior in the rural South. When examined as a group and utilized as an oral history tool, the pictures reveal information about ethnicity, social interaction, and unwritten cultural regulations. The population she portrayed represents men and women, blacks

and whites, and children and old people; middle-class homes are juxtaposed against modest cabins, and work is punctuated by leisure. Within this framework, however, are different people with their own perceptions about the meaning of daily life and its demands. It is these perceptions which flesh out Stovall's documents and lend greater understanding to the traditional lifestyle of her community.

Several of Stovall's works—including "Hog Killing," "Cutting Meat," "Dressing Turkeys," and "Peaches Are In"—show black and white people working together. An art historian studying this aspect of Stovall's works wrote, "within the employer-servant relationship [blacks] were usually considered as individuals; contemporaries, sharing a parallel—if not similar—concern with the exigencies of country life."[40] While not exactly a misconception, the statement shrouds the issue of what is *not* shared by blacks and whites and why. A complex social structure exists beneath the cloak of common concern over the "exigencies of country life." Stovall's paintings, together with oral history, offer a window into this structure, illuminating particular attitudes and expected behavior characteristic of the employer/servant arrangement.

Stovall's verbal description of the farmhands' attitude about butchering differs from both her depiction on canvas and the farmhands' narrative. According to Stovall, "Butcherin' was an occasion—the Darkies was always singin' and laughin' and being real happy. The weather was always cold and one time Mama asked if we hadn't some wine to give'm. I told her ya so we gave'm some wine and glasses."[41] Yet when I asked James Johnson if the workers ever sang songs or told jokes and stories while they butchered he replied: "No, we never told no jokes. We didn't have time to sing. You know, when you kill twenty-five, thirty hogs, you got to stay right at it." Allen Dempsey concurred, and added that butchering was a "very hard job at the time." Despite Stovall's verbal recollection, her painting echoes the worker's perception of the chore. In the picture, there are no signs of cheerful camaraderie or singing; in fact, no one is even smiling. It seems that Stovall's picture is a more accurate record of the occasion's work atmosphere than her verbal account. Although the event she recounted no doubt happened, it was the exception to the rule and not a typical part of the black farmhands' experience.

"Monday Morning," a depiction of washing clothes in front of a cabin, evoked different responses from black narrators than from whites (plate 15). One white woman I interviewed—a close friend of Queena's—recalled:

Almost everybody [all whites] had servants, even the people of very modest means. They had washwomen too. But they would come and get their dirty clothes—we call it laundry now—Monday morning and take it to their home. The washing was done at the home of the washerwoman, who was always colored. Negro. Then they would bring it back usually on Friday. Everything starched and beautifully finished.[42]

Hiring out laundry has deep roots in the South. Margaret Ward, testifying before a Senate committee in the 1880s, described her experience with servants based on life in Rome, Georgia, before the Civil War:

> I do not suppose we ever had less than three servants who were very good cooks, ... then we had our regular washerwomen. In those days we would always have in one of the cabins close by the house one or two washerwomen, who took the clothes out on Monday morning and washed them straight through the week.[43]

Queena identified with the segment of Southern society which came to rely heavily on black employees. No doubt she was as stunned as her husband to learn that in parts of Virginia white people survived without the help of blacks. Brack wrote from Pennington Gap, Virginia, in 1915:

> I am plum out in the country. ... There are absolutely no darkies up here. Have not seen but one colored family in the last two days. All the women do their own work. ... the old lady [with whom he stayed] does all her cooking and I expect washing too.[44]

Brack always insisted that Queena have help. "I always had a piece of Negro to help when I had children," Queena said, "all through, up until the sixties. With a big family, you know, you just have to have them."[45]

Interviews with black women, however, revealed a different perspective. Washing clothes and linens in large pans in the yard reminded them of their double burden—taking care of white families as well as their own. Moreover, traditional methods of doing laundry required considerable preparation and a constant eye on the pot and fire. Julia Hunt recalled collecting the necessary materials and making soap.

> We used to make lye soap. Save that grease and make soap. That times you took the bones and made soap. That the old fashioned way. They used to cook them bones up, they get soft. [Then] they begin to make it out of "soap grease," we called it. When you have waste grease to make it out of.[46]

Florine Slaughter's grandmother worked for a white family, cleaning their house and washing their clothes, while training Florine and her brother to help out. "She had a certain day she'd wash and had her washboard," Slaughter said. "She'd tell us what to do. We'd rub them on a washboard and get the dirt out of them."[47]

Slaughter also recalled the danger involved for small children attempting to help with the boiling pots. Her grandmother (referred to as "Mama") tried to keep watch over the operation, yet tragic accidents still occurred:

> [Mama said] "Stay away from that. Don't do that." So when she went in the house, I went there to chuck the clothes down. I was chucking the clothes down, and the wind come and I caught fire, and I run. Instead of going to Mama, I run from her and I burnt, just where I fell

and laid. I was out there hollering. And somebody came by and [said], "Your child's burning up out there." My Mama saw me out the window. She said, "Lord, that child's burning." Mama said that she come and got me up.

From the perspective of black women, traditional ways of doing laundry represented a complicated chore, involving hours of preparation and a potential threat to the welfare of their family.

Despite Stovall's perspective as an employer, her painting "Monday Morning" captures some essential ingredients of the servants' side of the story: the woman doing laundry wears a domestic's uniform, a symbol of her role as a caretaker of white families; several children look after themselves as their mother concentrates on her work; and a breeze blows across the yard where a boiling pot is standing in the open, a potential hazard to uncautious children.

A symbol of ethnic identity and traditional unwritten rules sanctioned by whites appears in the paintings which portray Stovall's domestic helper, Sally Mae McDaniel. McDaniel can be identified in "Cutting Meat," "Dressing Turkeys," and "Making Apple Cider" by her brown paper bag hat. While working at the Wigwam, she regularly wore a paper hat. Stovall's daughters remember that McDaniel kept a bag hat close at hand on the back porch, so it was easy to grab on her way outside to do chores. McDaniel laughed when I asked her if she wore a bag on her head as recorded by Stovall: "I sure did," she said, "I certainly did."

At first McDaniel explained that it was an inexpensive, easy solution to the problem of protecting her head. "It keeps the rain off," she said. Other narrators elaborated on this explanation. Julia Hunt said, "When it rains, you can take one of these paper sacks that you get your groceries in from the store. Those old big brown bags, you can put them things on your head when you go out in the rain and keep your hair from getting wet." McDaniel added that her hat "keeps the hair out." This statement refers to a vestige of a traditional regulation imposed on black employees by white employers. According to Slaughter, the paper bags were worn because "the white people would say [that] the colored people's hair would break off and go in the food."[48] She thinks paper sacks replaced other forms of head coverings worn by black women in the past. She explained that "my Mama always tied a big handkerchief on her head, see. Or she'd get a big white piece [of cloth] and put on it. They'd make them out of cloth...or you can tie a rag on your head."[49]

Other paintings include similar accoutrements: the black woman churning in "Come, Butter, Come" wears a duster cap; and black women in four later paintings—"Toting Water," "Aunt Alice, No. 1" and "No. 2," and "Comp'ny Comin'"—wear cloth turbans or scarves (color plate 6). Such examples stand as a symbol of past traditions and for the changing times and shifting relationships between blacks and whites in Stovall's community.

"A Grand Price"

Stovall's first year at her easel brought unexpected praise and attention. Of "Hog Killing," she recalled:

> Pierre looked at it, and he said, "Don't touch it!" I was right disappointed. I thought he meant there wasn't anything I could do to help it. He kept walking away and coming back, and I would say, "What about this over here?" and he would say "Don't touch it!" and walk away. Then he would come back and have another look. Two days later, Rosalie called and said, "Aunt Queena, Pierre is telling everybody who goes to the show not to miss the 'Hog Killing.' He's got a bench out front where people can sit down and really look at it."[50]

A daughter's friend offered to pay twenty-five dollars for the painting. "I thought that was a grand price," Stovall said. "I never heard of anyone selling a painting for over ten or fifteen dollars, you know."[51]

But during Stovall's next painting phase, she earned well over twenty-five dollars per painting. Although David Hugh Dillard tried to convince her to keep the paintings in the family, the lure of increased financial security prevailed over her brother's wishes: "David Hugh didn't want me to sell any of them. He told me he'd buy them and pay the same anybody else paid, plus one hundred dollars, but I just didn't want him to have to help to buy my paintings, and I needed the money and so I just went on and sold them as I finished them."[52]

Phase II, 1951: Productivity and Profits

During an eleven-month period in 1951, Stovall completed sixteen paintings—an unprecedented display of artistic energy never to be equaled again in her career. Her prolific output during this period (Phase II) reflects the chain effect of supply and demand: the market demand for her paintings stimulated the expansion and refinement of her artistic approaches and resources, which in turn enabled her to paint more efficiently. Devoting more attention to her methods and techniques, Stovall cultivated a formula to expedite the transfer of her mental images to canvas. And as close friends and family realized the extent of Stovall's pleasure from painting, they made a concerted effort to nurture her talent. Although she continued to document farm work scenes, she laced the obvious with subtle clues about the importance of companionship among women and the relationship between women and children. Diluting the drudgery of chores, she integrated vignettes about the presence of play and humor in country life. Stovall had a lot to say during her second year as an artist, and she lost no time gathering the resources and developing a way to say it.

"I Just Went On and Sold Them"

Two major influences affected Stovall's enthusiasm and, therefore, her high rate of artistic production during Phase II: her brother's endorsement (particularly his willingness to pay more than the offered price for her paintings), and recognition by professional artists and art buyers. Early in 1951, the Director of the Oglebay Institute in West Virginia wrote: "The photographs of your paintings arrived the other day and we were delighted with them....I am sending you the photographs, marking on the back the three paintings we would like to see....From these three, one will be selected for our permanent gallery."[1] By mid-February, the Director had sent a check for $250 for "Come, Butter, Come." Most assuredly, the letter accompanying

the check pleased Stovall: "My Art Committee enjoyed seeing your work very much. Each painting was interesting and it took us awhile to decide which one we wanted."[2]

And Grant Reynard spared no words of encouragement, recommending that Stovall *"paint* and *paint"* while he searched for an appropriate art dealer in New York City. At the beginning of Stovall's second year as a painter, Reynard wrote, "I am sure that your biggest effect will be to show a good sized group at once to a prospective dealer. The impact of a lot of work is the thing which will show that you are not a flash in the pan painter."[3]

The atmosphere of success generated by approval and sales had an invigorating effect on Stovall. About "Saturday Night Bath" Queena's daughter-in-law recalled: "I know one picture I never saw . . . a Saturday night bath. She did it real quick, it was just a real fast picture. It was done and painted, and somebody saw it and bought it and it was gone."[4] Stovall's children recalled that the paint was still wet when "Saturday Night Bath" was taken to Kraushaar's Gallery in New York City.

By now Stovall was convinced of the potential for profit from her work. Her daughter Annie Laurie described her mother's attitude. "She was thinking financial. She was surprised when people bought them, but when they did she thought of them as financial assets."[5] Common sense joined forces with a lively memory and ingenuity. Stovall averaged at least one painting per month throughout 1951, completing three during each of the months of January and April.

Garnering Artistic Resources

Stovall's close friends and family increasingly supported her interest in painting. On many occasions, they heard her say "painting is just plain fun." Indeed, her enthusiasm for painting was contagious, and her inner circle began contributing in a variety of ways to her artistic resources. Already providing moral support and modeling for figures, her husband, children, and close friends also shared their ideas.[6] Accustomed by now to what Stovall liked to paint, they enjoyed keeping an eye out for promising scenes and subjects.

Stovall's daughter Narcissa knew of an elderly black man living near Elon who she thought would interest her mother. "Go up there and see him," Narcissa suggested according to Bobby Stovall, "by the tobacco barn at Pedlar Mills."[7] Following her daughter's suggestion, Stovall went to see for herself and, as a result, painted "Uncle William, No. 1."

Over the years, Stovall remained open to the recommendations of those in touch with her traditional world. She said: "Mr. Dinwiddie, the social security man, he and his wife used to come out here nearly every week. He said, 'I've got in mind two pictures that I think you could paint. One would be

an old colored man shavin' with a straight razor and then havin' him dressed up for Sunday morning,' don't you see."[8] The images Dinwiddie described meshed with Stovall's familiarity with similar scenes, and inspired her to paint "Saturday Evening" and "Sunday Morning" (plate 16). Another time Stovall relied on Dinwiddie's account of a particular circumstance that she had not seen firsthand. She recalled that Dinwiddie

> used to tell me about a scene he saw once that he thought would make a good picture. Some people had come to look at Uncle Nathan's little black mare. Well, when he left the mare out it started to chase him around just a nippin' and a snappin' at him all the way, Uncle Nathan just doin' all he could to get out of the way. I never saw this happen, but I tried to do it just like Mr. Dinwiddie said.[9]

Because of his job, Dinwiddie had frequent opportunities to observe the small events in Stovall's community; he functioned as a talent scout, on the lookout for appropriate subject matter. Dinwiddie's lively description coupled with Stovall's general inventory of mental imagery resulted in "Uncle Nathan and the Little Black Mare."

In order to balance the ideas gained from verbal suggestions, Stovall collected graphic resources to facilitate her artistic production. For example, a friend gave Stovall an album of snapshots taken in and around Killikranke, the farm and orchard owned by David Hugh Dillard on Tobacco Row Mountain. The photographs document hog killing, picking fruit, and other examples of country chores, and are present among Stovall's artistic paraphernalia.

Supplementing her private sources of inspiration, Stovall continued to clip commercial illustrations which reminded her of the traditional aspects of her community. Her scrapbook grew as she trained her eye to zero in on magazine and newspaper illustrations which reflected the traditional patterns of her community. Although she clipped many illustrations from national publications such as *Life* and *The Saturday Evening Post*, she also cut out several press photographs from local newspapers.[10] Altogether her collection of illustrations inspired the depiction of people based on three different connections: (1) those whom she did not know personally but who she thought represented a familiar, recognizable image; (2) those whose identity was determined only after she began painting; and (3) those whom she actually knew and whose photographs appeared in a local newspaper.

The first way Stovall used illustrations was as a guide for a figure she considered characteristic of certain people in her community. The two "Aunt Alice" paintings are based on a press photograph and story printed in a local college newspaper. Apparently, Stovall did not know Aunt Alice personally. However, because of Stovall's familiarity with some rural black women in Amherst County, she considered the photograph a reflection of a representative character in the community. Stovall used the illustration to

assist in sifting through and sorting out the plethora of information in her memory—to sharpen her sense of selection and guide her artistic expression.

Although the two companion portraits for "Aunt Alice"—"Uncle William, No. 1" and "Uncle William, No. 2"—were also based on an actual person, Stovall did not know Uncle William personally. As with Aunt Alice, Stovall appreciated "Uncle William" for his characteristic qualities; in her mind, he stood as a symbol for a certain group of older blacks in and around Pedlar Mills and Elon. She considered him typical of old black people she knew who historically were esteemed by blacks and whites alike.

Stovall's perception agrees with historical writings about Southern society. Frederick Douglass wrote, " 'Uncle' Toney was the blacksmith, 'Uncle' Harry the cartwright, and 'Uncle' Abel was the shoemaker, and these had assistants in their several departments. These mechanics were called 'Uncles' by all the younger slaves, not because they really sustained that relationship to any, but according to plantation etiquette, as a mark of respect, due from younger to the older slaves."[11] In *Barren Ground*, Virginia author Ellen Glasgow describes an old black woman endeared to a white family: "Aunt Mehitable Green had assisted at Dorinda's birth, which had been unusually difficult, and there was a bond of affection, as well as a sentimental association, between them.... During Dorinda's childhood both mother and daughter had visited Aunt Mehitable in her cabin at Whistling Spring."[12] And R.H. Early wrote an informal history of Campbell County (contiguous with Amherst County) describing an "Uncle Ned," who represented "a very self-respecting colored man.... an exhorter to his people to do right."[13]

Stovall discovered that a second useful purpose illustrations served was to enable her to get started on a figure whose identity emerged as she painted. For example, in "Swing Low, Sweet Chariot," the portrayal of Willie Sandige (the elderly woman with a cane standing to the right of the casket lid) is based on a magazine photograph of an anonymous individual.[14] Stovall used the photograph to jog her memory of friends; consequently, the figure evolved into a portrait of Sandige. "I'll start out to draw a figure without any idea who it will be," Stovall said, "and it will turn out to be someone I know."[15] Stovall's figures often "just happened," she said, triggered by an illustration or photograph which provided a link between her mental image and the painted picture. In "Swing Low," she altered the clothing, hat, and expression of the woman in the magazine picture as the figure evolved into Sandige, thereby transforming the picture of an anonymous person into a specific individual.

The third way Stovall utilized illustrations was in depicting specific individuals she knew well and planned to portray. In order to paint the subject of "Basket Maker," Hobart Lewis, Stovall referred to his photograph in a local newspaper (color plate 7, plate 17). Lewis had been hired to demonstrate basket making at the opening of Guggenheim's Department Store in Elon, and

the story was covered by a local newspaper. But Stovall was never satisfied to be a copyist: "I can't copy," she said. "I'm not a good copyist. I think I can improve on what I've got to draw."[16] Uninterested in the photograph as a whole, Stovall extracted the figures of Lewis and his two grandchildren, and depicted them inside his cabin on the canvas.

Throughout her career, Stovall used press photographs of people she knew. In portraying the central figure in "Swing Low," she recalled:

> It's a good likeness . . . of the funeral director, Carl Hutcherson, a light skinned colored man. I told my daughter, "I wish I had a picture of Carl Hutcherson. I know what he looks like." She said, "I know he has plenty of pictures—I'll go by there and ask him for one." I think it was the very next morning there was a picture of Carl Hutcherson in the newspaper for bein' the first colored person to be on the school board. So I just took the pose like he was standin'.[17]

Once again, a press photograph—this time of Hutcherson—provided Stovall with a bridge to connect her mental image to the canvas (plate 18).

The portrayals of Pierre and Louis Daura in "End of the Line" are also based on a press photograph (color plate 4, plate 19). Indicative of her attitude about copying, she separated the Dauras, who had been pictured together in the photograph, and placed them in different areas on her canvas. Pierre, wearing a dark suit and tie, is seen directly behind the pitcher being held up for bidding, while Louise, in a V-necked dress and looking down, stands at the end of the auctioneer's table. The Dauras's press photographs offer additional information about Stovall's technique. In anticipation of the next step in her artistic process, Stovall cut around the profile in the photograph in order to produce a pattern with a more defined outline.

She concentrated on getting the figures of her paintings exactly as she wanted them. She said:

> I just draw 'em, just take it slow, just draw 'em. . . . And if that isn't right, then I have to try again until I do get it right. Take off some or add it on. When you do it that way, you can tell about the size. You can tell how big it will look on the canvas.[18]

After making a drawing she created a cut-out pattern from it, so she could place it directly on the canvas. "[If] I have trouble with a face or building," Stovall said, "I kinda' have to make a little sketch and cut it out, and put it on the canvas to see how big it's gonna' look."[19] The cut-outs provided a flexible device in her struggle over a technical problem. "I really do have a hard time doing it, because I just don't know, don't you see, the proportions. I try what would look life size to me."[20] There is no evidence, however, that Stovall traced around the cut-outs on the canvas, a method frequently used by another self-taught painter, Anna Mary Robertson Moses (Grandma Moses).[21]

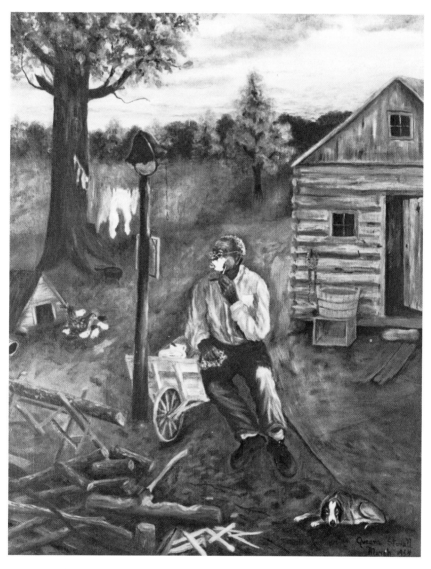

Plate 16. Queena Stovall, "Saturday Evening," March 1954
 20″ × 16″.
 (Mrs. Jonathan B. Stovall, Jr., Lynchburg, Virginia; Photo by author)

Basket Maker Pursues Art on Elon Road

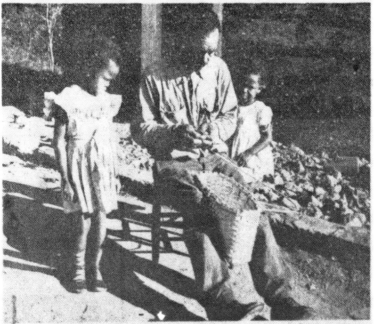

Hobart Lewis, 52, shows two young friends how nimble fingers can weave baskets from thin strips of wood.—(Staff Photo by John Friedman).

By DOROTHY S. BROOKS

Although basket making, generally speaking, is fast becoming a "lost art" in this section of the country, there resides near Lynchburg at least one person who painstakingly follows the trade, both as a hobby and as a source of income.

He is 52-year-old Hobart Lewis, a Negro resident of Elon road, who has never roamed from his native State of Virginia but once and that was several years ago when he went to West Virginia to attend a brother's funeral.

Lewis, who makes baskets "for curiosity and because I love the work," first became interested in weaving at the age of 9 or 10 years. While visiting a relative in Roanoke, Lewis said, he became acquainted with an old man who made baskets and other woven products.

"I just watched him and then took it up," he declared. Now Lewis has had so many years practice that he can take a quick glance at a piece of woven work and then go home and duplicate the original.

Lewis has been, as he says, plagued by bad luck. The old home place, just off Elon road on Route 130, where Lewis was born, burned to the ground some 12 years ago.

"I built a four room house not far from the old location," Lewis said, "and that place burned about six years ago. Now Lewis is working on a six-room location which he put up himself, living in the interim with one of his daughters and her four children.

stroyed in the two fires which also burned furniture and clothing as well as the houses, Lewis declared.

Several years ago, becoming discouraged because people failed to realize the vast amount of work that must go into the making of a single basket, Lewis "gave up." Later, after a knee injury forced him out of manual labor, he resumed the making of baskets.

Shaking his head as though perplexed by life, Lewis told this reporter that it takes him a "whole day" to make a basket which sells for $3. "And," he added, "the prospect of timber around here is mighty light . . . unless I buy some, and that makes the price of the baskets go up."

Best wood for making baskets, Lewis said, is white oak but maple and hickory can be used. He described the process of preparing the wood for use as "tedious." "I can make two baskets while I am getting the wood in strips for one."

One of the most outstanding events in his life, Lewis recalls, occurred back in the depression when he couldn't find any work, people didn't have money to buy baskets, and his family was suffering from hunger.

"I had a basket it had taken me two whole days to make," he related, "and I was so desperate I had to trade it for a sack of flour worth only a few cents."

Now, in addition to baskets, Lewis makes baby cradles, small stools, chair bottoms and breakfast tables. Some of his handiwork, he said, has gone as far north as New York.

"I never seen a basket I couldn't make," he added, "and then they want one like it. Long as I can do it . . .

Plate 17. Press Photograph of Hobart Lewis, Subject of "Basket Maker"
(Photo by author)

Plate 18. Press Photograph of Carl Hutcherson Used for
"Swing Low, Sweet Chariot"
(*Photo by author*)

whose work is now on view in the first one...
series of Lynchburg Art Center, discusses with...
f they 13th Century Gothic home in St. Cirq...
are in the exhibition.

Plate 19. Press Photograph of Pierre and Louise Daura Used for "End of the Line"
(Photo by author)

Plate 20. Queena Stovall. "Blackberry Picking," July 1950
17″ × 23″.
(Mrs. T. Suffern Tailer, Southampton, New York; Photo by author)

Plate 21. Queena Stovall's Painting Table
Her art supplies were kept in the drawer.
(Photo by author)

Ever inventive, Stovall also experimented with another type of pattern. At least once she drew a figure on a piece of wax paper. The figure is seen in "Blackberry Picking," as the woman whose arms are raised, holding a bucket (plate 20). Stovall's objective with this technique is not clear: perhaps she used the wax paper as tracing paper to copy the figure from another drawing, or drew the figure freehand, hoping the wax would leave a faint outline when retraced onto the canvas. Whatever her motive, the point is she continued to search for and experiment with ways to improve her artistic method.

Once she decided a drawn and cut-out pattern was satisfactory, Stovall began the process of painting in the figure on the canvas. She approached this step pragmatically; she varied her technique according to each circumstance. Sometimes she would "start at the head. I put the face in the figure."[22] Other times, "I put his feet where I want him to stand and then bring him up."[23] Stovall explained that her approach depended on "however it's the easiest to put them in."[24] Addressing each artistic problem methodically, Stovall created a range of procedures to expedite her work without compromising her artistic standards.

The Stock-in-Trade of Stovall's Art: A Formulaic Strategy

Stovall's penchant for detail in her paintings is seen in her earliest work. The kitchen scenes in "Come, Butter, Come" and "Favorite Breakfast" exhibit a colorful backdrop of skillets, stoneware, dish detergent, and cleansing powders; and "Fireside in Virginia" minutely records the furniture and other decorative arts of Stovall's living room. Typical of her growing skills, Stovall's interior scenes indicate advances in her drawing methods.

One of my narrators, Kathleen Massie, provided information which led me to a better understanding of the method Stovall devised to render details. Massie (Hobart Lewis's daughter) had worked for Queena, cleaning house and helping with "chitlin'" dinners, and thus knew about the furnishings in the Wigwam. When Massie saw a print of the "Basket Maker," she paused for a long time. The picture, she said, "didn't look right."[25] She further explained, "Some of these things look more like Mrs. Stovall's." Moreover, she said, her father never owned a quilt like the one shown on the bed; in fact, it looked more like one of the quilts at the Wigwam. Massie's hunch was confirmed by additional field research. Indeed Stovall had drawn upon her own material surroundings while painting "Basket Maker." One of Queena's many Victorian crazy quilts closely resembles the pattern of Lewis's bed quilt in the painting. Alerted by Massie's discerning eye, I soon discovered two other objects in the painting that belonged to Stovall.

The wooden table on the right side of the picture was Stovall's painting table (plate 21). Stovall also used one of her own belongings when she

rendered the framed stitched picture above the door in "Basket Maker." Several examples of this kind of antique picture decorated the Wigwam's walls.

Although the table, quilt, and stitched picture's presence in the painting of Lewis's modestly furnished dwelling is misleading, the items exemplify and clarify Stovall's artistic process. Supporting her inclination toward details, Stovall devised a technique for depicting material content on canvas, whether or not it existed in the actual setting. She explained her motive during an interview when she described her intolerance for empty spaces on a canvas: "If I had an inch of space," she said, "I had to put something in it . . . it looked vacant."[26] When an image failed to come to mind, another more concrete inspiration close at hand served the purpose.

Over the years, Stovall developed a repertoire of images, including the material culture previously described and human and animal figures (see appendix B). These figures are repeated throughout her works. The repetition is often obvious. For example, the calendar in "Basket Maker" is replicated in "Family Prayers" (plate 22). Although painted a different color, the dresser and mirror in the two paintings are also strikingly similar.

The repetition is less obvious in other instances, however, such as when Stovall modified and tailored an element to suit her artistic vision and the specific circumstance of a scene. She repeated figures which, after passing through various stages of modification, reached a point where the initial figure was quite different from the final one. For example, in "Peaches Are In" the basic form and position of the woman on the left snapping beans (modeled after a magazine illustration) is repeated by the woman peeling peaches (color plate 8, plate 23). A few months later, Stovall used the same figure for "Making Apple Butter," adapting her clothing for colder weather by adding a shawl around the figure's head. The next occurrence of the figure is in "Old Woman Driving Cow," where the top portion is retained, but the legs assume a standing position (plate 24). Finally, in "Cabin on Triple Oaks Farm" and "March Fury," the figures are similar, except for changes in clothing and the direction in which they face (plates 25 and 26, color plate 5). As mentioned, the initial figure is different from the final version, but by tracking through the paintings a lineage from beginning to end emerges. Discovering a satisfactory model, Stovall gradually transformed the image according to her needs for various paintings, each time relying on the success of the former effort. She saw no reason to reinvent the wheel; with subtle ingenuity she perpetuated an element that could be rendered efficiently due to its relationship with preceding compositions, yet did not appear blatantly redundant.

In 1951, for the first time in her career, Stovall duplicated an entire painting. "Uncle William, No. 1" was painted in January, followed by "Uncle William, No. 2" four months later. Also, two almost identical portraits of "Aunt

Alice" were completed within a few weeks in April. Later in her career, she continued to duplicate paintings. After painting and selling "The Baptizing," she repeated the scene, but expanded on the theme to produce "Baptizing— Pedlar River"[27] (plate 27). And lastly, "February, No. 1" was the forerunner to "February, No. 2" (renamed "Herefords in the Snow"). These duplicate efforts exemplify her formulaic strategy—a product of practice and repetition—on a larger scale.

In summary, an examination of Stovall's resources and strategies indicate the development of a systematic artistic process. This process allowed her to paint more effectively, especially during a period when the demand for her work heightened. Often guided by the objects and people around her and by popular illustrations, Stovall translated her concept into an artistic format: she assembled stock-in-trade elements which could be used repeatedly. Step by step, she was teaching herself to be a better painter.

Reading between the Lines

A cursory look at Stovall's paintings conveys an obvious emphasis on farm work. But an overall analysis of the characters depicted, especially during Phase II, discloses underlying messages that add personality to the daily routine of chores. Along with a few examples from Phase I, the women and children depicted in 1951 portray the mutual goals and friendship among women and their relationship with their children. In addition, the paintings express the role of play and humor as a way of dispelling the tensions from the precariousness of small farming.

The undisguised imagery of agricultural bounty in "Peaches Are In" most lavishly illustrates Stovall's food-oriented, farm-work themes. Besides the bushel baskets of peaches on the porch there are baskets of melons and peas and a pile of corn. Other details suggest a preoccupation with food before, during, and after the burst of productivity in late summer: a butter churn and garden hoes are momentarily idle and a silent dinner bell awaits the next call to the table. These contents also express Stovall's interest in women's tasks and in their opportunity to interact with one another.

The food displayed in "Peaches"—already picked and stored in baskets— has become the charge of the women portrayed. The final link in the food chain has been entrusted to these women, who are pictured canning peaches and snapping peas before they shuck corn and can melon. They share the burden and rewards of ensuring regular and nourishing meals—a grave responsibility as well as a source of fulfillment.

Artistically, "Peaches" provided an environment in which to portray a group of female figures. (All previous scenes were either male-dominated or

showed solitary tasks.) Stovall showed the women canning peaches as if it were a social event similar to a quilting bee. But narrators commented to the contrary. "Most people made [canned peaches] by themselves," Sally Mae McDaniel said. "Women didn't usually get together and make them."[28] And one of Stovall's daughters told me that her mother portrayed a family friend in the painting who was not even a likely participant: "Of course, [the friend's] not the kind that would can peaches," the daughter said with a chuckle, "Mama just put her in."[29] Stovall forfeited historical accuracy, but this time a specific event was reshaped, perhaps, to make a social statement. "Peaches" symbolizes the bond of fellowship shared by farm women who often lived in relative isolation.

In another early painting, "Fireside in Virginia," the pleasure of friendship between women is seen within the context of leisure. Stovall said "standin' in front of the fire is an old Virginia custom. It was the first place people went in cold weather, to warm themselves and catch up on the latest talk. In this particular instance, Judy [Stovall] and Mary Massey are standin' in the front of the fire sharin' the latest news."[30] Although a form of pleasure for both men and women, Stovall's perception of standing by the fireplace is manifested through the portrayal of two women communing with one another.

In Stovall's second painting phase, she produced two more paintings displaying situations in which women enjoy each others' company. "Blackberry Picking," for instance, shows three women pooling their efforts, filling buckets with berries. Based on the quantity picked, the task probably afforded the women the greater part of a morning or afternoon to converse while harvesting their crop. And the painting "Saturday Night Bath" shifts our focus from women interacting around the common goal of food preparation to another core activity—child rearing.

"Saturday Night Bath" portrays Stovall's five oldest children during a period in the 1910s when Queena rented a farmhouse near Elon. For Stovall the painting represented a time when she single-handedly managed a farm and several children. She longed for her mother to visit, providing companionship and help with the children. Queena communicated her loneliness to her husband, who quickly wrote back from West Virginia: "I was mighty glad to get your letter today and know you have been lonesome and blue out there by yourself. . . . I am kinder afraid that . . . Mrs. D [Ella Dillard] won't spend much time with you. I think I will write grannie tonight and send her enough money to come."[31] Brack's mother ("grannie") visited enough to merit a position in "Saturday Night Bath." According to Stovall's children, the woman curling the girl's hair in the painting is their paternal grandmother.

Within the realm of mother and child relationships, black and white women experienced similar challenges. Regardless of race, mothers were

Plate 22. Queena Stovall, "Family Prayers," November 1951
18½" × 24".
(Rosalie D. Basten, Lynchburg, Virginia; Photo by author)

Plate 23. Magazine Illustration and Cut-Out Sketch Used for "Peaches Are In"
(Photo by author)

Plate 24. Queena Stovall, "Old Woman Driving Cow," February 1951
18″ × 24″.
(Dr. and Mrs. Powell G. Dillard, Jr.; Photo by author)

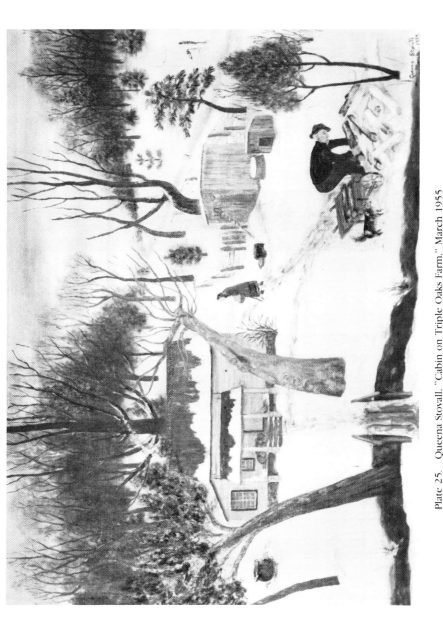

Plate 25. Queena Stovall. "Cabin on Triple Oaks Farm," March 1955
20" × 30".
(*The estate of Queena Stovall, Lynchburg, Virginia; Photo by author*)

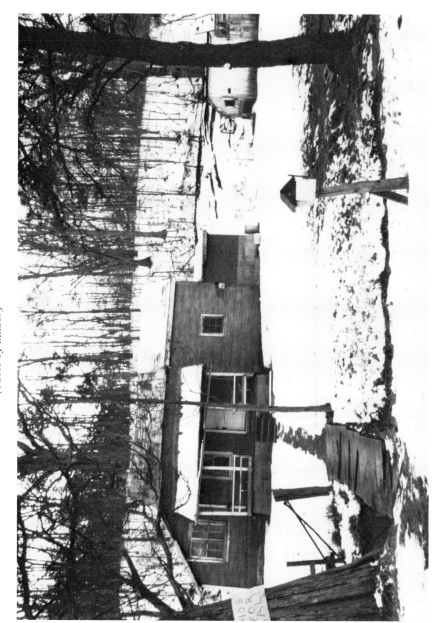

Plate 26. Site of Triple Oaks Farm, near Elon, Virginia
(Photo by author)

Plate 27. Queena Stovall, "The Baptizing," March 1951
23" × 32".
(Mrs. T. Suffern Tailer, Southampton, New York; Photo by author)

responsible for child rearing, which included administering discipline as well as distributing favors. But while these women were expected to function as the major caretakers of their children, the children, too, had responsibilities.

Several of Stovall's paintings document the role of children in the family chore structure. In "Monday Morning," children take care of younger siblings while their mother washes clothes; a little boy helps snap peas in "Peaches Are In"; two youngsters help carry water in "Toting Water"; a boy milks the cow in "Milking Time"; a boy and a girl have their own buckets to fill in "Blackberry Picking"; and Stovall's oldest son, Brack Junior, polishes his shoes in "Saturday Night Bath."

Oral narrative supplements the pictorial records. Regarding berry picking, for example, Hannah Escoe said "my sister and I, we would get that tub full of blackberries. We'd see how many gallons we could pick in two or three hours. We'd have that thing full."[32] And about "Milking Time," Stovall said "the job milkin' was always left to the youngest. . . . In the picture, Chug, Whitey's boy is doing the milkin' in the evening."[33] Narrators agreed that it was the children's duty to milk the family cow. According to Allen Dempsey, "the four girls, they had to milk the cows"; and Julia Hunt recalled, "My younger sister used to do the milking."[34] The paintings correspond with the attitude of the community—children were expected to pull their weight.

Black women's maternal duties often included taking care of a white family's children. Segregation between blacks and whites was less distinct when it came to child care. Literature written on the Old South is replete with examples of black "mammies" caring for the children of white families. By the time Stovall painted her pictures, the practice had been modified to fit the employer/servant system, but black women still had close relationships with white children. Julia Hunt recalled her experience with the granddaughter of a white family for whom she worked: "The granddaughter used to be a little old thing, a little old girl running around there wanting to learn how to cook and be useful. I'd make a little pie for her, show her how. After I'd get through making desserts, she'd say 'let me sop, lick the pan,' and I'd say, 'all right' and she go around and lick the pans out." Stovall's painting "Come, Butter, Come" reveals the kind of relationship described by Hunt: a young white child steals a taste of fresh butter from a black woman's churn.

Some of the same paintings that characterize the relationship between women, and between women and children, also note the existence of fun and humor in rural life. In "Monday Morning," a small boy urinates behind the cabin's chimney, while his brother chases a scampering pig. A rare example of music, in "Making Apple Butter," shows a child fascinated by an old man playing his fiddle. The little boy in "Blackberry Picking" acts silly after filling his basket. He gobbles berries, staining his face and overalls, then turns his

bucket upside down to wear it as a hat. It's no wonder that Hannah Escoe laughed when I asked her about berry picking. "We used to love it," she said.

Perhaps the biggest treat for children in the country was making ice cream. Balancing the disciplinarian role, mothers dispensed special favors. Mothers were usually in charge of preparing the custard that the children churned into ice cream. Florine Slaughter recalled that "Mama always cooked hers. You break up the eggs and beat them good. And you put what kind of vanilla you want to put in it."[35] Hunt described the excitement of churning ice cream: "Children used to turn it. They'd say 'let me turn it,' and 'let me sop the paddle.' Lord, lord, we used to make ice cream." Carlena Robertson explained that "when you had a lot of children that was the biggest thing, doing something like that. We always had more fun freezing ice cream."[36]

Stovall's painting "Licking the Dasher" captures the moment after churning when children (and even a puppy) run toward the ice cream freezer for a taste. Their mother smiles, savoring an opportunity to encourage frivolity, rather than correct errant behavior. In fact, certain women were revered for their prowess at making ice cream. Perkins Flippin said "I've got a friend who still says that the best ice cream she ever ate in her life was [my] mother's."[37] Stovall, too, must have been a popular ice cream maker. No doubt children appreciated her "secret in makin' good ice cream without havin' to churn a lot." She claimed the temperature of the milk was critical: "I used to set the milk and cream out on the old cook stove the night before so's it'd be just right the next day."[38] Less time churning meant quicker results for eager children.

"Family Prayers," the last painting Stovall completed in 1951, captures a humorous vignette within the context of a solemn event.[39] "I recall the younger children forever playing pranks and giggling and the older ones anxious to leave," Stovall said.[40] And, in fact, were it not for the father reading the Bible, the scene might reflect the antics of children better than the pious atmosphere of a family devotion: one child is preoccupied with his bare feet, another snoozes, while a teenage boy fidgets with his hat, impatient to leave. But the religious theme, despite a lighthearted interpretation, portends Stovall's next artistic phase—one where her spirituality influences the themes she selects and the messages they carry.

Phase III, 1952-1959: Artistic Reflections of Spiritual Beliefs

A full year passed, following her prolific period in 1951, before Stovall began her third painting phase. Phase III of her artistic career, which began in the fall of 1952, lasted for seven years. During this period Stovall averaged about two paintings per year, a dramatic decrease in production compared to the previous phase. Moreover, she shifted her thematic emphasis. Although Stovall continued to produce pictures of farm chores and country landscapes, she also stressed sacred themes, particularly scenes describing the religious behavior of her black neighbors and employees. Stovall's slower production pace in Phase III occurred in part because she was basking in the success of her career; her local and regional fame grew as more paintings were exhibited and purchased in central Virginia. But her slackened rate can also be linked to circumstances and events in her personal life which, in my view, instigated a period of philosophical and spiritual introspection.

In the early 1950s, Stovall's husband Brack contracted cancer. By 1952 he had become weak and frail, and on Christmas morning in 1953, he died. Even though Brack's death did not catch Stovall unaware—he was considerably older than she, and had been ill for many months—she nevertheless suffered deep sorrow. And despite her relative youth and good health, Brack's death and her own advancing age gave her pause to contemplate her own mortality and reaffirm her Christian convictions. As during other challenging times in her life, Stovall relied on her faith in God for emotional strength and consolation. But this time she was also equipped with another means of comfort—her art. She took the advice of the Dauras who wrote, "dry your eyes, Queena, and seek consolation in your painting."[1] Integrating her artistic creativity with her spiritual preoccupations, Stovall channeled her grief over Brack and veneration for Christianity into her paintings.

Stovall produced six canvases during her third painting phase that indicate her absorption with religious faith and ritual, and the presence of divine authority in nature. First, she portrayed a woman shouting "Lawdy,

Lawdy, What'll I Do?" as a fire ravaged the woman's cabin (plates 28 and 29). Next, as if a eulogy for Brack's death two months later, Stovall completed "Swing Low, Sweet Chariot," a scene of a local funeral. She then produced two paintings about getting ready for and going to church. In one picture, "Saturday Evening," an old man shaves, and in another, "Sunday Morning," he walks off to church. Later, inspired by a dream, Stovall rendered "March Fury," featuring a Virginia thunderstorm in early spring at the moment when a bolt of lightning cracked with holy terror across a turbulent, black sky. And, lastly, Stovall painted "Baptizing—Pedlar River" (actually, her second version of the scene), thus completing her spiritual painting cycle with an expression of hope and renewal, as signified in the Christian ritual of conversion and rebirth.

Of these six paintings, two—"Swing Low, Sweet Chariot" and "Baptizing—Pedlar River"—are considered monumental works by Stovall and her community as well as by folklorists and art historians. Through an examination of these two paintings, I will discuss the interplay of experience, memory, and creativity in Stovall's art; the meaning of black religious ritual, as perceived by both blacks and Stovall; and the relationship among Stovall's spiritual beliefs, her art, and her interest in subjects and themes derived from the black people in her community.

"In My Mind's Eye": Experience, Memory, and Creativity

Queena Stovall's mental reservoir of artistic material was monopolized by the people, places, and events that she judged special. In forming the reservoir, she filtered out the unfavored images, sustaining the favored ones. She stressed the importance of having a vivid mental picture based on a direct and enjoyable experience before beginning a painting: "I...don't think I could paint something somebody told me to paint unless it happened to [be] something I had seen or liked and could see it in my mind's eye."[2] About the scenes depicting black religious ritual she wrote, "No doubt, an association of many years with these people, and the witnessing of many scenes and happenings around this countryside, have left an indelible impression on my mind and heart."[3] "Swing Low" and "Baptizing—Pedlar River," two of Stovall's favorite works, exemplify the melding of mental vision with emotion in her artistic process.

The significance of the emotional aspect in Stovall's fascination with black subjects will be discussed later. But in terms of artistic method, "Swing Low" and "Baptizing—Pedlar River" reveal Stovall's practice of either focusing on a single favored event for inspiration or, when no one occasion could be recalled, "composing" an event from numerous observations over time. Aside from the initial inspiration, the finished canvases of the funeral and second

baptism scene represent the superimpositions of many mental images collected from various experiences. For Stovall, the "mind's eye" meant a clearinghouse for artistic information, selected from likeable sources and frequently shuffled together; she kept that information filed and ready to be used as grist for her creativity. Reshaped by Stovall, her perceptions sometimes agreed, and sometimes disagreed, with actuality.

When asked in the mid-1960s, and again in 1974, about the exact funeral which inspired "Swing Low," Stovall's recollection of the event was hazy. She said "'Swing Low' was painted from memory of the many [N]egro funerals which I went to."[4] Another time Stovall stated, "I believe it was at one of these [funerals] that the urge came to me to try to paint this scene."[5] Blacks from Stovall's community confirmed that she frequently attended their funeral and burial services, especially the services at Timothy and Chestnut Grove Baptist Churches. Although she had some notion of when the idea struck, the moment of inspiration had been assimilated into her memory of funeral experiences in general. While she could not remember a specific funeral, Stovall's "mind's eye" contained sufficient material to conceive and paint the picture.

A comparison of the church and cemetery in "Swing Low" with their location in Amherst County brings to light differences between Stovall's perception and the actual settings. Stovall claimed that "the setting is at Pleasant View, the church is Timothy Baptist right in the bend of the road."[6] But the cemetery at Timothy Baptist is in front of the church, separated by a paved county road. In fact, the cemetery in "Swing Low"—both its position and proximity to the church—is remarkably similar to the setting at Chestnut Grove Baptist Church, located about two miles from Elon. As seen in plate 30 Chestnut Grove's cemetery skirts the side of the building, vaguely separated by dirt paths. This scene is depicted in "Swing Low."

In short, surroundings in "Swing Low" look more like those of Chestnut Grove than of Timothy Baptist. Yet, the church in the painting, especially the building's shape and its cupola, is strikingly similar to Timothy Baptist (plate 31). Given the number of funerals Stovall attended over the years, I think she superimposed more than one familiar church cemetery setting onto a single funeral scene. In spite of preparatory sketches of the landscape, Stovall's "mind's eye" overlaid characteristics on the canvas from similar settings. Almost without exception, narrators responded freely to questions about the picture's accuracy, offering generous amounts of supplementary information. Whether identified as Chestnut Grove (Hobart Lewis's response) or Timothy Baptist (Teeny Winston's response), "Swing Low" stimulated narrators to describe at length their experiences at the funerals of friends and families. I began to wonder why "Swing Low" summoned information so readily.

Plate 28. Queena Stovall, "Lawdy, Lawdy, What'll I Do?" November 1952
24″ × 20½″.
(*Carrington-Dirom-Basten Company, Inc., Lynchburg, Virginia;
Photo by author*)

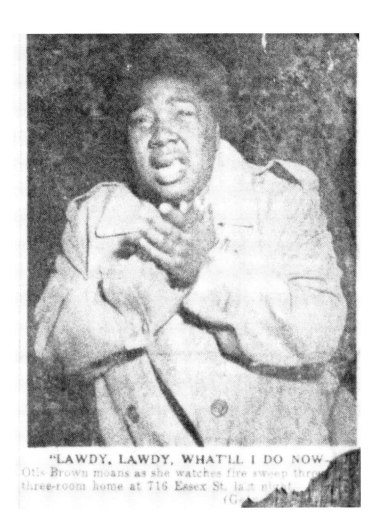

"LAWDY, LAWDY, WHAT'LL I DO NOW..."
Otis Brown moans as she watches fire sweep through
three-room home at 716 Essex St. last night.
(G...

Plate 29. Press Photograph Used for "Lawdy, Lawdy, What'll I Do?"
(Photo by author)

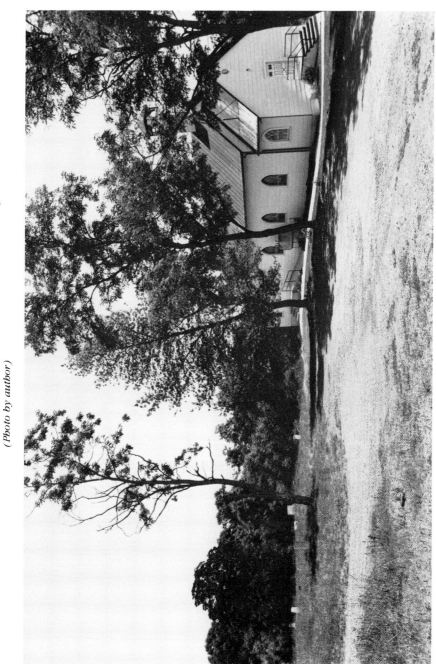

Plate 30. Chestnut Grove Baptist Church, Chestnut Grove, Virginia
(*Photo by author*)

Plate 31. Timothy Baptist Church, Pleasant View, Virginia
(*Photo by author*)

Perhaps Stovall's eclectic effect in applying "mind's eye" images to "Swing Low" unwittingly made the picture more real or authentic to viewers than would the depiction of a single experience.

Unlike "Swing Low," the exact event inspiring "Baptizing—Pedlar River" and its forerunner, "The Baptizing," is a matter of record. Both Queena and Margaret Stovall, the daughter-in-law who took her to the baptizing, vividly remembered the event. As Margaret Stovall recalled, her mother-in-law telephoned early one Saturday morning and said, "Come on and take me up to this baptizin'."[7] Queena had heard from some of her friends, most of whom were members of Timothy Baptist Church in nearby Pleasant View, that they planned to baptize new converts later in the day. Her recollection of the baptism focused on her role as an observer turned participant:

> They saw their friend Stovall and said they'd like to have a few expressions. Well, you know, I can't express myself in private, let alone in public. My daughter-in-law said I did all right. I was ashamed to say nothing, I had to say something.[8]

No doubt Queena Stovall would have preferred to offer her painting instead of her public speaking about which she usually felt uncomfortable. The first version of the baptism scene, completed in 1951, was sold within a year through Kraushaar's Gallery in New York City. Six years later, in 1957, Stovall painted "Baptizing—Pedlar River."

To augment her direct observation of the baptism for the first version, Stovall had a snapshot taken. According to Margaret Stovall, a picture was taken "so she would have, you know, a little idea of the way the land lay." Several years later, for the second version of the scene, Queena returned to the baptism site—but not while the ritual was underway—to make a sketch in a small spiral notebook. In my view, the second baptism painting provides a more complete record of the entire process, although once again Stovall's imagination fills in the gaps between the "real" elements of the composition.

A comparison of the two baptism paintings reveals the later composition's expansion of the 1951 version. In the earlier version, the crowd's primary focus is on the preacher about to baptize a young girl in the river, hence sustaining a narrow aperture through which to view the celebration. In comparison, the 1957 version captures more of the ritual's process, revealing the variety of behaviors that Stovall perceived as typical of the event from start to finish. She accomplishes this by giving rein to her inclination to portray active individuals in her paintings. The viewer's eye is distracted from the central figures in the water by other figures in the crowd: a little boy sitting on the bridge becomes restless and strikes up a playful flirtation with a girl sitting on the bank below; an old man, bent over and cane-supported, arrives late to the ceremony, slowly walking toward the river bank; a mother dries off her child among some trees close by. These small scenarios

are brought together to share the same instant in time. Stovall's achievement in "Baptizing—Pedlar River" is a gestalt account in one large scene of a serial process.

Another factor influenced Stovall's depiction of the baptism site. An examination of the actual location on Pedlar River as it looks today helps to explain how fit the subject was for Stovall's art. The snapshot Stovall used as a guide no longer exists; however, a recent photograph of the site, taken with a wide-angle lens, indicates that both baptism paintings encompass a broader portion of the landscape than could be included in a snapshot frame. Stovall created space for the working of her imagination. Essentially, the upper left-hand quarter of the painting, a rocky, grassy slope, is dissimilar to the actual setting, a steep, heavily-wooded shoreline.

Black Subjects and Themes in Stovall's Art

Stovall favored black people as subjects and their traditional activities as themes for her paintings. Of Stovall's forty-nine canvases produced during her entire painting career, more paintings exhibit all black people (36%), and black and white people together in the same scene (22%), than exhibit only white people (32%). Futhermore, of a total of 284 figures portrayed in the paintings, 159 (56%) are black individuals (see appendix C). During Phase III, Stovall's interest in depicting blacks reached a pinnacle with the completion of the two religious scenes, "Swing Low" and "Baptizing—Pedlar River." Besides the paintings' usefulness in the previous discussion of experience, memory, and imagination, they offer an historical record of two rituals considered socially and psychologically important by the black people in Amherst County. And as two of Stovall's favorite works, they presumably represent her artistic and documentary biases as well as the values of importance to her.

Many of the people Stovall portrayed in "Swing Low" and the baptizing paintings participated in the traditional celebrations of Amherst County churches throughout their lives. Oral histories disclosed a wealth of information on the changing social and spiritual meaning of funerals and baptisms during the first half of the twentieth century, furnishing a context for Stovall's painted scenes and enabling an assessment of the accuracy of her perceptions. A distilled account of these oral histories is presented here in order to compare Stovall's perceptions with those of the black participants and to supplement her perceptions, providing background material for an examination of her interest in black themes and subjects.

Stovall's baptism scenes represent one segment of a complex, multiple-stage conversion process. "Getting religion," baptism, and church membership are equally important steps in a lifelong commitment to the

church, and demand active involvement in exchange for salvation.[9] In Stovall's scenes, the individuals have already experienced the spiritual ecstacy of conversion, but not yet the pride of church membership.

Conversion begins with an intense Christian ritual called a revival. Until recently, revivals in Amherst County took place in August and lasted from a week to a month. Julia Hunt reconstructed the advent of the week-long ritual at her church:

> They start off [on Sunday] with a homecoming dinner most of the time. They have a sermon in the morning, and then they go and have the dinner. All the members of the church just fixes all kinds of food. They have tables all up and down there, chairs for people.[10]

The potluck repast offered a welcome interruption, a time to relax among friends between sermons, among friends, in an informal environment.[11] Because of the concentrated schedule of sermons and prayer groups, those attending wanted to remain close to the church while they ate and rested. But Hunt stressed the importance of praying and preaching: "At three o'clock you go back up in the church and have another sermon." Every evening during the revival "you have prayer meeting a half an hour, then service at 8 o'clock."

Following a few days of intense prayer meetings and "fire-and-brimstone" sermons, people attending the revival are allowed to express their desire to "get religion" or to be "born again of the Spirit." Because reactions vary within a general state of ecstasy-possession, getting religion is considered in some respects to be a unique, individual experience.[12] Florine Slaughter described the height of her emotional experience:

> You go to church for a whole week. Preacher asks you "Come, please come, you want to be saved? Who want to be saved, who next?" You get up and go to the mourner's bench, get down on your knees and pray. And then if you got religion, it'll tell. You pray and pray and pray until you feel good. "Save me Jesus," you pray, and ask God to pray for everybody.[13]

Hunt recalled a similar experience, but elaborated on the loss of passionate behavior among black youngsters today:

> The Lord will strike you in your heart when you really get religion. But now I don't know what them children do because they don't make no do much for religion. I just got so happy and I couldn't sit still. All of us used to be that way. . . . You could feel it in your soul. Now children just gets up and shakes your hand a little bit and go on and sit down.

Before the recent change in response to getting religion, preparation for and participation in the conversion process gave parents an opportunity to reinforce authority and control over their children. Hunt said:

Our mothers used to tell us, "You all don't understand the getting religion. When you get twelve years old, you should know." ... Yes, that's what they told us, and that's what we went by. When we get a certain age we say, "well, we must pray because if we die without having religion, our soul will be lost." And sure enough, we got religion when we were twelve years old.

Indeed, bonds among parents, children, and the community were strengthened by a common belief in Christian prophecy. When "the Lord struck you," children were reminded that their elders were not only knowledgeable but instruments of God's will.[14]

Black religious rituals have been valuable instruments in socializing black youth.[15] The entire congregation has profited from revivals: "Revivals do much to elevate the moral tone of the black community because they cleanse the community of 'vices and unwanted foreign elements' that are considered bad for a Christian community."[16] In Hunt's opinion, the diminished ardor among children currently converted indicates the vice of ignoring authority: "Now they have children come up [to the mourner's bench], but they just sit straight up and look at you ... look right at the preacher, and not bow down like they used to, and hide your face."

Stovall's paintings illuminate the baptism held in September. As a rule, several individuals are converted during the revival meeting, providing ample candidates for baptism. And like the meetings, the baptism ceremony was charged with religious zeal. According to Slaughter:

You pray and then the preacher go in the middle of the river. He walks in with a black robe, and a white shirt and tie. He'll lead you in if you're afraid. I wasn't scared because I had religion. He caught me by my hands, took me down and brought me back. I walked out crying, "Thank you, Jesus, thank God, I'm saved."

Hannah Escoe talked about the spiritual momentum gathered from "singing and praying right at the river bank."[17] And in addition to singing hymns, Hunt said the congregation "would word off what you call a hymn. Theys word it off, you know: 'Did Christ, oh sinner, weep and shall our cheeks be dry.' Old people used to have all different kinds of hymns and word offs." Inside or outside of their church, the converts and members generated a magnetic atmosphere, indicating the importance of ritual as an emotional outlet.

In both paintings Stovall rendered figures which represent the emotional atmosphere described by narrators. The figure of a woman with arms raised heavenward stands in the crowd to the right, illustrating the fulfillment of ritual. Captured at an instant of spiritual attention, the preacher stands in the river delivering a sermon or leading the congregation in song or prayer.

The atmosphere, however, did not always provide candidates with total security. Even the most passionate believer might clutch at the moment of

reckoning. There was a dark specter threatening to expose some candidates if they should be less than one-hundred-percent sure of their commitment to the Lord. Narrators spoke of certain individuals who "strangled" as the preacher immersed them. "Stranglin'" was interpreted as a sign of a candidate's unsuccessful attempt to get religion and unpreparedness to be baptized.

Yet along with the spiritual explanation for strangling is a recognition of the procedure's practical aspects. Hunt laughed as she said "the children know a whole lot how to hold their breath because a whole lot of them swims anyway. They hardly ever get strangled because them children done been in water. Many of them swim and they know what to do." Stovall portrayed children waiting to be baptized, alert and smiling, indicating anticipation rather than apprehension—children who "know what to do."

The ability to swim did not alter the fact that baptizing often required a rugged personality. The ritual took place outdoors at a mill or ice pond, quarry, lake, or a river: "That water was like ice water," James Johnson recalled with a shiver. "It was September, about the last of September."[18] Colored leaves and bare trees in Stovall's "Baptizing—Pedlar River" attest to Johnson's recollection of the season.

In the cool fall climate, wet individuals quickly retreated to a sheltered spot and discarded their soaked clothes. Beatrice Braxton recalled that "we'd go on back in the bushes and put on our dry clothes."[19] Teeny Winston hinted at her changed outlook regarding acceptable behavior in the past: "The funny part about it, we'd go out in the cornfield or anywhere and take those wet clothes off."[20] In "Baptizing—Pedlar River," Stovall documented the adaptable behavior and improvisation required in the past: a mother dries off her small child by the side of the road, and exchanges wet clothes for dry ones carried in a shopping bag.

Baptizings are exciting and highly sociable events. Even when only a few candidates are produced from revival meetings—a recent tendency—the majority of the congregation gathers for the ceremony. "Last year we only had three," Hannah Escoe said, "so they baptized at a church in Lynchburg. All of us went over there. We had a wonderful time." In the past, revivals frequently produced numerous candidates for baptism, necessitating the help of church lay members. Hunt was one of thirty-seven people baptized on the same afternoon. James Johnson, another candidate, remembered, "When I was baptized, I stayed in the water and helped to baptize twenty-nine." Stovall's baptism scenes illustrate the custom of members lending a hand with the ceremony. "The Baptizing" shows a gray-haired man holding a pole used to measure the water's depth and to help the candidate back to shore. And "Baptizing—Pedlar River" shows a dignified man in a suit facing the congregation, waiting to lead the next candidate into the water.

People of all ages were brought together by mutual commitment, enjoying the company of other believers. Most candidates were children, yet older people, called "sinners" prior to getting religion, were also baptized. "This past year we baptized a cousin of mine which was seventy-one years old," Escoe proudly stated. "We were very happy that he was baptized." Stovall's paintings, however, dwell on younger candidates and fail to distinguish the "sinners" that might be involved.

Baptizings were usually held on a Saturday, Escoe said, because "then Sundays was when you go to church and have your right hand in fellowship and you were officially a member of the church." The "right hand of fellowship" literally means extending your right hand and shaking hands with everyone in the congregation. The gesture signifies the eternal bond among Christians as well as the "social transition from the status of a child with a few responsibilities to that of an adult with considerable responsibilities."[21] Successful completion of the conversion ritual is very important; prestige increases with church membership. And, of course, in order to vote, participate in church organizations, and sing in the choir, one must become a member.

Within the last decade, Timothy Baptist and other Baptist churches in Amherst County have broken from the tradition of annual revivals and ceased to baptize in the ponds and rivers. "In late years," Winston said, "we'd have a revival oftener. Sometimes you don't have but one, [but] it's different now because we have it often and have the pool down at the church." Some churches are now racially integrated in Amherst County, and those that remain all-black or all-white share cement-lined baptism pools built in or near their sanctuaries. Stovall's paintings record baptizing at the end of an era: ponds and rivers were still used and the participants expressed spiritual energy without inhibition.

Black religion involves "the attainment of spiritual freedom ... achieved both by the temporary attainment of religious ecstasy and by the release of death and the promise of ultimate fulfillment in heaven."[22] "Swing Low" records the ecstasy and the release of ritual with characteristic detail. The painting shows the graveside segment of a two-part funeral. "Most of the time they preach funerals in the church," Escoe said. But in the less common two-part service, "you begin it in the church and continue it to the graveside."

Narrators questioned Stovall's rendition of the open casket at the grave site. "They opens the casket in the church and let the people go up and review the remains," Hunt said. "They close them caskets before they carry them out." But Slaughter pointed out an exception to the rule: "Now there's a whole lot of people who couldn't get there [in time] ... so they open up at the grave to look at them." "Swing Low," then, represents a variation on the customary black funeral—a graveside service with an open casket.[23]

Material culture associated with funerals is symbolic of kinship relationships and social proximity. The type of clothing worn at a funeral distinguishes bereaved family members from friends and acquaintances. Relatives of the deceased wore "something black"; women wore a black dress and veil, and men, although not expected to wear a black suit (many couldn't afford to buy one), usually wore a black insignia on their sleeve. Winston recalled that "it would be something black: a heart, a cross, or a black band." Stovall chose to render a black heart on a man's sleeve. Most narrators remembered black hearts, but considered them a past custom: "I ain't seen 'em for a long time," Ora Johnson said.[24] More often men wear a band of black chiffon or other kind of cloth. I think that Stovall depicted a heart because it satisfied her bias for signs of older traditions in her pictures (similar to the wooden barrel in "Hog Killing"), as well as representing her specific exposure to black mourning symbols: in order to help a bereaved employee or neighbor, Stovall commonly sewed a black heart on their coat sleeve.[25]

There may be a connection between the heart insignia and the customary heart-shaped flower arrangements used in "Swing Low" and recorded elsewhere in the South.[26] Anthropologist Christopher Crocker states that the "bleeding heart" and the "unbroken circle" motifs in floral displays connect form with explicit statements regarding grief over deceased loved ones and the bittersweet cycle of life and death.[27] (It is significant, I think, that a pregnant woman holding a baby stands in the middle of circular flower arrangements, underscoring the painting's symbolism of life's continuity and cyclical patterns.)

In addition, the circular floral arrangement in "Swing Low" represents notions of black culture from the perspective of white people. Stovall painted a round floral wreath with a ribbon stretched diagonally across it; on the ribbon is written "Pearly Gates Club." Stovall claimed that she asked a florist about the kind of wreath and labeled ribbon ordered by black customers.[28] Lucille Watson offered comments about the wreath that were typical of other white narrators: "That sounds typically colored—Negro. They loved organizations. They all had their little clubs, as they called them."[29]

However, while church organizations were described in detail by the blacks I interviewed, none of the narrators had heard specifically of the Pearly Gates Club. Winston said "we have a workers club, a missionary club, and we have a pastor's aid club," but none of them were ever called "Pearly Gates." But even though an understanding of black church clubs among whites appears to be shallow, Stovall did correctly recognize the concept if not the particular name. Clubs indeed existed and commonly sent grave decorations like the floral wreath to the funeral of a deceased member.

Before the custom of purchasing flowers from a florist began—as illustrated in "Swing Low"—Escoe said "we just gather roses, the wild flowers,

and make our own bouquets." Hunt added that "they have so many flowers sometimes. Flowers on top of flowers." According to Crocker, "the presentation of flowers in American society is generally associated with the affirmation of affectual solidarity, of feeling so intense that it may be expressed in no other type of gift but flowers."[30] Thus flower girls—as bearers of symbolic objects of affection—are critical social units in the funeral process. In Stovall's painting, the four women serving as flower girls are centrally positioned, prominently holding their wreaths and bouquets, illustrating the importance of their duty.

Both blacks and whites commented repeatedly about the doleful nature of black funerals. In fact, Stovall found "the uninhibited show of emotions of this colorful people" a moving phenomenon and an inspiration for "Swing Low."[31] But, unlike conversion rituals, emotional behavior at funerals is not always condoned by blacks. Winston stopped going to funerals for several years because of the mournful atmosphere:

> When I was younger I used to go to funerals, then I stopped. It was very sad in the olden days, the way they cried and passed out and screamed. That's one reason I stopped going. Very sad in the olden days, it were.

She immediately recognized the figure of Idella Rose—dressed in white, with her back to the crowd—in "Swing Low." Rose is tearful and weak-kneed, requiring assistance from the man on her left; she "always passed out, and somebody had to be near her," Winston recalled. Then Winston expressed the irony of changed times when she stated, "Now that [Rose is] a nurse, she attends all the funerals to help other people."

Additional signs of change were indicated by a few black narrators who held firm opinions about the emotional display of their fellow church members. Hunt said:

> People these days is right reasonable because they don't hoop and holler and cry and carry on. Most of the time now people consider there's no use in doing that and they try to behave, and not make all that do. Some people [used to] run up to the casket and try to kiss the people who are in the casket. They don't allow that anymore.

Curiously, Hunt supported the rejuvenation of ecstatic behavior during the conversion ritual, but declared the traditional emotional expression of grief unacceptable behavior.

Along with moaning and "carry[ing] on," the sorrowful atmosphere was enhanced by slow, solemn hymns sung either by a choir, as shown in "Swing Low," or by those attending the service. Although Stovall's title for the painting comes from the hymn "Swing Low, Sweet Chariot," narrators agreed that "years ago they sung it [at funerals], not anymore."[32] Instead, narrators named

other hymns currently sung at funerals which express life- and hope-oriented messages: for example, "The Lord Will Make a Way Somehow," "One Day at a Time, One Step at a Time," and "Get Right with God."

In conclusion, funerals and baptisms are critical rituals during the life of a rural black Christian. Stovall's depictions illuminate the link between black religious ritual during the first half of the twentieth century and the ritual of earlier times: "To the slaves these services and celebrations were special times, counteracting the monotony of life in slavery. In their meetings slaves enjoyed fellowship, exchanged mutual consolation, and gave voice to individual concerns. And here, too, some slaves found the place to exercise their talents for leadership."[33] Until the middle of the twentieth century, many of Amherst County's blacks were still sharecroppers or at best small independent farmers, struggling to subsist. Their desire for fellowship, excitement, consolation, and responsibility was as important to them as it had been to their enslaved ancestors years before.

But what was the basis of Stovall's artistic fascination with the blacks in her community? And what was the relationship between her sociocultural perspective as a post-bellum Southern woman and her portrayals of blacks? Information relevant to these questions is available from Stovall's statements about her association with black friends and employees, her affection for the traditional past of her rural community, and her abiding religious faith. Additional insight, particularly regarding the issue of race, can be gleaned from an examination of three Southern women writers—literary artists who have social and cultural backgrounds and creative talent akin to Stovall's: Ellen Glasgow, Eudora Welty, and Flannery O'Connor. When viewed as a group, all of these gifted, creative women—who have mined the traditional social scene of their Southern homeland during the twentieth century—represent the perspective of white females from educated, aristocratic families.[34] Because Stovall's remarks about her attitudes toward blacks and their place in her art are meager, the opinions and attitudes of Glasgow, Welty, and O'Connor are particularly helpful in understanding a sensitive issue.

In my opinion, Stovall's interest in portraying black characters is inextricably interwoven with her love for and belief in a traditional rural lifestyle. Her affection for the country was the consequence of her commitment to wholesome values, her practical, down-to-earth approach toward life, combined with nostalgia. For Stovall, the good life of bygone days was symbolized in traditional black culture. So important was this symbol to Stovall that when blacks shifted from traditional to modern lifestyles, Stovall ceased to paint. (A fuller account of Stovall's perception of how her art was influenced by the social changes in Amherst County is presented in chapter 5.) Reflecting on changes she witnessed in the black community during the 1960s, Stovall said,

The old negroes had gone. You didn't see any going around . . . with careless shoes and their heads tied up in a cloth, or anything like that. The time had passed for them. You didn't see any more log cabins. They all dressed up better than you are.[35]

Progressive social changes, encouraged by the Civil Rights Movement, blurred the differences between blacks and whites. No longer were blacks distinguished by their bandanas and log cabins. As they were assimilated into white society—trading differences for similarities—they lost their symbolic status for Stovall. "There's nothing with the colored people that I want to paint anymore. They are really so colorful, but you don't see them like they used to be. The world has just changed and you can't get country scenes clear anymore."[36]

Furthermore, I think that Stovall's nostalgia was coupled with her notion of the exotic characteristics of rural black culture. Just as blacks sought excitement and release in ritual, Stovall escaped the monotony of her own farm obligations by first observing and later painting scenes about a "really colorful" people who existed within her larger Southern culture. Before she became a self-taught painter, she was—in a manner of speaking—a self-taught ethnographer, developing an anthropological eye and a field worker's fascination for the customs of a distinctive human group.

Robert Coles could have been describing the paintings of Queena Stovall instead of the fiction of Flannery O'Connor when he wrote of "how a particular element in a regional life has connected so wondrously with one writer's natural endowment. An element, she makes clear, that is a pervasive religious one."[37] Coles adds that a fundamental virtue of the rural South is what he calls its *hard, hard religion.*[38] Stovall, too, recognized this virtue: she "was deeply religious. . . . she never missed a church service."[39] To Stovall, the basic religious concerns of all Christians are parallel and central to human existence; and despite Stovall's particular denomination, she and her black neighbors believed in the same underlying doctrines: sin, redemption, and judgment.

Within the overarching symbolism of the past, as defined by traditional black culture in Stovall's paintings, is the intensely meaningful symbol of the sincere spirituality of black people. Bridled by the religious customs of her aristocratic white Protestant background, Stovall respected the unrestrained emotions of her black friends: their heartfelt religious expressions satisfied the unexpressed intensity of her own faith. Stovall's deep-rooted faith and her inclination and ability to see with an artist's eye filtered her vision of black religious worship. She focused on the aesthetic aspects of the material culture and religious behavior of the black community. In selecting the theme for "Swing Low," Stovall recognized the artistic and spiritual merit in "the uninhibited show of emotion of this colorful people." Their display of grief

offered her a moving and sensitive theme for a painting and satisfied her need to communicate the virtue of "hard religion" in her rural existence.

Keeping in mind the goal of determining the usefulness of Stovall's paintings as historical documents and her deep interest in depicting black subjects, the question should be asked: how can a well-bred white Southern woman born in the 1880s portray rural black life without the distortions produced by racial prejudice? In order to determine the effect of Stovall's attitudes on her pictures, we need to understand her artistic objectives and the period during which she painted. First of all, the question of prejudice was not addressed by Stovall in her paintings. Her foremost objective was not to produce a political statement, but rather to describe the traditional patterns of her locale and the people who practiced them—namely, blacks and middle-class whites who lived in her rural environment.

Viewed from Stovall's perspective in the 1950s, her depictions of blacks were not proclamations about race or racism because her pictures were not concerned with the black race at all—her intentions focused on black *individuals*. From Stovall's standpoint, the key element in understanding her attitude toward the blacks in her life and in her art is their individuality. Lucille Watson, Stovall's close friend and contemporary, explained:

> The best thing I ever read on the subject of our race relations was an article I read . . . years ago. [It] said that in the North they loved the race but hated the individual, and in the South we loved the individual and hated the race. I think that's exactly what it was because every white family in the South that I ever knew had a colored servant that was like a member of the family. . . . We all called the women "aunt" and the men we called "uncle." They lived with us. When they were sick they were taken care of by the family, and when they died they were given funerals by the family. It's very difficult for people in the North to understand that.

Stovall stated that the individuals in "Swing Low" "are all people that I knew and loved."[40] Because those individuals were former employees and friends, Stovall was concerned about their response to her paintings: "I have identified these people as near as I can remember—hope none will be offended."[41]

Stovall's close communication with the blacks in her community extended the limits of the traditional Southern relationship between white employees and black servants. Her keen artistic appreciation for black characterization distinguished her from whites whose relationship with blacks never extended beyond the sharply defined boundaries dictated by society. Although tradition allowed for some blacks to be "like members of the family," Stovall's circle was larger and included numerous blacks who worked for her frequently, but usually lived separately. She was allowed greater access to the activities of the black community because of her willingness, as an employer and a friend, to share her time and assets. Her attitude is revealed in

her participatory role: "I have been to a number of funerals of my old colored friends (generally finding a black coat, hat and veil for someone to wear)."[42] Another time Stovall recalled, "You had to sew a black heart on the sleeve for the men or put a band on there [pointing to a sleeve]."[43] She also said that "in those days (1920s and 1930s) the Negros didn't have many cars and I had to go [to funerals] because I could provide some transportation."[44] That Stovall loaned her clothes, helped to sew on mourning insignia, and provided a means of transportation afforded a channel of communication between her and her employees, allowing greater opportunity to know them as individuals.

Emphasis on the individual is also expressed by Stovall's literary counterparts. "In my Negroes," Ellen Glasgow wrote, "I have come very near to actual portraits."[45] Black writer Alice Walker asked Eudora Welty during an interview if Welty thought anything was wrong with Mississippi—if there was a race problem—in the days before Civil Rights legislation. Welty answered,

> I could tell when things were wrong with *people,* and when things happened to individual people, people that we knew or knew of, they were very real to me.... I think this is the way real sympathy *has* to start—from direct feeling for something present and known. People are first and last individuals, and I don't think of them in the mass when I feel for them most.[46]

The response to Walker's question about whether or not Welty's black characters would necessarily suffer from a racist perspective might not be very different from one Stovall could offer if asked the same question: "I hardly see how anyone could claim that," Welty answered. "Indeed to my knowledge no one ever has. I see all my characters as individuals, not as colors, but as people, alive—unique."[47]

Glasgow, Welty, and Stovall all claimed to have had some close black friends, or at least daily intimacy with a few blacks. As might be expected, the women's close relationships with blacks were developed from within the domestic sphere, as described by Lucille Watson. Glasgow's tie with particular blacks is reflected in her fiction. In her novel *Barren Ground,* "a Negro woman became Dorinda's closest companion, just as [Glasgow's] closest companion was her secretary and nurse: 'The affection between the two women had outgrown the slender tie of mistress and maid, and had become as strong and elastic as the bond that holds relatives together.' "[48] Welty spoke of "a schoolteacher who helped me on weekends to nurse my mother through a long illness—she was beyond a nurse, she was a friend and still is, we keep in regular touch."[49] In Stovall's life, Sally Mae McDaniel remained a friend after retiring from domestic work. "[She] lives in town now but she still comes out to visit," Stovall said.[50]

In my opinion, an explanation of Stovall's attitude is best understood when viewed within her social circumstances. On the subject of relativity,

Phase IV, 1960-1975: The "End of the Line"

Queena Stovall's final painting phase provides an opportunity to study the height of her technical standards for rendering figures, underlying motives in her artistic production, and her reasons for ceasing to paint. After a period of approximately two years when little painting occurred, Stovall finished "End of the Line" in December 1960, initiating Phase IV of her artistic career. Between 1960 and 1975, she completed a total of four works; two others were begun but later abandoned. Stovall closed the circle on her painting career with individual parting messages to the three types of subjects she preferred to paint over the years. Of the paintings completed during Phase IV, each subject category previously established in Stovall's repertoire is represented: "End of the Line" is a scene with predominantly white individuals, "Comp'ny Comin' " and "Joe Peeler" are portrayals of black individuals, and "Herefords in the Snow" is a landscape with cows.

Focusing on Figures

Information exists revealing Stovall's primary concern with the depiction and multiple utilization of figures during her fourth and final painting phase. As discussed in chapter 3, Stovall cultivated techniques for rendering figures to her satisfaction early in her career. During Phase IV, however, her interest in particular figures reached a peak: she increased the amount of preliminary drawings and patterns in order to improve the quality of those figures, and she extracted certain figures from the context of a composition to decorate objects to be given as gifts.

"Comp'ny Comin' " exemplifies the epitome of Stovall's efforts to impose high standards on her work. Her sketch and scrapbooks reveal numerous cut-out patterns and a drawing made in preparation for this picture: five patterns for the man chopping off the head of a chicken, and eight for the woman scalding the feathers and skin of another chicken (plate 32). Based on the number of patterns, the amount of attempts made to attain a depiction of satisfactory quality exceeds the amount made for any other single painting.

Judging from the similarity of the patterns and drawings for "Comp'ny Comin'," Stovall achieved a satisfactory rendition of the basic pose of the two main characters in the picture from the beginning. Her experimentation through repeated attempts is directed toward subtle changes in specific features. In the five separate patterns of the man decapitating the chicken, the figures are seen bending over at slightly varying degrees; and the eight patterns and one drawing of the woman show only small variations in the tilt of her head, angle of her arms, or the size of her body. It is also significant that "Comp'ny Comin' " is one of Stovall's last pictures, and as such represents her determination to maintain artistic standards. Despite failing eyesight, she doggedly pursued her objective for the way figures should look until the end of her career.

Although the number of canvases continued to decrease during Phase IV, she unrelentingly held to her standards of artistic execution. Stovall explained that

> I always see something that I might have changed, could've made possibly a little better. . . . I enjoyed painting them [but] I really had to work hard painting them, because I wanted them to look right—to be like they were suppose to be. I just couldn't put something down and leave it and think, 'well, that's a foot, or that's a hand there.'

Her high standards, however, did not cloud her perception of a successful rendering. She later added with a laugh, "Then some of them I'd think, 'well, that was mighty good.' "[1]

Beginning in earlier painting phases, Stovall used selected figures from her works for decoration on functional objects. For example, she drew a collage of figures for the cover of one of her exhibition catalogues; and she painted figures and names on paper sacks as luncheon favors for her friends, who were invited to fill their decorated, personalized sacks with Queena's fresh garden vegetables. In my view, Stovall increased the production of these smaller projects—by-products of her easel-generated works—partly because of her special interest and skill in painting figures. Her skill, honed through practice and experimentation, led to more efficient rendering. Furthermore, serving Stovall's desire to be generous, these abbreviated products provided coveted mementos of her artistic talent for her loyal admirers, many of whom were close friends.

In 1971, Stovall decorated the lids of at least four cardboard boxes as a donation to the annual Lynchburg Fine Art Center box lunch, an event held in conjunction with the Lynchburg Garden Day.[2] The painted figures on the boxes are reminiscent of the central characters in "Blackberry Picking," "Comp'ny Comin'," "Monday Morning," and "Come, Butter, Come." In spite of poor vision, Stovall agreed to do the project: "I didn't want to do it especially— I don't see as well as I once did, but I felt badly about refusing such a small

Plate 32. Cut-Out Sketches for "Comp'ny Comin'"
(Photo by author)

request."[3] The gesture was Stovall's way of sharing the fruits of her creative abilities, and the prestige from her art, with her community.

Indicative of the same attitude, Stovall decided to paint her final picture, "Joe Peeler," as a gift to her son David Hugh Stovall.[4] "Joe Peeler," a close-up portrait (therefore unique in Queena Stovall's collection of work), shows the top half of an old black man, befriended by her son. This small picture is further evidence of the artistic products motivated by Stovall's love for and commitment to the people in her life.

Country Auctions and Antiquin'

Another motivating force in Stovall's art can be found in her interest in antiques. "I always just loved auctions," Stovall said. "Always went to any of them just to kinda' keep in touch. You could always pick up a little something there."[5] Her presence at auctions in Lynchburg and the surrounding area was taken for granted, and a seat was usually saved for her. Stovall's daughter-in-law Margaret Stovall recalled:

> Mrs. Stovall always took the front seat. She never moved. She never left that seat for anything, all day long. That was just really the thing that she loved most.[6]

Even while raising her children, Stovall found time to go to auctions and scout the countryside for old or handmade items—a pastime referred to as "antiquin'"—which remained in the modest cabins of Amherst County.

Appropriately, Stovall painted "End of the Line," the scene of an estate sale, as a final and monumental tribute to particular people and pet activities in her life. "End of the Line" is a complex self-portrait, including not only Stovall's portrayal of herself among her intimates but also many of her cherished belongings. Stovall took great pride in this particular picture; she said "I used my artist equipment to make myself look good."[7] Her profiled figure is central in the painting; she stands straight, alert to the bidding, while the woman seated behind taps her on the shoulder. And an array of antiques are arranged against Stovall's favorite landscape of grassy fields, colorful trees, and the Blue Ridge Mountains. The outstanding achievement of her final painting phase, "End of the Line" reflects Stovall's social and material context more completely than any other of her paintings.

"End of the Line" was inspired by an auction Stovall attended in neighboring Rockbridge County. She said "the sale that I had in mind for 'End of the Line' reminded me of one that Pierre [Daura] and his wife let me know about."[8] In the spring of 1959, Louise Daura wrote to Queena that "next Saturday, May 23rd, there will be a sale at Rockbridge Baths, at the Page Shoulder store, at 10:00 A.M."[9] Because Queena never learned to drive, friends

or family members drove her (and often her friends and employees) most places. Her son Brack, Jr., and his wife, Margaret, drove to the auction in Rockbridge Baths.

Although Stovall chose to depict the auction in the fall of the year rather than in the spring when it actually occurred, she preserved the somber mood of the sale. Margaret Stovall said "they were selling up a couple who had no children, no relatives, just no one. The husband and wife had both died [and] I guess there was no one to leave anything to. They had to get rid of the stuff so they just made a public auction out of it." In the painting, a lonely old man sits on the porch, watching the sale of his worldly goods—symbols of a long life—dispersed among total strangers. In title and atmosphere, "End of the Line" expresses the end of a particular hereditary lineage and the sorrow attached to cessation of continuity.

About "End of the Line," James Davis said, "What she did with this painting, she saturated this painting with people she liked, and family. Miss Queena knew everybody that was in that picture, every one of them by name."[10] Though a slight exaggeration, the painting does include numerous people from Stovall's world. She identified at least eighteen individuals portrayed. She included the Dauras because of her gratitude toward them for their artistic advice and because they told her about the auction to begin with.

Interestingly, Margaret Stovall's portrait in the painting exemplifies Queena's artistic license as well as her emphatic opinion about family priorities. Margaret is portrayed as pregnant when, in fact, she was not. She explained that "somebody asked Mrs. Stovall, they said, 'Oh, I didn't know Margaret was pregnant when you painted this picture,' and [Queena] said, 'Well, she wasn't but she should have been.'"

But not all the individuals portrayed in "End of the Line" actually attended the auction at Rockbridge Baths. Several of them—inveterate antique collectors—were regular bidders at other auctions throughout the area and were good friends or relatives of Stovall's. She portrayed two of her daughters, Judy and Annie Laurie, a cousin, Annie Ford, and several close friends, such as Florence Morton and James Davis, not only because they too loved auctions but because of Stovall's love and respect for these people.

Some of the other people Stovall portrayed were widely regarded as colorful characters, well known for certain behavioral trademarks. Mrs. Poindexter, the heavyset woman in a blue dress near the tree, usually sat in the rear of the crowd, representing a formidable presence. Margaret Stovall recalled that "old Mrs. Poindexter was always at a sale ... sitting under the tree with her arms up like this [crossed in front]. She had an [antique] shop up there. She had a husband and a bunch of boys, [and] she ruled them with an iron rod. She'd speak and they'd jump." The identity of another woman, shown diligently searching through a trunk, became known by her portrayal in "End

of the Line." Stovall laughed as she explained, "[she's] the one that came out here and looked at the picture while I wasn't here. The cook I had said that a lady was out here but she couldn't remember her name. Then she said that it was that one who was lookin' in the trunk in your picture."[11]

Stovall's attraction to auctions went beyond the objects for sale. "That was a great day for her," James Davis explained, "to get out and see all of her friends. [They would] come up and visit her. It was like going to a church social." Mrs. Ivey said "It was fun. It was a gathering. I felt that way, and I know Queena did too."[12]

But the social atmosphere was spiced with rivalry and the stimulation of purchase by competitive bidding. "If I'd hear about an auction," Ivey said, "I'd tell those who usually attended." Then she added that Queena, in her lighthearted manner, would often intensify the competition: "'Don't tell anybody else!' [Queena] would say." Of course, word spread, especially the news of Stovall's interest in a specific sale, increasing the attention. "If Queena was at an auction," a daughter said, "people would know it's a good one. She bids, and prices go up."[13] Nevertheless, the sales "used to be funny, we'd laugh, joke and tease," Ivey recalled. "Now they've gotten to be cutthroat," she added in a tone of disappointment.

But the dynamics between bidders at an auction during Stovall's time is revealed through the depiction of the woman sitting in back of Stovall in "End of the Line." The woman was

> an old cousin of mine, she always loved for me to go to auction sales. She had plenty of money . . . [she] was real sweet. She would always give me five dollars so I'd have a little extra piece of money to spend when I went to an auction. . . . she didn't want me to get wild. She's tapping me on the shoulder, not to buy that. That [pitcher] was cracked . . . wasn't worth it."[14]

Margaret Stovall said it was typical of the Stovall family to spar over each other's bidding behavior: "Some of them love to buy and the others would be trying to keep the others back, to keep them from buying. You know, 'you don't need that,' or 'don't buy that.'" In keeping with this behavior, Davis said "I'm not immune to haggling over something. I think they expect it. [Bidders] like to haggle all the time." Yet Queena thrived on the entire process. She summed up the appeal of auctions succinctly: "I think I have a little gamblin' instinct. It puts a little new life in me."[15]

Aside from the presentation of different personalities and their recognizable behaviors in "End of the Line," the picture also reflects Stovall's taste for traditional material culture. As discussed in chapter 3, Stovall frequently used her own material surroundings as models for the contents of her paintings. "End of the Line" is the ultimate example of this strategy since the majority of Stovall's belongings came from auctions to begin with. In a

parting artistic gesture, she returned them to their source. The painting also suggests the wider range of activities associated with her interest in antiques. Moreover, the scene inspired a wealth of complementary information from oral history narrators, who provided vivid descriptions of the circumstances (often comical) surrounding antique collecting.

Many of the items for sale in the front yard depicted in "End of the Line" could be seen in Stovall's home at the Wigwam. Stovall's painting table (this time painted light green, in the lower central section of the painting) previously appeared in "Basket Maker." Other objects include a Boston rocker, sofa, marble-topped table, table lamp, pitcher and bowl, quilt, stoneware, grandfather clock, end table, stitched picture, trunk, and footstool. And several other items reflect equipment found on the grounds surrounding the Wigwam home: for example, the dinner bell, knife sharpener, and iron pot.

The magic of an auction or the opportunity to acquire old things seemed at times to possess Queena. She would even drop her paint brushes to take advantage of a chance to visit a shop or store stocked with quaint old merchandise. Margaret Stovall said "Sometimes she would hear about a sale and she'd say 'Let's go!'" This recollection made immediate sense to me because while investigating Stovall's sketchbooks I found a page from her pad, streaked with paint and dotted with rough drawings, on which she had hurriedly written her family a note: "We have gone to Ramsey's antique shop near Brightwell."

Stovall's experience and interest made her a sought-after companion for antiquing. Her women friends admired her connoisseurship. Lucille Watson recalled: "We would go out through the countryside just with the idea of buying things. [Queena] knew things that were good. She had good taste and she loved good things . . . they were the things that she had grown up with and learned to love."[16]

According to women who shared Queena's enthusiasm for antiquing, husbands were not always happy about their wives' outside interests. Money was usually spent, children and husbands were upstaged, and domestic chores—not the least of which was dinner on the table at the assigned time— often got pushed to the side when women went off together. Narcissa, Queena's oldest daughter and an ardent collector of old things, described a typical plan formulated to allow the women their jaunts while keeping their husbands appeased:

> My Rosalie was so little—that's my oldest child—that we'd put a pillow on the back seat. Then we had a clothes basket when she got a little bit bigger. We'd put that clothes basket in there, squeeze it in the back of the car. And we'd go and say we'd be back. Well, we'd get back just about in time to get the frying pan on the stove and throw an onion in it, so that if anybody came in they knew we were there cooking supper. We wouldn't have a dern thing but that onion smelling in the frying pan.[17]

Another story which Queena's children remember with glee is an incident that occurred when Dave Stovall drove his mother to a general store which was going out of business. Dave Stovall recalled:

> We were antiquing up around Pedlar Mills, Mama and me, probably twenty years ago. And we went in to Willie Jones' store. Willie, in his latter years, had been an alcoholic from the time he got out of school. In later years, the store had gone down, down, down, so he had practically nothing in it except kerosene, bread, cigarettes. But he still had all the old stock that they always had—old high button shoes.... Mama was digging through boxes back behind the counter. [Willie] was sitting on a barrel on the outside. Mama kept rummaging. You can't imagine how she was twenty years ago, finding, and asking questions: "Mr. Jones, do you have any lace?" He pulled out a pine box and it was full of hand crocheted Irish lace. Five cents a yard, all rolled up. And she would ask him about [another] item: "Mr. Jones, do you reckon you have any old spool cabinets or anything like that?" "Well, I don't know if I got any or not," Willie said, getting more irritated with her questions. "If I got 'em they're back there." Finally he looked at Mama—weren't nobody else in there. She asked him one question too many and he said, "Mrs. Stovall, why don't you come back when it ain't so *goddamn* hot." I thought Mama would fall over![18]

Although the incident is illustrative of Queena's stamina for antiquing, she probably didn't enjoy Willie's remark as much as her son Dave did. In any event, Queena got the last laugh. As Bobby Stovall recalled, "Mama got the entire contents of the back storage room for, I think, twenty dollars."[19]

"The Romance and Color Is Gone Out of My Subjects"

Probably no question was asked more frequently of Queena Stovall than why she stopped painting. Though specific wording varied, her responses were usually similar—physical ailments and the modernization of her community. Stovall's health steadily declined during the fourth phase of her painting career. She explained that "I had a little heart spell, a stroke, or something."[20] Although her daughter Judy Fairfax suggested that her mother's problems were "brought on by 'End of the Line' "—a major artistic challenge—Stovall disagreed. For her, there was nothing disabling about art. In Stovall's view, it was simply a matter of old age catching up with her, finally affecting the priorities in her life. And within that reasoning she considered the principal physical problem to be her eyesight.

Bobby Stovall remembered the frustrations his mother experienced while she struggled with her final painting:

> The last picture she did—"Joe Peeler"—she'd been working on it right much. In the photograph that she'd been doing it from . . . she couldn't *see* his arm going out and his hand up over his mouth. So she asked me if I would try to work on it. She said she just couldn't do anymore. His face and hair were not touched [by Bobby]. His face was absolutely marvelous, and she had the right hand right. She did the hard part.[21]

That Queena successfully rendered Peeler's face despite her lack of success with other portions of the picture represents her interest in and skill at portraiture.

Toward the end of the 1970s, Stovall attempted two more canvases. One scene, to be entitled "Three Old Maids," never surpassed the drawing-board stage. "The children brought me a canvas a few months ago and I thought I'd paint a picture of three of my girls getting ready for bed," Stovall said. "I was always telling them that they waited too long to get married. I tried to paint it but I just couldn't."[22] Several rough drawings of this picture on manila paper are stored with her sketches and scrapbooks. Actually, she admitted subsequently that she could have managed to finish the painting, but her penchant for rendering detail became the deciding factor: "I could have used broad strokes, but that's not the way I painted. I had to be close, to get in the little things."[23] Regarding her second attempt, Stovall said "I tried a country doctor but I think I was too ambitious. I didn't like the way I had it so I never finished it."[24] When "Three Old Maids" and the country doctor scene failed to reach fruition, Stovall never attempted another painting. "I just hadn't done anything since," she said. "Now I can't [even] read."[25]

Perhaps more significant than physical ailments to the end of Stovall's artistic career were the drastic social and economic changes occurring in Amherst County in the 1960s and 1970s. After 1954, when the Supreme Court ruled "that in the field of public education the doctrine of 'separate but equal' has no place," Queena's traditional world began to crumble.[26] Effects of the Civil Rights Act of 1964 reverberated through her rural community, eventually altering the availability of inexpensive black domestic and farm labor. For over seventy-five years, Queena lived in a social and economic atmosphere passed down from the nineteenth century. Even after emancipation it remained customary and acceptable to the white Southerners for blacks to continue to carry on the traditional lifestyle—one dependent on servants—of the white middle and upper classes.

Queena's children recalled the effect of "the black uprising" of the 1960s on their mother's painting: "She stopped because things had changed—the social changes. People didn't come to the door and say 'do you have any work for me to do today?' "[27] And Queena felt hurt and insulted when "we couldn't go to their homes when they were sick or in sorrow, or to funerals, because we were white people and they really didn't want us."

Queena's attitude echoed many others of similar social status who were raised in the South between Reconstruction and the middle of the twentieth century. Her family once told me that Queena's traditional views prevented her from understanding the "ways of modern blacks." While in the hospital in the 1970s, for instance, Queena shared a room with a young black school teacher. The teacher called her "Queena" instead of "Mrs. Stovall." This

offended Queena, who was unaccustomed to such familiarity from black people, especially those she didn't know well. The teacher, in Stovall's eyes, had crossed the boundary of acceptable behavior. In the words of Flannery O'Connor, "it requires considerable grace for two races to live together. . . . It can't be done without a code of manners based on mutual charity. . . . The South has survived in the past because its manners, however lopsided or inadequate they may have been, provided enough social discipline to hold us together and give us an identity."[28] Stovall attached great importance to the aesthetic potential that she recognized in traditional black culture. But when the "code of manners" changed between blacks and whites, so did Stovall's artistic ardor:

> One reason I haven't painted, now I can't find anything to paint. It seems to me like all the romance or color or something is gone out of my subjects. You don't find any colored people like it used to be. Practically all around here have died out.[29]

Although her memory continued to supply the images, the fact that the images were no longer representative of living human beings and their traditional behavior punctured her enthusiasm, deflating her desire to continue painting.

Along with the signs of social change, Stovall considered the modernization of material culture a discouraging element to her art. "[There's] little farm work that's done by hand . . . it's big machinery, or they don't do it at all," she said. "Nobody 'round here has a garden or keeps a plow, or pigs, or chickens. . . . I'm the only one that does."[30] Stovall often said, with resignation but followed by a laugh, "I couldn't paint a machine if I tried!"[31]

"Sold!"

A few months after Queena died in 1980, most of her household goods and antiques were auctioned off on the front lawn of the Wigwam. "This is what Mamma wanted," said a daughter. "She planned this auction for 60 years and always said she wanted Archie [Trevillian] to handle it."[32] Trevillian, an auctioneer from Lynchburg, shared Stovall's appreciation for the past, cleverly applying his verbal skills to the sale of old things "provid[ing] just the right nostalgic touch."[33] Similar to the scene in "End of the Line," Trevillian sold Queena's cane-bottom chairs, marble-topped tables, rocking chairs, and unlimited bric-a-brac to the highest bidders, many of whom were collectors and dealers or family members and close friends. Evidently, the Stovall auction evoked unanticipated emotion. Stovall's daughter recalled: "[Trevillian] got up there after he sold one or two things, and he just broke down. He got so emotional that he had to get his assistant to get up there for awhile until he

could get himself back together."[34] In the ultimate creative twist, Stovall transformed her painted document back into an actual event—and the source of artistic inspiration—by requesting the postmortem sale of her belongings. No doubt Stovall would have thoroughly enjoyed her auction. "She used to laugh when she talked about having one of her own," Trevillian said. "She'd say, 'I want to be there—right up front.' "[35]

The Effect of Stovall's Art on Her Community

When Queena Stovall painted her first picture in 1949 no one thought her interest in art would lead to more than a temporary escape from canning and cooking. But artists, dealers, and collectors took notice of her work, and her preoccupation with oil painting evolved into a twenty-five-year career as a painter. The majority of her paintings have remained in or near Lynchburg, Virginia, or are part of private and public collections elsewhere in the South.[1] The sentimental value of Stovall's themes for Southerners, along with the relatively small number of her total works, explain the limited geographic distribution of her pictures. More so than with artists whose work is purchased by collectors and dealers from across the country, Stovall's paintings (and, later, reproductions) have remained available to directly affect the members of her community over the years. This availability has been due to a growing audience within a defined area; the same population of Southerners has been exposed to repeated exhibitions. And, for those who do not frequent museums and private galleries, newspaper coverage of Stovall and her work has been readily available.

In my view, the value of Stovall's work and her role as an artist can best be determined within a framework of the attitudes and reactions of those people touched by her paintings. Separated from context and evaluated as aesthetic statements alone, Stovall's artistic contribution is diminished and her goal to document her community is largely unappreciated. Furthermore, a contextual approach promises to increase the understanding of how artistic processes reflect the social patterns of a society. For these reasons, this chapter is devoted to the effect of Stovall's art on the people she portrayed along with other creative people in her community, and on those who value her pictures for sentimental and investment purposes.

A Respected Family and Cultural Heritage

Before investigating the range of topics relevant to the effect of Stovall's creativity on her community, two fundamental factors need to be elucidated.

First, Stovall was a member of a highly respected family that had been prominent in the Lynchburg area for decades. And Stovall herself—as a cultured Southern woman—reinforced her family's solid reputation through her devotion to her family, generosity and loyalty to friends and employees, commitment to working hard, and dedication to Christianity. Second, the residents of Lynchburg and its environs have been active participants in and supporters of cultural opportunities—especially the arts—for generations. Queena Stovall's talent germinated and blossomed in the fertile soil of a community that was receptive to artistic ambitions and proud of its successful, cultivated citizens.

Archival data from personal correspondence and local news media underscore the importance of Stovall's background to her audience. For example, when her painting "Baptizing—Pedlar River" was selected for exhibition in 1958 by the Mead Atlanta Paper Company, a newspaper article focused on the fact that "Mrs. Stovall . . . is widely related here, daughter of the late Mr. and Mrs. James Dillard of Lynchburg and Amherst County."[2] And an acquaintance wrote, "we are always admiring all you do. This picture [press photograph of Stovall] reminded me so very much of your mother. We love all the Dillards."[3] Such recognition is hardly unusual if one does even a cursory search through the Lynchburg newspapers, particularly the society page. The Dillards were frequently mentioned throughout the first seventy years of the twentieth century.

Queena Stovall was deeply admired and loved by those who knew her. Supplementing her status as a member of the Dillard family, Queena enhanced her own image by assuming her role as a devoted mother and dutiful wife with grace and charm. In fact, Pierre Daura considered Stovall's personal attributes to be as meritorious as her artwork. Louise Daura wrote:

> With this letter I include a copy of the letter Pierre wrote in April recommending you for Mother of the Year. I thought you ought to see how highly he regards you, as a person as well as an artist. You certainly *should* have been Mother of the Year! Of *this* and every other year, too.[4]

Besides her reputation as an exceptional mother, she was known to be a warm and affectionate friend. James Davis said "I never saw Miss Queena at her home or at an auction that we didn't kiss. She was a lovely woman."[5] And later while commenting on Queena's sense of decorum, Davis added that "she was just a lady, a genteel woman."

Moreover, Davis considered Queena's ability to survive financial droughts to be an ennobling trait. That she kept her family clothed and fed through bad times was to her credit. In his eyes, Queena's hardships strengthened her character. As he explained, "She had all the great experiences that you can have . . . being poor. She had really a hard time." And

once after a chitterling dinner, a guest described his pleasure in viewing her "paintings which portray the most vivid imagination and observation of a person who has enjoyed simplicity to its fullest.... Even the [other guests], most of them known to me, were different. They were all basking in an environment...with a humility in keeping with the Holiday Season."[6] Although not explicitly stated in her admirers' descriptions, their emphasis on her "humility" and "simplicity," two of the essential tenets of Christianity, augments Queena's identity as a woman of faith.

Her dedication to Christianity as a way of life placed her in a position of respect in both the black and white community. As previously stated, "she never missed a church service." And Hobart Lewis's statement is typical of the blacks I interviewed: "Mrs. Stovall was a good woman. A Christian woman."[7]

According to those I interviewed, Queena's Christian beliefs and puritanical philosophy were exhibited in her dedication to hard work. Lewis elaborated on one of his experiences: "Mrs. Stovall's a hard working woman that's all.... That woman could do more work with a hoe than anybody I've ever seen. She could go when I couldn't move...she was going into the sunshine, and kept going."[8] Occasionally, Queena's hardiness became exasperating. As Lewis recalled, "I was half mad 'cause she was workin' me so hard in that garden."

Yet, for the most part her neighbors were grateful for her stamina. Queena often claimed that "growing lots of food is fun. Do for your own family and then for the neighborhood."[9] Even after she got too old to work in her own garden she instructed her daughter to plant over one hundred tomato plants in addition to other kinds of vegetables. For the Dauras, Queena's benevolence provided both material and nonmaterial sustenance: "Pierre & I marvel at your unfailing generosity," Louise Daura wrote. "You must certainly be a 'Friday's child,' because you are 'loving and giving,' whether it is products from 'Queena's Supermarket' ('No Cash, Just Carry!') or spiritual gifts."[10]

Because of Stovall's image as "Mrs. Breckenridge Stovall, the hard-working Christian mother," people reacted with amazement when they learned about her talented pursuit of oil painting. Her presence at the butchering site as an artist—not strictly as a mother and overseeing farmwife—was noticed and considered a memorable event by those she portrayed. "But [to] this very day," James Johnson said, "I remember how it was. Mrs. Stovall stood there at the window painting this picture."[11] And there was an element of surprise along with admiration in Melvin Bailess's comment about the accuracy of Stovall's hog butchering scene: "She did a good job!" he marveled.[12]

Largely due to Lynchburg's industrial wealth, the city's residents have long promoted cultural activities and institutions of higher learning to provide training and experience in the arts. Randolph-Macon Woman's College (R-

MWC) was founded in 1891 "to establish in Virginia a college where our young women may obtain an education equal to that...for young men....where the...highest literary culture may be acquired by our daughters."[13] From the time the college opened its doors to students in 1893, classes in drawing and painting were offered. A dynamic young Virginia woman, Louise Jordan Smith, taught the courses while maintaining her own career as an artist, coordinating exhibitions, organizing an art association, and starting the R-MWC Collection in 1923.[14] Smith studied French and art in Paris around the turn of the century, and brought to R-MWC both a knowledge and an understanding of fine arts in the European tradition.

Lynchburg College was founded around the same time as Randolph-Macon, with similar goals in mind. Early in the twentieth century, Georgia Morgan, the artist who once took painting lessons from Ella Dillard, established an energetic art department at Lynchburg College. Morgan taught at the college for thirty years, becoming a popular painter of local scenes in Lynchburg and Amherst County.[15] Eventually, Lynchburg College needed a larger space for its growing permanent art collection and works borrowed for exhibitions. David Hugh Dillard, Stovall's brother, funded the construction of a building named the Dillard Fine Arts Building.[16]

In 1901, a charter was obtained for the "Sweet Briar Institute" [now Sweet Briar College] in Amherst County. The Board of Directors, after reevaluating a donor's intentions for a women's seminary, decided that Sweet Briar should be a "liberal arts college of the highest degree." The imposing classical architecture of the Sweet Briar campus is testament to the Board's dedication to "attractive surroundings and artistic buildings." Architectural historian S. Allen Chambers, Jr. wrote that "the college was launched on an architectural plan no less impressive than its educational aims."[17]

In addition to the cultural interests of the local colleges, many amateur and professional artists residing in the Lynchburg area participated in the events of the Lynchburg Art Club. The club has coordinated and sponsored numerous exhibitions over the years. Another organization, the Lynchburg Antiquarian Club, was formed in the 1930s for the purpose of studying antiques.[18] Queena became a member, probably in the 1940s, joining other women who were interested in lectures on decorative arts. And, in 1962, The Lynchburg Fine Arts Center was completed, providing galleries, a theater, reception area, and office space to accommodate local artists and their patrons.[19]

As we can see, Stovall's career as an artist did not take place in a cultural vacuum; nor was she or her family unknown at the time her talent was discovered. Stovall's artistic career rested on a foundation of creative skill combined with a prestigious heritage, a favorable image as an individual, and a network of educational and cultural organizations that altogether insured the enthusiastic reception of her work by her community.

Reaction to Stovall's Portrayals

After more than thirty years of exposure to Stovall's pictures—including originals and reproductions—most of her subjects are aware of their presence in her scenes. But how do Stovall's subjects feel about their portrayals? As is the case with most people seen in historical photographs of everyday settings, the people depicted in Stovall's paintings represent unsolicited portraiture—the "sitters" did not hire or even ask Stovall to paint them. Their responses to her portrayals, then, provide information about how ordinary people relate to an art form (in this case easel art) in which they and their lifestyles are represented unsolicited. The subjects I interviewed tended to answer questions on this topic in two ways: their responses described how they felt about being included in the pictures in a general sense and how they felt about Stovall's particular rendition of them, especially their perception of accuracy or unflattering aspects of their portrayal.

Generally, reactions among the subjects about their portrayals were favorable, although individual responses varied. But a small number were not entirely pleased; they, too, offered a variety of explanatory remarks. As might be expected, the most enthusiastic responses came from people Stovall knew well. Basically, these were older people who she had known and worked with for decades; those closest to her, whether rich or poor, black or white, were almost without exception delighted to have been included in her creative world. As I moved out from that intimate core, however, the reactions and feelings diversified, reflecting both positive and negative responses, and different concerns according to ethnic affiliation.

James Davis, who appears in "End of the Line," said "I was completely surprised when I found out that I had been put in there. I was terribly flattered that she put me in." Margaret Stovall was particularly pleased about her prominence in the same painting. "I'm sitting right there in front," she said. "I love it."[20] That the identity of her (pregnant) figure was not readily apparent didn't dampen her satisfaction in the least. She laughed, asking in a rhetorical tone, "do you think it looks like me?" Revealing the same degree of satisfaction, Stovall's daughter Mary White Lewis was grateful for a photograph of "Saturday Night Bath." (The painting is privately owned and located far away from Lynchburg.) Despite the fact that the picture portrays Lewis as a child, looking much different than her adult image, she feels emotionally attached to the scene. "It's the only one of Mama's paintings that I'm in," Lewis explained as her eyes moistened.[21]

One subject whose portrayal is included in "End of the Line" voiced disapproval about the way her body was depicted. She was mildly insulted that her image revealed heavy legs that she considered an exaggeration.[22] Although dissatisfied with the look of the portrait, and mincing no words in relaying that opinion, the woman later modified her response by stating that

she enjoyed teasing Stovall about their differing perceptions. I gathered from the woman's comments that vanity was a more significant factor than accuracy. Even if she had looked like Stovall's depiction, the woman seemed to prefer a more flattering portrayal over a mirror image.

At the beginning of my field research, one of Stovall's daughters told me that "the darkies that worked in the house, on the farm, loved Mother's paintings. They didn't have any resentment, or [bad] feeling. They were most interested in [the paintings]."[23] Although the daughter's subjective impression was based on a restricted sample, the blacks that frequented the Wigwam while Stovall painted generally expressed delight about being included in the pictures. As Sally Mae McDaniel, the subject of "Favorite Breakfast," recalled, "Oh, I thought that was great."[24] Another time she said "I feel good about it. I feel right good. I'm going to get me a frame for [my reproduction of] it." (Stovall recalled that when McDaniel was first shown her portrait all she could say was "Well, Lawd! Well, Lawd!") About "Hog Killing" and "Cutting Out the Meat," James Johnson said "It's beautiful, it's nice . . . really nice." He laughed while pointing to the figures of himself: "That's old Jim, right there!" And both McDaniel and Johnson enjoyed the fact that because of reproductions and exhibitions, their portrayals were seen by thousands of people. For them, the portraits granted a kind of celebrity status.

Members of Selvy Burton's family (appearing in "Making Sorghum Molasses" and "Swing Low, Sweet Chariot") were pleased with their portrayals for different reasons. Teeny Burton Winston said that her father Selvy (known as "Sullivan" by many local residents) "loved it. You could tell by the expression when they told him. Yeah, he liked that."[25] Burton ran his own mill and supplied molasses for blacks and whites living in Elon and Pleasant View. He was proud of a picture showing him at work at his own mill. A respected member of his community, he was grateful for further recognition of his position.

For Burton's children, the picture evoked fond memories of times when they baked sweet potatoes in the fire under the cooking pan and visited with neighbors. In addition, the children's endeared, late grandfather, Alexander Landrum, appears on the far left in the picture. His portrayal struck a sentimental chord among his grandchildren. As important as the pride and sentiment attached to the scene is the picture's importance as a family record. It remains one of the few pictorial records of Burton and the grandfather since most of the Burtons' personal effects were lost when a fire destroyed their home.

But Teeny Winston offered a different reason for her pleasure over "Swing Low, Sweet Chariot." Throughout her life she has been a member of Timothy Baptist Church in Pleasant View, Virginia. She was extraordinarily moved by Stovall's selection of Timothy Baptist for the funeral scene. As

mentioned previously, dedication to Christianity is important to the people of Amherst County; therefore, Stovall's painted monument to an old and revered church was well received.

Perhaps the most enthusiastic response from the black community came from Carl B. Hutcherson, the director of a funeral home in Lynchburg and the central figure in "Swing Low." For Hutcherson, like Selvy Burton, the painting symbolized his status as the owner of a successful business. Hutcherson was a civic leader in Lynchburg who had broken "the color barrier" before the forced integration of the 1960s. Apparently, he was impressed with his painted likeness, which was based on a photograph of him from the Lynchburg newspaper. He was so pleased, in fact, that he wanted to buy "Swing Low." Stovall recalled:

> Of course, he wanted that picture so bad, but his wife didn't let him buy it. I was asking, I think, four hundred or five hundred dollars for it.... I put in one of those old fancy draped hearses.... [I] had it sitting there at the church. His wife didn't like that at all because he had a brand new shiny black one. So Carl didn't buy it, but he sent me word to please will him that picture.[26]

Lillian Hutcherson, Carl's wife, thought the price was too high. She also feared that the old-fashioned hearse would discourage customers since her husband had it in mind to display the painting prominently in his funeral home. However, Carl Hutcherson's attachment to "Swing Low" continued unabated until the art department at Randolph-Macon had a color print made for him in 1967.[27]

Not all the blacks portrayed responded with unqualified delight. One young woman who initially seemed happily surprised to be in "Swing Low" later expressed a preference to be a different figure—which she considered to be more attractive—from the one Stovall had identified. Her response, similar to the woman who objected to Stovall's heavy-set depiction, seemed to indicate pride in appearance even at the cost of accuracy.

Another subject, Hobart Lewis, claimed that he chided Stovall about her intentions: "[I] remember the day Mrs. Stovall took that picture [pointing to a reproduction]. She was riding around having a time. 'Take my picture,' [I said]. 'You gonna' make you a fortune and give me none.'" Attempting to get verification, I asked Lewis, "You told Mrs. Stovall that?" Lewis explained that he thought he knew Stovall well enough to exercise a joking relationship. Then he said "yeah, I told her that. I wasn't gonna' fuss with her, nothing like that, [but] I said, 'I sure want to see you because I want to quarrel with you,' [and she said], 'What's the matter, Hobart?' Mrs. Stovall was awful sweet."[28] I think Lewis was trying to express his awareness of the broader implications and financial repercussions of Stovall's art without being disrespectful.

A few years before Lewis died at the age of eighty-four, Stovall's son Dave,

manager of a Leggett's Department Store (part of a chain in Virginia), asked Lewis if he would be interested in demonstrating basketmaking for the store's opening. An exhibition of Queena's paintings and memorabilia were planned as part of the opening ceremonies, and Dave thought Lewis's presence near "Basket Maker" would enliven the atmosphere. Sensitive to the issue of pride and fair compensation, Dave made an offer to Lewis for his services, and invited Lewis's daughter to accompany her father, all expenses paid. Following his experience at the opening, Lewis expressed his pride in his participation and claimed to enjoy the limelight.

But another individual I interviewed—a member of the black community—expressed skepticism about so-called opportunities offered to talented blacks.[29] Before I interviewed her, some people from a local college had approached members of her family—makers of traditional crafts—about a film production. The family was put off by the "one-sided" goals of the film makers. As a result, my narrator was suspicious of similar projects, and held mixed feelings about being included in Stovall's picture. When I asked her how she felt about being portrayed, she paused and then said "Well, okay, but what can I do about it, anyway? There's no law against it. If you don't know it's happening what can you do about it?" Her message sounded serious and resigned, yet without bitterness or anger; it was not the first time she had pondered the issue of equity and social participation.

Blacks not portrayed in Stovall's paintings expressed varied reactions to her paintings. The responses from the wider black community indicated confirmation by blacks that the scenes were reasonable depictions of common activities occurring in their communities in the recent past. Responses to Stovall's scenes of black subjects and events also came from blacks who did not know her personally. Mary F. Williams recalled the reaction of R-MWC's black employees during an exhibition on the campus: "When an exhibition is in the Main Hall building, everybody sees it over and over as they walk from the lobby down the corridors. Stovall's exhibition was tremendously enjoyed, especially by the servants."[30] And during the installation of the 1975 exhibition at AARFAC in Williamsburg, a black curatorial assistant, unpacking Stovall's paintings, remarked: "Is she black or white? She's really got soul."[31]

Another perspective was expressed by a young black businessman attending a 1982 trade fair in Atlanta, Georgia. The man owns a shop in Georgia where he sells art reproductions. While ordering prints of Stovall's scenes with black people to sell in his store, he was asked if he resented the fact that the scenes were painted by a white artist. "No," he said, "you've got to understand that we have so little in the art world that we can relate to."[32]

A further clue about the relationship between blacks and Stovall's scenes was provided by two black customers shopping for prints at a Lynchburg shop. They told the salesperson that they were interested in buying prints of Stovall's

pictures depicting black subjects. After a prolonged period of looking through the entire selection of sixteen-by-twenty-inch prints, they finally approached the counter holding a copy of "End of the Line." "Do you have this one in black?"[33] one of them asked. In my view, the woman's question indicates her capability to relate to the auction scene in spite of Stovall's decision to use it as a setting for her white friends. That the scene could have interchangeable subjects, representing one or more ethnic groups, supports the woman's capacity through past experience to envision herself in similar circumstances. Although Stovall decided to paint her auction scene with mostly white people, the fact that black people also attended auctions made the painting relevant to the customer. The particular circumstances may have differed for blacks and whites, but the basic events of traditional activities were often the same for members of both races.

A Source of Inspiration

Queena Stovall's work has influenced, and continues to influence, talented individuals in the Lynchburg area and in other places in the South. Her artistic ideas are an inspiration not only for amateur painters, sculptors, and carvers, but also for special populations, such as the aged and the mentally disabled. That Stovall was in her sixties when she began painting is touted by organizations interested in promoting second careers for the elderly. And, pending future research, Stovall's scenes of rural life may prove useful to art therapists.

The admissions office for a community designed for the aged in Lynchburg featured Stovall on its publicity flier. Two photographs of Stovall illustrate the following text: "Westminster-Canterbury is built on the belief that life goes on after 65. And people like Queena Stovall are proving us right every day. At age 62 ... Queena Stovall, 'senior citizen,' found a new gift within herself and began a new career."[34] The connection between Stovall's old age and her creativity proved to be mutually beneficial to both the art museums and the elderly. During a Stovall show at Randolph-Macon in 1980, held in honor of the Queena Stovall Scholarship Fund, Westminster residents were invited to a private tea at the gallery and offered a special viewing of the paintings.[35] As a result, museum visitation increased and the elderly received special attention and a respite from their daily routine.

About seventeen hundred mentally disabled individuals live in the greater Lynchburg area. Many of them are students, or former students, at the Central Virginia Training Center, an institution established to offer special education and job training to mentally disabled people. Students from the school commonly shop in downtown Lynchburg; and some are regular visitors to a shop mentioned earlier which displays and sells prints of Stovall's paintings.

One young man was especially captivated by Stovall's landscapes and often came to the shop to view them. One day, after numerous visits, he arrived with a painting he had made on material similar to posterboard; the painting was based on Stovall's work "Herefords in the Snow." The young man had written on the back of his painting that he realized his rendition "was not as good as Queena's, but I want it to be." It was the impression of the salesperson, to whom the painting was presented, that the young man appreciated the simplicity and familiarity of Stovall's idyllic scene. He found the rural tranquility of "Herefords" to be comforting and therapeutic, and decided to paint the scene himself.[36]

Three of Stovall's sons, Bobby, Dave, and Jim (now deceased), have demonstrated a flair for art. Each one considers his mother's artistic pursuits and talent to be a source of inspiration.[37] But each son has absorbed her influence in his own way, reminiscent of Stovall's method of self-teaching intertwined with exposure to experienced artists.

Both Bobby and Jim oil paint on canvas and have exhibited and sold their works. Jim enjoyed telling the story of the prize he won in an amateur art competition, also entered by his mother whose work earned no reward! Bobby makes dollhouses complete with furnishings and miniature copies of his mother's paintings. One of Bobby's most clever works, and perhaps the most important from the standpoint of historical documentation, is a depiction of Stovall's 1975 exhibition at Cooperstown with, of course, her pictures as they hung on the wall in the Fenimore House galleries. In addition, because Bobby has parlayed his creative talent into a successful art reproduction business, he has become involved with a variety of projects focusing further attention on his mother's pictures.

Over the last few years, Bobby's artistic interest has focused on a concern over the problem of the quality of the reproductions of his mother's work. For personal and commercial reasons he is making an effort to reproduce the majority of her paintings, ensuring the excellence of each color print. His stock of items based on Stovall's work includes frame-worthy prints, postcards, and rubber stamps with popular figures. And Bobby is asked to speak in Lynchburg and Amherst County by groups that value his artistic knowledge as well as his close connection with Queena Stovall. The Elon Chapter of the Amherst Home Demonstration Club asked Bobby to lecture at its annual meeting. (Queena was a member of this chapter, and the some 150 members elected to dedicate that year's meeting to her.) Recently Bobby designed teaching aids for elementary school students based on his mother's art: third and fourth graders, for example, color in line drawings traced from "Making Apple Cider" as an introduction to folk technology.

Dave Stovall's forte appears to be clay sculpture and wood carving. His favorite themes and subjects remain close to the Stovall mold, evident in a clay

Plate 33. Queena Stovall, Andirons
Modeled after central figures in "Fireside in Virginia."
(Photo by author)

bust of Brack, Sr., and a scene of carved wooden and painted figures placed in a scaled-down replica of Willie Jones's general store in Pedlar Mills. Following the artistic inclinations of his mother, the figures represent various people Dave knew, the most recognizable being his friend Joe Peeler. Another artistic project inspired by Stovall is a pair of andirons patterned after the two women warming their legs in "Fireside in Virginia." She had made plaster models of the two figures in the early 1950s, from which molds and, after, aluminum casts were made (plate 33). Years later, Dave had the figures cast in brass. The brass andirons are now owned by several members of the Stovall family.

Through the varied interests of Stovall's sons, the influence of her creativity is appearing in a diverse range of media, including cast metal, wood carvings, and rubber stamps. Her artistic ideas are being used for educational materials and public presentations. As channels continue to develop and more people learn about her work, her influence will extend beyond Virginia.

There exists at least one artist residing outside of Virginia who is currently inspired by Stovall's themes. Darrel Scarboro, a car repairman in his forties and a native North Carolinian, began making clay figurines while recuperating from a back injury. His initial inspiration came from a television program showing Dr. Tom Clark of Davidson, North Carolina, sculpt with clay.[38] But shortly after Scarboro began making molded figurines, someone showed him a picture of "Come, Butter, Come" in *Southern Accents*. Because of his attraction to traditional life he decided to reproduce the central figure in clay. Eventually, Scarboro met Bobby Stovall and got permission to sculpt the other figures in Stovall's paintings. Other figurines based on Stovall's characters are Brack as he appeared napping in "Fireside in Virginia," the washerwoman in "Monday Morning," and the woman preparing a chicken in "Comp'n'y Comin'."

Stovall's inspiration, however, did not always end in success. While working on a clay figure of Hobart Lewis, the main character in "Basket Maker," Scarboro told Bobby Stovall, "It fell out of my hands and into the trash basket. I'm not sure that the Lord wants me to do that one."[39] Indeed, similar to other self-taught artists including Queena Stovall, Scarboro respects the guidance of higher orders. Scarboro recalled that while watching the sculptor on television, "a really strange feeling came over me then. Something told me that's what I ought to be doing.... [God] had given me the hands to work with. Now he was showing me the medium and the way."[40] Scarboro's specific goal is to render "the expressions and characteristics of genuine human people—that's what I want to create." He relates this goal to his upbringing in a small town where people develop close ties over a long period of time.

During the winter of 1984, Scarboro was invited to exhibit and sell his clay figures in the Mint Museum of History in Charlotte, North Carolina.

Although the celebrity and potential for profits from his hobby is appealing, he is discovering his limits for commercial involvement. His emotional attachment to the way of life depicted by Stovall was expressed by his refusal to sell one of his Stovall-inspired figurines. Despite a customer's offer, Scarboro said no. "That fella was messin' with my heart," he explained.

Stovall's Art and the Marketplace

An investigation of the position of Stovall's art in the marketplace revealed information regarding the problem of determining a dollar value for her canvases, the social repercussions from reproducing her paintings for a mass market, and the significance of nostalgia in the popularity of her art. Stovall's work offers an opportunity to study the relationship between emotional appeal and the collecting of contemporary self-taught paintings of rural, everyday scenes. The personal flavor of Stovall's themes encouraged local people who knew and loved her to buy her paintings. In turn, the concentration of her works in the Lynchburg area, owned by people unwilling to sell, keeps them out of the mainstream art market and, hence, separated from the complexities of supply and demand as regulated by commercial interests.

By the mid-1950s, sales of Stovall's paintings were brisk among the residents of Lynchburg. Stovall—by now convinced of her selling power— retained the gallery prices assigned by Antoinette Kraushaar. Stovall's Lynchburg customers were mainly family members and close friends who, because of their love for her and their attachment to the past, were undaunted by New York City prices.[41] In light of recent market trends in folk art, those who bought Stovall's paintings at exhibitions in the 1950s and 1960s do not regret their sentimental indulgences, because prices for contemporary naive paintings have skyrocketed. As Perkins Flippin said, "when [Stovall] first started painting nobody could believe that they were that good. A million people kick themselves now that they didn't have sense enough to buy them."[42]

According to the records and my interviews, market value was not a major concern among the owners of Stovall's work until the mid-1970s. Around the time of the Williamsburg/New York State Historical Association (NYSHA) exhibitions in 1974 and 1975, however, owners of her art began to ponder the value of their paintings, and at least three owners sought Louis Jones's opinion. The first two requests about valuation were ostensibly made in order to insure the paintings.[43] Jones cautiously replied to the requests, explaining that "I can only tell you what I would do if they were mine, and I don't pretend any expertise on these matters of value."[44] Attempting to provide some pertinent information in spite of his reluctance, Jones replied:

The problem is that none of Queena's paintings have been on the market. We don't know what the current exposure is going to do to the values. Knowing what has happened to other naive painters whose work has suddenly become widely known, my assumption is that all of her paintings are going to jump greatly in value. But what is the value? There's no market record to go by.[45]

Other requests for valuation followed.

Understandably, Jones was hesitant to advise further on the matter of monetary value, given the problems of conflict of interest. Because Jones was indebted to the Lynchburg network of family and friends, who were willing to loan their paintings for exhibition and share their recollections of Queena, he tried to accommodate the requests. He wrote: "your letter ... poses a serious difficulty for me for during my years as a museum director I was careful never to give valuations on works of art and I still refuse to. But, because this is Queena I am making the first and last exception to an ironclad rule. The other problem is that I do not keep up to date on prices in the current market."[46] Based on his lack of familiarity with the art market and his discomfort as an appraiser, Jones adroitly and diplomatically handled the sticky issue of personally valuing the paintings by serving as a go-between instead. He contacted dealers and knowledgeable collectors of self-taught and folk art and sought their opinion. Jones then passed on the dealers' and collectors' estimates, presumably satisfying the owners' needs.

Since the mid-1970s, collectors of Stovall's art in Lynchburg have developed further notions about the worth of their paintings based on feelers from a few prospective buyers. One owner believes he could sell his Stovall for over $75,000.[47] Other owners believe that their Stovalls might sell for $20,000 to $25,000. Still, none of these long-term owners have yet sold their paintings. The emotional reasons for this stability in ownership will be discussed later in this chapter, but nonsentimental reasons also exist, stemming from a growing appreciation for financial investment as well as respect for the care of and future accessibility to Stovall's pictures. Some members of the Stovall family feel that eventually their paintings should be owned by a museum or an institution prepared to pay a competitive price, and conserve and exhibit the works.[48] One of Stovall's nephews considered selling his painting to either members of the Stovall family, the Dillard Gallery of Fine Arts, the Virginia Museum, or NYSHA. Indeed he sent letters to the four parties asking for bids, but apparently none were satisfactory.[49] He did not sell the painting after all, and it still hangs in his office. Only time will tell if the family or other owners can be convinced to sell, for monetary, curatorial, or other reasons. In the meantime, the fact remains that no official market value has yet been established, and opinions about the current price of Stovall's paintings continue to be based on unofficial estimates and speculation.

Charles Percy, a printer and local historian who lived down the road from

the Wigwam in Madison Heights, took an early interest in the market potential of reproductions of Stovall's paintings. In the 1950s, he proposed a commercial venture involving the reproduction of four paintings as "informative notepaper"; however, Percy's hope to make a profit on the notepaper never reached fruition.[50] By 1961, the arrangement was amicably discontinued. Percy Press Publications severed its contract with Stovall because the expense of production would prohibit sufficient profit. Nevertheless, Percy made an important statement about the nature of Stovall's audience: "Your work in the series is popular, Queena, but the spread is not enough for profit.... We may have some customers who will write in for yours year after year; but it takes a great many of these to show a profit."[51] In other words, as with her original canvases, reproductions of Stovall's art at this time had a loyal yet relatively circumscribed, localized audience.

A second effort to market Stovall reproductions was made in the 1970s by an entrepreneur from New York. For several years, postcards and posters of Stovall's pictures from this enterprise were sold in department stores and bookshops across the nation. But Stovall became distrustful of the operation and elected to dissolve the arrangement. During this period, her reputation was given a boost from the Williamsburg/NYSHA exhibitions, and her common sense together with advice from friends and family persuaded her to withdraw her permission for the prints.

Among those advising Stovall on her rights regarding the reproduction of her paintings was her son Bobby. His interest in starting his own art print business was fostered by the ethical considerations of other transactions and the inferior quality of prior products. He was concerned that Stovall's work would fall into the wrong hands, resulting in distasteful promotion and low-quality reproductions. Bobby Stovall's commercial endeavor continues to grow, ensuring the high quality of prints at affordable prices.

Although based on informal observation, one difference between the individuals who own originals and those who own reproductions is their socioeconomic class and ethnic affiliation. While only a generalization, reproductions are owned by blacks and whites of average or below-average means, whereas the originals are owned by whites of greater means. The ownership of the prints and the canvases suggests the same skewed pattern of distribution found in other communities where members have varied economic statuses. For the most part, people of average or below-average means own the less expensive items, in this case a Stovall reproduction rather than an original.

But the demand for and easy access to the supply of Stovall reproductions—Bobby Stovall's business is located in Lynchburg and includes mail-order options—has resulted in a social network of giving and receiving which crosses ethnic and income boundaries. One of my oral history sources,

Teeny Winston, who works as a domestic and is portrayed in Stovall's paintings, told me that she received her print as a gift from a white employer.[52] Evidently, the employer was delighted to discover that Winston was portrayed. As Winston talked, it occurred to me that a new dimension had been added to an existing pattern of interaction and exchange between the white employer and her black employee. Acceptance into Stovall's repertoire created a different perspective from which to view the employee. In fact, the portrait generated respect for and pride in the black employee, elevating the employee's status.

Reproductions also play a role in the relationships among socially prominent blacks and whites in Lynchburg. In a public presentation during the 1970s, Stovall awarded a large, framed print of "March Fury" to the principal of a predominantly black elementary school.[53] The print is displayed in the school's library in memory of Lillian Hutcherson, the deceased wife of Carl Hutcherson. Hutcherson and his son attended the presentation ceremony and, with Stovall and the school's principal, appeared in a press photograph published in a local newspaper. That Stovall personally presented the print reflects, I think, the social status of the recipients.

As previously stated, most of Stovall's canvases are owned by the initial buyers, friends and family in and around central Virginia or the South. Aside from an increasing appreciation for their investment potential, these paintings are valued for sentimental reasons. The demand for reproductions is often based on the fact that people like the "simple, old-fashioned" themes. But the nostalgic feeling expressed by those who favor Stovall's pictures is more than a single sentiment.

Stovall's pictures are preferred by some people because their portrayals are included in her paintings. Other people say that they like the pictures because the location and period remind them of personal past experiences. As one fan wrote to Stovall, "your exhibition of paintings...left me with sharpened memories of my childhood days in Amherst County....I want to... 'thank you' from my heart."[54] For still others, admiration for Stovall's role in documenting and preserving country traditions for future generations is given as the leading factor.

In general, Stovall's audience represents individuals who are drawn by their pervasive sense of a lost America, never to be recaptured. A common theme among art historians writing on American art of the mid-nineteenth century is a movement called "the rediscovery of America."[55] The literature of Washington Irving and James Fenimore Cooper, the landscape paintings of Thomas Cole, the genre paintings of William Sidney Mount, and the ballads of Stephen Foster heightened the American consciousness of the attraction for descriptions of everyday life. As industrialization and urbanization increased and the pace of society quickened, Americans found solace in looking back

nostalgically to a past era of country life—a life remembered as simple and free from the pressure of urban demands.[56]

As Amherst County became more industrialized, Stovall—like the genre painters of the nineteenth century—attempted to hold on to the fading traditions of her everyday, rural surroundings. Interestingly, Stovall's community retained a traditional lifestyle longer than many comparable regions. Small farm plots were still owned in the 1950s, people continued to baptize in ponds and rivers until the 1960s, and large gardens were tilled by hand as late as the 1980s. In my opinion, the shift in American life and consciousness that began in the mid-nineteenth century continued to be felt in twentieth-century Amherst County. Stovall and her admirers—representing a prolonged reaction to change and a persistent romantic sentiment—are among those who mourn the loss of America's rural landscapes and traditional way of life.

The Evaluation of Stovall's Art outside Her Community

Published and unpublished references to Queena Stovall and her paintings, occurring between 1949 and the mid-1980s, represent the various perspectives of artists, art historians, social and cultural historians, folklorists, journalists, and art dealers. Their views toward Stovall's art—as expressed through scholarly articles, exhibitions and catalogs, regional magazines, national network television coverage, and commercial reproductions—have dominated the creation and development of Stovall's image as an artist. With few exceptions, these references to Stovall's art reflect an established body of ideas about American folk art grounded in an appreciation for aesthetic, particularly stylistic, characteristics.

Stovall's paintings appeared in the 1950s when an emphasis on the way a picture looked had a dedicated following among folk art enthusiasts. For over thirty years, collectors, dealers, critics, and curators had been identifying folk art on the basis of a primitive or naive design and composition and, accordingly, presumed the maker was a common, ordinary, or even anonymous person, lacking formal academic training, and, hence, self-taught.[1] Furthermore, often based on the unself-conscious, straightforward, or quaint look of an object, the maker was considered innocent, provincial, or unsophisticated. It was, then, from an object-oriented perspective that Stovall eventually came to be classified as a "folk" artist.

Pigeonholes from the Past

From 1950 through 1958, most printed information on Stovall appeared in newspaper articles. Essentially, three people were responsible for the content of these articles: Pierre Daura, Stovall's art instructor at Randolph-Macon Woman's College (R-MWC); Grant Reynard, a painter and graphic artist who advised Stovall about selling her work; and Antoinette Kraushaar, owner of the New York City gallery handling Stovall's paintings in the early 1950s. Daura

and Reynard candidly expressed their views on Stovall by submitting to interviews, offering information for catalog text, and lecturing on her work. Kraushaar, in contrast, said little, choosing instead to let the paintings that she displayed speak for themselves. She closely controlled media coverage and the manner in which Stovall was presented as an artist. As a group, Daura, Reynard, and Kraushaar were significant influences in shaping Stovall's image as an artist during the early stages of her career.

Daura and Reynard's views on Stovall's art were affected by their experience and aesthetic appreciation as fine artists. They relied on a trained eye to distinguish good art from bad art but, for the most part, did not confuse their sense of evaluation with a need to classify. Daura, in particular, was sensitive to the association of Stovall with classifications and nomenclature which had become common in the folk art establishment. Aware of the confusion surrounding contemporary self-taught painters, Daura early on stated his disenchantment with the term "primitive" as a qualifier for Stovall's art. In 1950 he wrote to journalist Martha Adams that, "so much has been written about what is generally called 'modern primitives' and so much abuse has been made of that denomination. To my way of thinking 'primitive' is not . . . what Mrs. Stovall could be called."

While Daura referred to the "innocence and candor" of Stovall's canvases, and her "[lack of] skill, as this is taught at school or at the academy," in terms of inspiration and approach to subjects he considered Stovall to be similar to Giotto and Cézanne—two artists whose work is indisputably a part of a mainstream art movement.[2] Public awareness of Daura's high regard for Stovall increased as a result of articles in local newspapers which quoted him. One newspaper printed that Daura "compar[ed] her gifts and their exemplification in her work with the motivation and manner of Cézanne and Giotto."[3] Several years later, a caption under a press photograph reported that "for their structure and spontaneity, Mrs. Stovall's works have been compared to those of Cézanne."[4] In my opinion, Daura used these comparisons to explain why he admired and respected Stovall's aesthetic contribution. He assessed her paintings in the same way he assessed all art. Thus, the terms "candor," "innocence," and "spontaneity" are as valid for Stovall as they are for Giotto.

Like Daura, Grant Reynard was often the source of information about Stovall's art quoted in newspapers. Reynard led an active life, lecturing and writing when he took time away from his paintings. He was fond of Stovall and considered it an honor to articulate his opinion about her work. Reynard, too, advanced comparisons between Stovall's paintings and the work of mainstream artists. In his introduction to an exhibition catalog, Reynard aligned Stovall with Bruegel, the sixteenth-century genre painter: "[Stovall's] compositions [are] rich with people and animals, with turkeys and chickens

and pigs and horses and babies and those Virginia hills [are] so rich and warm in color that Bruegel might have coached her."[5] A professor from R-MWC writing an editorial about the exhibit borrowed Reynard's comparison: "[Stovall's] fantastic burial scene, [is] as ambitious as a canvas of Bruegel in presenting the collective life of a community."[6] Of course, Reynard's reference to Bruegel, reiterated in the editorial, amplified the importance of Stovall's artistic creativity in the minds of the scholarly community and the public.

Akin to Daura, Reynard emphasized the self-taught aspect of Stovall's art. Reynard characterized Stovall as "a full blown painter without the need of any study under teachers."[7] Ever impressed with Stovall's natural ability, he communicated his view through the Lynchburg *News* when he called Stovall a "full blown original" with an "unspoiled urge."[8] Although Reynard referred to Stovall's "naive assurance" as an artist,[9] he praised her works as "thrilling and surprising...[in their] character and originality."[10] Naturally, when Antoinette Kraushaar, a highly respected dealer, decided to take Stovall's paintings on consignment, Reynard enthusiastically supported the idea.

Antoinette Kraushaar shared Reynard's disapproval for the manner in which some contemporary self-taught artists—for example, Grandma Moses, Horace Pippin, and John Kane—were influenced by the art marketplace. Kraushaar and Reynard shared the opinion that many self-taught artists were negatively influenced by commercial success, painting pictures in an assembly line fashion or adapting their subjects to meet the demands of a buyer. While handling Stovall's works, Kraushaar insisted on approving all exhibitions of or publications about Stovall's paintings. According to Reynard, who negotiated the consignment agreement for Stovall, Kraushaar preferred to disassociate herself from dealers specializing in "primitives." After Kraushaar accepted Stovall's paintings, only a brief notation with no photograph appeared in the *New York Herald Tribune* announcing the works: "Realism in Queena Stovall's charming naive 'Baptism' also figures...to give this group a varied, pleasant appeal."[11] Although Kraushaar may not have approved of the adjectives "charming" and "naive" (commonly used by folk art dealers at the time), the simplicity of the announcement reflects her low-keyed approach.

By not promoting Stovall's paintings in a manner typical of media-conscious folk art dealers, Kraushaar became an exponent of the non-classificatory perspective. She liked Stovall's early works because they fitted the aesthetic criteria applied to *all* art works accepted in her gallery; she considered Stovall in the same way she considered all contemporary painters. In other words, Kraushaar, like Daura and Reynard, maintained Stovall's image as a noteworthy painter without pigeonholing her further as a folk artist.

By the late 1950s, references associating Stovall with other "primitives" began to appear in newspapers. This association corresponded with interest

in Stovall's paintings among art museum staffs. Through the sale of her paintings to museums, Stovall's visibility increased as an artist, and art historians began to take note, describing her talent through their own perspective. Liberated from the agreement with Kraushaar after 1956, Stovall began entering juried state and regional art competitions. Juries were often composed of museum staff, many of whom were trained in art history.

Sherman L. Lee, then director of the Cleveland Museum of Art, was a member of the jury that selected "Baptizing—Pedlar River" for purchase by the Virginia Museum in 1959. It was Lee's references that publicly linked Stovall with "primitive" painters. A local newspaper reported on his speech made during the presentation of the purchase awards: "[Lee] compared [Stovall's work] with 'The Peacable [*sic*] Kingdom' by Hicks, one of America's best known primitive painters. He [Lee] lauded Mrs. Stovall's work saying that it...was more outstanding than the work of Grandma Moses."[12] Lee's reference to Grandma Moses provided fodder for journalists who, for years after, called Stovall "Virginia's Grandma Moses" and a "painting grandmother."[13] Despite Lee's inclination to associate Moses, Hicks, and Stovall as a group apart from the mainstream, one might assume that he considered Stovall's work to be of noteworthy aesthetic quality judging from his views on art and the purpose of art museums. He advocates "dedication to collections and exhibitions of fine works of art, chosen for their quality and meaningfulness in artistic terms."[14]

Comments about the purchase of "Swing Low, Sweet Chariot" for R-MWC's art collection further supported the image of Stovall as a "primitive." Newspaper articles quoting art historian Mary F. Williams, Chair of the college's art department, stated that "Mrs. Stovall's work is in the category known as 'primitive painting'.... [Her] paintings are often compared or contrasted with those of Grandma Moses.... Both are known as primitive painters."[15] The first book to include a reference to Stovall appeared in 1965. Edited by Mary F. Williams, *Catalogue of the Collection of American Art at Randolph-Macon Woman's College* contains a picture of "Swing Low." The caption under "Swing Low," as previously cited, is taken from Stovall's own words, describing her source of inspiration for the painting: " 'Swing Low' was painted from memory of the many Negro funerals that I went to.... The setting is at Pleasant View. The church is Timothy Baptist right in the bend of the road.... They are all people that I knew and loved, many of them worked for me at some time or another."[16]

During the 1970s and early 1980s, references to Stovall increased in number with some change in kind. Art historians and their students continued to show interest in her work, joined by scholars in folk history and social and cultural history. Coverage in the mass media expanded to slick coffee table magazines, television, and commercial reproductions of her paintings. At least

three theses written about Stovall between 1971 and 1982 represent efforts to supplement stylistic analyses with cursory biographical and contextual information: newspaper references and items from private archives are cited, and a few interviews with Stovall provided information on the sources of her themes and the influence of Pierre Daura. But in each study, the decision to investigate Stovall in the first place was based on the aesthetic and stylistic appeal of her paintings, with only tangential interest in her life experiences and creative process.

In 1971, Mary Ellett wrote a paper about Stovall for an art history course taught by Mary F. Williams at R-MWC. Ellett was the first researcher to collect biographical data as well as information about method and technique through interviews with Stovall. Perhaps as a result of talking to Stovall, Ellett recognized the problematic nature of separating art into categories: "The dedicated painter of any era considers himself to be an individual artist working apart, perhaps, from school, tradition or academic category. His aims, his challenges, his solutions may be highly personal; yet, before the paint is barely dry, his contribution can be slipped upon a giant pegboard and categorized within any one of several niches bearing Headings, Sub-Headings, and other labels necessary from an eagle's view of art history." Still, from Ellett's "eagle view," Stovall's work was categorized within the niche of "primitive" painters because she had "little or no formal [art] training."[17]

The majority of the paper concentrates on comparisons between Stovall's paintings and the work of other "primitive" painters from the United States and Europe: Clara McDonald Williamson, Camille Bombois, Linton Park, Susan Merrett, Lawrence Lebduska, Thorvald Hover, and Dominique-Paul Peyronet. "If this group [of untrained artists] must fit into a category," Ellett stated, "it could be called 'primitive' or 'naive' or 'popular.'"[18] Stovall and the others, according to Ellett, chose similar themes—cabin interiors at Christmas, cows grazing, public gatherings in the country—and practiced the same "unacademic" style. While not explicitly stated, Ellett implied the idea that Stovall is part of a cross-cultural artistic tradition based on unacademic style.

In 1979, Nani Yale, another art history student at R-MWC, wrote a senior thesis entitled "The American Folk Art Tradition and Queena Stovall." In addition to her paper, Yale organized an exhibition by the same title as part of her project. Her thesis reveals a confident use of "folk" when describing Stovall's work: "Thus we see there are 20th century folk painters who are producing works that *seem* [emphasis mine] to follow in the tradition of the early American folk artist. . . . we see that Queena Stovall has painted in the folk tradition that was introduced in America in the 17th century and has continued to develop through the eighteenth and nineteenth centuries up to the present 20th century."[19] Continuity through time, complementing Ellett's

idea about horizontal, geographically widespread commonalities, is a major theme in Yale's paper.

A brief text in the checklist accompanying the 1979 Stovall exhibition at R-MWC reveals a similar view—stylistic traits identify the paintings as "folk" and justify them as a relevant category. According to the checklist, the paintings come from a part of society "untouched by the vagaries of the more sophisticated, style-conscious society around it. Whether the Folk [*sic*] artist is trained or untrained, amateur or professional, he or she uses a style that appears simple and direct."[20] And when not on exhibit elsewhere, Stovall's "Swing Low, Sweet Chariot" hangs next to a painting by Grandma Moses in Randolph-Macon's Maier Museum, suggesting a common kinship based on a "primitive" style.

A paper written in 1982 by Charlotte Emans, a graduate student at New York University studying with the staff of the Museum of American Folk Art, represents another example of an art historical perspective. Because Stovall had died by the time Emans wrote her paper, sources came mainly from newspaper articles, Ellett's paper, and the catalog accompanying the 1974 exhibition at Fenimore House in Cooperstown. Following a biographical summary and a description of phases in Stovall's painting career, the bulk of the paper deals with stylistic interpretation of the paintings, concentrating on techniques and themes. By themes, Emans means Stovall's spiritual presence in her paintings, the viewer's participation, Stovall's sense of humor, the role of nature, and the depiction of blacks.

The identification of Stovall as a folk artist was not questioned in Emans's paper, a status that seems to have been firmly rooted by this time. Perfunctorily, Emans presents her criteria for folk art in the last paragraph of her paper: "In the truest sense of the word, Queena Stovall is a folk artist. In her execution, her work is naive, unskilled and untutored." And within the category of "folk," Stovall is praised as an outstanding example; in spite of her naivete, "her great sensitivity and understanding of the human condition permits her work to stand out as remarkable."[21] In Emans's view, lack of training is the criterion for "folk" identity, but a compassionate personality serves adequately for evaluations of quality.

By 1972, Stovall's work had caught the eye of folklorists. During that year, Louis C. and Agnes Halsey Jones spent a year surveying the eastern United States for American folk art. Funded by the National Endowment for the Humanities, their trip took them to Lynchburg where they met Stovall through mutual friends. Enthusiastic about Stovall's work, the Joneses subsequently declared that she was the most important discovery made during a year of searching for folk art.[22] This statement by the Joneses represents, to my knowledge, the earliest published reference to Stovall as a folk artist. Two years after their initial visit, the Joneses—under the auspices of NYSHA, with

additional funding from the National Endowment for the Arts—coordinated a traveling exhibition of forty-one Stovall paintings. The exhibition traveled from Lynchburg (The Dillard Fine Arts Building at Lynchburg College), to Williamsburg, Virginia (AARFAC), and, finally, to Cooperstown, New York (NYSHA's Fenimore House Museum). Along with the Joneses' statement about Stovall's place on their list of discoveries, the participation of museums specializing in folk art served to support Stovall's identification as a folk artist.

NYSHA published a catalog to accompany the exhibit, with a brief introduction by the Joneses. While the appeal of Stovall's paintings for the Joneses was largely based on aesthetics, the introduction offered some biographical and contextual information as well as references to artistic techniques. As folk art scholars long aware of the debate over definitions, they treaded cautiously on the issue of Stovall's status as a folk artist: "[Stovall was] if not a folk artist, then a superb documentor of folklife."[23] The Joneses appreciated the mixture of folk and elite cultural influences on Stovall's life and the sophisticated aspects of her artistic talent: "[Stovall] draws well," Louis Jones stated in an exhibition prospectus written in 1973. Yet as the exhibition gained momentum, the aspects of so-called folk art described by familiar adjectives received most attention: "Her painting style is naive, colorful, vigorous, touched with humor and humanity."[24]

The influence of the Joneses on the image of Stovall as a folk painter was indeed significant. After a lull in newspaper and magazine coverage from the late 1960s to the mid-1970s, the renewed interest in Stovall prompted a renaissance of press attention. By the time the exhibit of forty-one paintings left the Dillard Fine Arts Building at Lynchburg College in October 1974, and were shipped to AARFAC, the press had no problem attaching the label "folk artist" to Stovall's name. One news article announced, "Lynchburg Folk Artist, 86, Exhibits in Williamsburg";[25] another reported, "Queena Stovall Breathes Soul into Folk Art."[26] But at first, "naive"—the term initially preferred by the Joneses—commonly appeared in the press. A news article entitled "Naive Artists Create Wonders" reported on a lecture by the Joneses which cited Stovall's work.[27] Although there is no written record of the Joneses calling Stovall "self-taught" an article entitled "Self-Taught Artist's Work Called Historical Record" appeared in an upstate New York paper.[28] The article coincided with the exhibit at Cooperstown for which there was much ceremony and media coverage. Since the Joneses stressed the importance of Stovall's lack (or paucity) of academic training, the term "self-taught" may have been expressed verbally at some point during the exhibition presentations and picked up by the press.

In spite of the initial choice of qualifiers, Louis Jones eventually considered Stovall to be a folk artist. By 1976, Stovall's work was included in a discussion of several "folk artists... [who] have created a still neglected

reservoir of information about the American people which calls for understanding and appreciation."[29] While Jones enriched the amount of biographical and technical information available on Stovall, his loyalty to stylistic interpretations remained.

A parallel current of residual descriptions also appeared in the press during the period of the NYSHA exhibition. Some articles repeated Daura's comments: for example, "Mrs. Stovall's works have been compared to those of Cezanne."[30] Feature articles referred to Stovall as "a primitive artist many prefer to Grandma Moses,"[31] and "Amherst County's Grandma Moses."[32] Affirming this image, the actress Joan Fontaine, visiting Lynchburg to promote her book, responded to a print of "March Fury"—presented as a gift to Fontaine—by declaring "why, this artist must be Virginia's 'Grandma Moses.'"[33] The most frequent references to Stovall in magazines and newspapers by the mid-1970s, however, claimed that she was a "Noted Folk Artist,"[34] "a nationally-known folk artist,"[35] "Eminent in American Folk Art,"[36] "one of America's leading folk artists,"[37] and "a premier folk artist."[38] Her obituary in *The Washington Post* read, "Emma Dillard Stovall, 92, Folk Artist, Began Painting Country Themes at 62."[39]

In 1978, a former graduate student of the Joneses, Elaine Eff, served as guest curator for "Folk Art: The Heart of America," held at the Museum of American Folk Art. Having been a student at Cooperstown shortly after the Stovall show was organized by the Joneses, Eff readily accepted Stovall's identity as a folk artist. Stovall's "Swing Low, Sweet Chariot" was selected for the exhibition at the Museum of American Folk Art because "it is rare to find a painting which includes hearts... [and] the heart in Mrs. Stovall's painting suggests one of the ritualistic associations of the heart (i.e., death)... [and] it is important that an artist from the Shenandoah be included in a gathering of objects from all parts of the country."[40]

A year later, in 1979, Stovall's "Baptizing—Pedlar River" appeared in "Artists in Aprons: Folk Art by American Women," another show held at the Museum of American Folk Art. The show's curators, Marsha and Betty MacDowell and Kurt Dewhurst, have backgrounds in the fine arts and art history as well as American Studies, but often their joint efforts are folkloristic in approach and content. The catalog for "Artists in Aprons" restated Stovall's status as a folk painter and emphasized the value of her paintings as historical documents.[41] Referring to Stovall's contribution as a documentor once again reveals the influence of the Joneses through whom Dewhurst and the MacDowells were introduced to Stovall's work.

During the winter of 1983-84, Dewhurst and the MacDowells again collaborated as curators, organizing "Religious Folk Art in America: Reflections of Faith." Two of Stovall's paintings, "Swing Low, Sweet Chariot" and "Baptizing—Pedlar River," were included in the show and catalog by the

same name. This time the catalog by Dewhurst and the MacDowells represented an effort to integrate the ideas of folklorists and folk culture research: "For folklorists, fieldwork within a religious community and with the producers of the material culture provides the basis for making such distinctions between true art and art as diversion. Wherever possible, folklore fieldwork studies have been cited."[42] But despite a stated interest in the makers of the objects exhibited, only a brief description of Stovall— reminiscent of the NYSHA catalog—is offered in *Religious Folk Art in America*. In any event, the exhibition provided a wide audience for Stovall's paintings. Located in the heart of Manhattan at the IBM Gallery of Science and Art, the exhibition was well attended, drawing several thousand visitors each day, and increasing the number of people who now connect her name with folk art.

In 1981, Simon Bronner, a folklorist, briefly mentioned Stovall's work in an article entitled "Investigating Identity and Expression in Folk Art." Bronner's principal focus in the article was the paintings of Anna Bock (a pseudonym), a member of a Mennonite community in Indiana. He associated Bock's choices of themes with those of Stovall: "Anna's emphasis on typical scenes of community life parallels many works of so-called nonacademic rural artists elsewhere. One could look at the subjects covered in genre scenes of Queena Stovall of Lynchburg, Virginia."[43] But Bronner chooses his terms wisely ("so-called nonacademic rural artists," for example), avoiding the categorical assumption that Stovall is a folk artist. He points out that the two artists share thematic concerns, despite the probability that their relationship to their community was different.

In 1980, *Southern Accents*, a glossy coffee table magazine on home interiors and gardens, published an article entitled "Folk Artist Queena Stovall."[44] The article contains a short text spotlighting colored prints of seven Stovall paintings. Her nostalgic themes are accentuated by their association with the photographs of antiques and other reminders of the past that fill the pages of *Southern Accents*. Once again, an explicit title along with reproductions of her country themes promote the image of Stovall as a folk artist in a publication read widely across the South.

Stovall's image as a folk artist in the mass media reached a nationwide audience in December 1981. "Three American Folk Artists," a film made by Jack O'Field, described the cultural background and artistic processes of Stovall and two other painters, Ralph Fasanella and Mario Sanchez. O'Field, a folklorist by training, probably found out about Stovall from Louis Jones, explaining O'Field's ready acceptance of her as a folk artist. But by the time O'Field conceived of the film different views of Stovall's paintings prevailed. Seeking money for his film, O'Field applied to the National Endowment for the Arts (NEA) which, by the later 1970s, had instituted a Folk Arts Program. His

project, however, received no funds partly because the review committee did not consider Stovall to be a folk artist.[45] Ironically, NEA had funded the Stovall exhibition coordinated by NYSHA in 1974, but four years later, she did not qualify. O'Field's application roughly paralleled the "shoot out"—a spirited and tense meeting among folk art scholars and enthusiasts—held at the Winterthur Museum in 1977, where some folklorists and social historians brought new questions to bear on the old problem of definition.

Attempts to commercialize Stovall's pictures have been carefully controlled by family members. But before Stovall died, her youngest son, Bobby Stovall, asked and received her permission to reproduce some of her paintings for a commercial market. With caution, moderation, and a quality that Queena would have approved of, Bobby has generated a number of high quality reproductions sold as prints for framing, as postcards, and as part of an advertising catalog. Besides a thriving mail-order business, the prints are sold in shops and department stores. Probably influenced by the popular reference to his mother as a folk artist in the 1970s, Bobby named his business "Folk Art America." And the success of Bobby's reproductions accounts, to some degree, for the continuing image of Stovall as a folk artist.

In summary, artists such as Pierre Daura and Grant Reynard, along with art dealer Antoinette Kraushaar, tried to curtail the movement to separate Stovall from the artistic mainstream. But the attitude of art historians toward style prevailed—Stovall's paintings were labeled as "primitive" and compared with those of Edward Hicks. The familiar image of Grandma Moses, America's "self-taught, painting grandmother," provided a ready slot into which Stovall seemed to fit. And, yet another generation of art historians, like their mentors, pursued stylistic analyses referring to Stovall as a "primitive" and, finally, as a "folk artist." Commercial endeavors reflected the same categorization. More recently, students of material culture, many working as curators under the dominating presence of directors, donors, trustees, and the art establishment in general, organized exhibitions with Stovall's works through the auspices of folk art museums.

An Alternative View on Stovall and Her Art

In my opinion, to place Queena Stovall's paintings in the category of folk art discourages the careful examination necessary to explain who she was and why and how she painted and encourages stereotyping and misrepresentation. Prior to rigorous investigation, Stovall and her work fell victim to characterizations of folk art, perpetuated in spite of their invalidity or inappropriateness.[46] These characterizations have led to presumptions that a folk artist must be poor and live in the country as well as be self-taught rather than academically trained. Furthermore, it is often presumed that the artist's

work is without exception "naive," that the influence of tradition pervades all aspects of the work, and, finally, that memory is the sole inspiration for a picture's theme and content.

Applying the concepts, goals, and methods of folk history and folklife studies, I arrived at another perspective on Stovall and her work, replacing the identification of "folk artist" with "self-taught, though not uninfluenced, painter of everyday, rural scenes." This label, I think, is freer from misleading presuppositions and more open to an explanation of the meaning of her art and its usefulness as historical document. Such an explanation represents an effort to closely examine Stovall's art in light of her social and cultural experiences, particularly noting her association with a rural, traditional (or folk) lifestyle, the extent of academic influences on her art work, the changes in her paintings over time, and her own perceptions of herself as an artist and member of her community. When stereotypical descriptions are tested against the information now known about Stovall and her art, a different image arises—one that represents a complex and multifaceted source of creativity.

Confusion exists about Stovall's lack of prosperity and her rural lifestyle. Despite an empty pocketbook at times, the Dillards always retained the family home and a "respectable" circle of friends and acquaintances—symbols of prominence in Lynchburg society. And Queena's life on a farm and her lack of prosperity during certain periods did not diminish the fact that the Dillards were a prestigious family in Virginia. " 'We were poor,' I don't like that," Queena explained. "We had so much—house was large, open for people to come."[47] Another time she tried to clarify her perception of the difference between financial hardship and poverty. "We were poor," Queena explained, "but we weren't poverty stricken because we always had the home which had belonged to my father's father."[48] A friend of Stovall's and resident of Lynchburg commented on the enduring nature of social standing: "What you must understand is that just because people lose their money or live on a farm or run a boarding house doesn't mean they lose their status in Lynchburg society. They're still thought of as the 'good' or 'first families.' "[49]

Further confusion resulted from Stovall's statement "I am a country woman,"[50] printed in the NYSHA catalog. A subsequent interview revealed Stovall's qualification of that statement: "We're not what you call country people, that had lived in the country all our lives."[51] Although Queena was born at "a country place," her mother and father were not struggling farmers dependent on crops or livestock for their income. After moving to Lynchburg, Queena received a solid formal education and, for a short time, training as a secretary and office assistant. She inherited her mother's flare for entertaining and love of high fashion. She was a product of gentility and refinement—her world was one of elite Southern culture.

Later in her life, Queena chose to live in the country. Exposure to farm life

in Amherst County during the 1910s and, subsequently, the 1930s at Pedlar Mills convinced her of the pleasures of rural living. When her well-to-do brother, David Hugh Dillard, suggested that the Stovalls move permanently to the Wigwam (after Ella Dillard's death), Queena enthusiastically accepted the offer. Her participation in and knowledge of the traditional folk aspect of Amherst County became an additional influence to a life already accustomed to progressive, urbane culture. After moving to the Wigwam, Queena remained in Lynchburg society through her membership in the Rivermont Presbyterian Church, participation in the Antiquarians, and, by the mid-1950s, a prominent position in the local art community. She was as comfortable curing hams on her farm as she was listening to a lecture on early American furniture in Lynchburg. And while she was surprised and awed by the attention given her art at gala exhibition openings, she was at ease in floor-length gowns amid elegant surroundings.

An examination of Stovall's relationship with Daura and Reynard provides information about the extent of academic influences—especially those outside a classroom—on her art. Both Daura and Reynard felt strongly that Stovall should not continue to take art lessons. When referring to Stovall, Daura nearly always commented on the potentially negative effects of formal training: "My problem with her, in my class, has been not to teach her anything that could deviate her from her own-self. I tried to save her personality, that's all."[52] Reynard echoed Daura's attitude when he wrote to Stovall: "No teacher on earth could tell you anything about how to go about it. It would be a waste of time to go into any class to perfect your drawing or technic [*sic*]."[53] Indeed, over the years Daura and Reynard held firm to their opinion that Stovall should not take lessons. Their point was made over and over in newspaper articles. For example, "Pierre Daura...said 'if she keeps taking lessons...she will cease to be' ";[54] "Pierre Daura...declared she must keep on painting without external guidance";[55] "Pierre Daura...was first to advise her to follow her natural talents and avoid specialized instructors."[56] Such redundancy, I think, influenced Stovall more than either Daura or Reynard may have realized.

By painting in her own way, she developed a very distinct, intentional, and conscious style, as does any determined artist. Her figures tend consistently to be shapely and roundish. They seem to have a cartoon quality, as if outlined with a single stroke, appearing to be independent entities within the composition. Facial expressions and gestures generally denote two moods: her subjects are shown contented, yet alert and responsive, or thoughtful and preoccupied. Inadvertently Daura and Reynard were sending the message, "we like what you've painted—keep on doing it in just the same way." In fact, Grant Reynard liked Stovall's paintings enough to suggest an exchange of their works in 1964: "It has seemed odd to me that over all the years of your painting

and whatever part I have had in your becoming an artist that we have never exchanged work and I do not own a painting of yours. . . . Do you have a painting which you would send me on an exchange between 'artists?' "[57]

Futhermore, comparison with European masters must have been flattering and intriguing to her. In fact, the concentration on detail in many of her compositions, as Reynard suggested, does remind one of Bruegel's canvases. "Bruegel's picture stirs with life," writes an expert. "[The scene is] crowded with teams of workmen, stone cutters, even a few foraging chickens. . . . The pictures are irresistibly appealing. It is impossible for us not to marvel at their authenticity and to believe . . . that the land and the people they show once existed, just as Bruegel painted them."[58] Most assuredly, Stovall read Reynard's entry in the 1956 catalog (reiterated in a newspaper editorial) comparing her work with Bruegel. Would not her pride and curiosity encourage her to look up examples of Bruegel or at least be more conscious of his work when it passed her way?

Informal instruction subsequent to the art class at R-MWC represents another type of influence from Daura. Mary Ellett wrote that "[Stovall] worked at home and would show her canvas to Mr. Daura at various stages of completion." Even Stovall herself may have underestimated the influence of Daura: "Pierre wouldn't tell me much, he didn't want to change my style. He would tell me certain things . . . 'you ought to have a shadow there' or 'play the light color against the dark and you may like it better' but he would never touch my canvas. . . . Pierre was a very fine teacher; he was very encouraging to me and gave me confidence to paint in my own way."[59]

As inconsequential as each individual instance of Daura's advice may have seemed, his influence extended the length of Stovall's painting career, allowing for an accumulative effect. Even her perception of his influence implied that verbal recommendations, as opposed to actual demonstrations, could not penetrate her manner of painting. Yet Stovall recalled potentially persuasive advice: "Pierre said that I should study human anatomy."[60] And when she ordered some frames her letter stated that "I have talked with Mr. Daura. . . . He gave me one of your old catalogues and I am enclosing a check to cover cost of the three frames."[61] After a flattering commentary in a local paper, she wrote to Daura, "I just have to send you this beautiful editorial so you can share with me all the honor, pride, and joy that has come through you."[62] Respecting Daura as she did (her one-person show in 1956 was dedicated to him) she was no doubt susceptible to his well-intended suggestions.

At least one time, Stovall accepted nontechnical advice from Daura. In the early 1960s, she showed him her painting of an auction scene before it was completed. Stovall recalled:

I was just calling it "Country Auction" and I didn't like the name and I asked Pierre when I
showed it to him, I said "Pierre, give me a name for this. I don't like to just call it 'Country
Auction' when it's so obvious what it is." He thought for a minute and said "well, how about
'End of the Line'? End of this generation and end of the man—his belongings..." I said,
"that's just fine," so that's what I called it.[63]

Daura reiterated his opinion about the title in a letter: "I have been thinking of
the title of the painting. Of course 'Auction' is OK but I do think that 'The End
of the Line' would maybe be more suggestive of the social or human
implication of a sale. Not just a cold photo subtitle."[64] Daura's title added a
metaphoric, intellectual element to Stovall's painting, increasing its symbolic
nature and the subtlety of its message.

Another potential source of direction from Daura remained largely
unrealized. When Stovall went to Europe in 1963, Daura wrote to her about
the opportunity for artistic growth: "I do think that you... would truly love to
stay, let's say in Paris or in Florence and discover the art current over there and
work even. I mean to paint under its influence."[65] He expressed his curiosity
about how Stovall's painting might be affected by studying the works of
European masters. "It will be interesting to see if in your painting... there will
be any new element tracable to the influence of your trip. I dare to hope you
saw the Italian early school, Giotto's and his schools' work. Also the Siennese
school."[66] But after her return to the United States, Stovall only completed
three more paintings—a small sample from which to detect significant
change. Daura's letter, however, made Stovall more aware of what she was
seeing and of the possibility that it might, indeed, influence her own way of
painting.

The point is Stovall was just as vulnerable and impressionable to what
Daura and Reynard *said informally* as she might have been to their formal
instruction. Self-instruction in her case (and I suspect with many self-taught
artists) was interlaced with ideas, advice, and recommendations from
academically trained artists whose insistence that she not take lessons
camouflaged the extent of their influence. That Stovall exercised her
imagination and creativity without extensive academic training is
unquestionable. What does deserve more scrutiny is the kind and degree of
influence on her art which remain unrecognized or ill-defined until the
objects made are studied within her social and cultural context. Stovall's
respect and admiration for Daura and Reynard as artists increased her
susceptibility to their suggestions—even if the suggestion was to concentrate
on being self-taught.

Because Stovall's participation as an art student in a formal classroom
setting ended after 1949, she was subsequently considered "self-taught."[67]
But *self*-taught, by definition, contradicts the sense of collectivity associated
with the term "folk." I agree with Robert T. Teske's distinction: "In most

instances, folk artists acquire their skills through an informal apprenticeship or association with one or more senior artists in their community who share their knowledge through direct instruction and criticism of the apprentice's work and provide exposure to the range of the tradition.... In other words, the self-taught artist is virtually never a folk artist."[68]

But even if the aspect of shared knowledge and instruction were not a vital aspect of folk art, the use of "self-taught" without further explanation remains problematical. For some, "self-taught" characterizes an early phase in the development of a creative talent. Several well-known American painters have been considered self-taught artists: for example, John Singleton Copley and Benjamin West were regarded as self-taught painters at the beginning of their careers.[69] A study of Copley's painting "Paul Revere" reveals the immaturities in the development of his skill during an early stage of his career. In the portrait, Revere's small finger on the hand holding the vessel is rendered flat, and too long. Yet, over time, and with more practice, Copley became one of America's most celebrated fine artists.

Both Copley and West started their careers when young and had the majority of their lives to work diligently and become respected professionals. But despite their beginnings as self-taught artists, they have never been categorized as folk artists. They are thought of as mainstream, fine artists partly because they lived long enough to learn to paint better. Although Stovall's career was shorter by comparison, her collection of paintings also shows evidence of change and improved renditions over time. It is tempting to speculate how her art might have evolved if she had begun when she was twenty rather than sixty-two and painted for the duration of her life.

Louis and Agnes Halsey Jones assumed that since "Daura wisely advised her, in effect, to go and paint in her own way" she was "if not a *naif* at least artistically naive." Primarily, the Joneses focused on the stylistic characteristics in Stovall's paintings historically used to identify art as "folk"— distorted perspective, bold colors, and uneven proportions. The Joneses referred to Stovall's "limitations of technique" and "color [that] is very rich."[70]

It appears, however, that Stovall's style is a combination of artistically mature and immature skills. On the one hand, "the composition of these paintings is often surprisingly sophisticated.... she has an astonishing natural aptitude for drawing. She catches the characteristic gestures of her figures with skill and subtlety"[71] (plate 34). On the other hand, Stovall herself admitted having technical problems that she never resolved in her art: "I do have a hard time doin' it cause I just don't know the proportions, don't you see.... If I put a rug on the floor it looks like it's hangin' on the wall."[72] But unevenness in rendering is common among all artists (look at Revere's finger compared to the rest of the portrait by Copley). For some Stovall's "astonishing" drawings might qualify her for inclusion in the mainstream,

Plate 34. Queena Stovall, Drawing for the Central Figure in "Monday Morning"
(*Photo by author*)

while for others, her rugs "hangin' on the wall" would be grounds for placing her in the folk tradition. Such ambiguousness, I think, indicates the pitfalls of classifying artists primarily according to the style of their work.

Stovall's paintings have been described as purely products from her memory and experience. "She never copied anything," an art history student reported, "but instead relied on her imagination to create subjects."[73] However, an investigation of Stovall's scrapbooks and sketchbooks reveals that she did at times turn to press photographs and magazine pictures for inspiration and guidance. As discussed in chapter 3, some of her painted figures resulted from a combination of cut-out magazine cartoons along with her own artistic interpretation of a familiar person. Stovall created an artistic expression which melded the resources of her experience with those of her contemporary world. Though she never entirely copied an illustration, she valued popular sources for inspiration and help with the technical problems of size and composition. Hence, there is a derivative aspect to Stovall's paintings which deserves to be identified and examined to understand better her artistic process.

Inasmuch as Stovall did rely on her memory for inspiration, she shares that inclination with both trained and untrained artists. Perhaps most illuminating for this discussion are the numerous mainstream genre painters who have portrayed traditional rural scenes based on their direct contact with the subject matter. William Sidney Mount, for instance, "gave all his attention to the rural life of the Long Island countryside, depicting his friends and neighbors making cider . . . or otherwise engaged in the activities which made up their daily experience."[74] And Eastman Johnson, too, relied on his memories: "Probably he did more canvases of the maple-sugar camp than of any other subject. Inspired by childhood memories of the maple-sugar camps in Fryeburg, near Augusta, Maine, he revisited the area after the war and became almost obsessed with the idea of painting his masterpiece on this theme."[75] The point remains that while memory plays an inspirational role in Stovall's work, it should not alone be a reason to classify her paintings as "folk."

It is important to understand the association between Queena's early background and both the traditional and nontraditional (or folk and nonfolk) aspects of her art. Her childhood and adolescence prepared her for involvement with easel art. Exposed to art and literature through her mother and father, she learned early in life to appreciate creative masterpieces of skill and intelligence. Through her familiarity with elite culture, she was aware of the procedures required to paint with oil on canvas. She was comfortable conceiving of a scene and working out the technical problems by herself in the contemplative environment of her bedroom-studio. In fact, Stovall's paintings were not only produced but, to a large extent, appreciated *outside* of the traditional folk segment of her community. She did not decide how to paint

through processes shared with her friends and employees in Amherst County. Indeed, many of the people she painted did not even know they had been portrayed in her paintings until after the canvas was complete. For the most part, Stovall's subjects had no idea that she had taken a few art lessons at a local college, and that the experience served to bring together her talent and creative ideas in a studio environment conducive to artistic expression. It was, by far, the nonfolk influences of her life that influenced her artistic process.

Long after adulthood (and Daura's class), her art continued to be conceived of and produced in a studio-based setting. Though she painted in her bedroom with a makeshift light, the area was specially defined as "the place where Queena painted."[76] A friend said that "she liked to be alone, where it was quiet."[77] Except for occasional visitors, her time and space for artistic expression were respected by family and friends. The circumstances of her painting, then, suggest that her art was not passed on to her by members of her traditional community. As an individual artist, working alone for the most part, her work is not the product of a shared community aesthetic—it is her own personal aesthetic statement. As a maker of painted tinware or decorated furniture she might indeed be legitimately identified as a folk artist. In this regard, Stovall can be compared to Mario Sanchez, a painter from Florida, as described by Peggy A. Bulger: "Mario Sanchez (who is known nationally as a folk artist) [is] fulfilling a personal aesthetic vision that has arisen outside of traditional experience. When Mario Sanchez rolls a cigar, he is a folk artist, and when he paints a scene of cigar-rolling he crosses the line to become an artist."[78]

Stovall's choice of oils and painting equipment further reflects mainstream influences. "I use Grumbacher brushes and paints," Stovall said. "That's what they started me with and that's what I used all through."[79] After painting for a while, she acquired a "proper student easel" which she considered a vast improvement over the one she started with.[80] Prior to her one-person show in Lynchburg in 1956, she ordered two custom-made frames from the Louvre Frame Company in Plymouth, Connecticut. Stovall wrote in a letter to the company, "I want the patina or finish in antique gold and white or grey."[81] Stovall's discriminating taste is also revealed in her request that one frame have a "special 3/8 linen inset."[82] Her first choice had been imported linen: "We are not sure about the *imported* linen," wrote a Mr. Allaben, responding for the company. "We think you would like our domestic substitute which is very close."[83] High quality art supplies and elegant frames represented Stovall's attitude toward her art—an attitude more in keeping with refined, academic artistic tastes.

Finally, how did Stovall describe herself as an artist? She considered herself to be a competent painter within the limits of her abilities and the range of activities she enjoyed pursuing:

It wasn't an urge in me that I just had to paint. That's the reason that I said I don't feel that I was a great artist. If it were, I would still be painting. My eyes *did* give out; I could've painted a couple more pictures if I'd wanted to, but I felt like I'd painted enough.... It doesn't come easy to me. There are other things I like to do mighty well. T'isn't my life's work that I'd rather paint than do anything else. I think if I had a great deal of talent, you know, that'd been paramount in my life.[84]

Admitting that she was not "a great artist," however, did not mean that she was unaware of her artistic contribution. I think she knew that the popularity of her works and their value as a topic of scholarly study rests on their qualities as paintings of rural themes reflecting a particular region. Both she and her audience were attracted to scenes of ordinary life in the Blue Ridge piedmont of central Virginia. In my view, Stovall painted because the documentation of her surroundings seemed worthwhile and because she thoroughly enjoyed the creative release it provided. Though painting was not her "life's work," she was a serious painter and concentrated on her methods and techniques; she took great pains to capture the likenesses of those she portrayed and to suggest the spirit and flavor of the cultural and physical landscape. While Stovall began painting as an amateur, I think the success of her art in the marketplace lends to her stature as a professional artist. She recognized the potential for profit from her work and quickly capitalized on an honest task that promised relief from financial hardship. On the other hand, Stovall was not interested in producing a large number of canvases in order to meet the popular demand of buyers.[85]

It should be appreciated that Stovall did not like to be pigeonholed as an artist. In fact, she openly discouraged references to herself as a "primitive" or "another Grandma Moses." According to her family, Stovall considered Grandma Moses to be a victim of commercialization. Stovall was repelled by the kind and number of—in her words—"cutesy" items modeled after Grandma Moses' pictures and sold to the public. Stovall didn't hesitate to respond to a newspaper article announcing the purchase of "Baptizing—Pedlar River" by the Virginia Museum. The Museum's Public Information Aide sent a letter of apology: "I regret . . . that our local press notice did not please you . . . I apologize. . . . Now that we know you don't like the inevitable 'Grandma Moses' tag, . . . we shall try to avoid it at the Museum and in print."[86]

Given Stovall's uncanny intuitive sense, perhaps she realized the possibility of erroneous perceptions about her and her pictures promoted by the public's notion of "folk art." While standing near "Swing Low" and "Baptizing—Pedlar River," on view at the IBM Gallery in 1983, I heard an authoritative-sounding voice say, "And these paintings are by Queena Stovall, a black folk artist from Virginia." Had her paintings been displayed in an exhibition entitled, say, "Religious Themes in Twentieth-Century American Painting" would the same unfounded assumption have been made?

By referring to Stovall as a self-taught, though not uninfluenced, painter of everyday, rural scenes, an initial impression is adequately expressed. Additional qualification through life history and the study of her artistic process places her work in a spectrum, representing a numerous and complex set of variables including the development of her skill—especially her techniques and style—through time, varying motives and sources of inspiration, the extent of either formal training or folk influences, and public and self-perceptions. All artists (once the thorny issue of whether or not their work should be called art is decided) deserve to be studied as rigorously and completely as possible, taking into consideration a wide range of available information.

The last time I visited Queena Stovall—about two weeks before she died in June, 1980—she called me to her side for admonishment. "I don't see how you can write about me," she said, looking me straight in the eye. "You don't know enough." It was as if she wanted me to delve deeper—to get beyond the classifications of her art and underneath the layer of information available about her from nearly thirty years of newspaper articles, magazine pictorials, and various exhibition catalogs. Regretfully, Queena did not live to see the project completed, but her admonition lingered in my mind, guiding the research and final product. She would have been satisfied, I think, that a study of her life and art underscores the importance of individuals whose role as conservators of traditional American culture has been underestimated or overlooked, and about whom "we don't know enough."

Appendix A

Biographical Chronology and Selected Exhibitions

1887 December 21: Emma Serena Dillard, called "Queena," is born in the country four miles south of Lynchburg, Virginia, one of twelve children of Ella Nathan Woodroof and James Spotswood Dillard.

c. 1896 James Dillard dies; Dillard family moves to home on Federal Street in Lynchburg.

c. 1905 Leaves high school during senior year to begin work as a clerk and secretary in Lynchburg offices.

1908 September 24: marries Jonathan Breckenridge ("Brack") Stovall; Stovall family lives at Ella Dillard's house on Denver Street in Lynchburg.

1913-1923 Rents a farmhouse in Amherst County, near Elon, during springs and summers; seven children born, three sons and four daughters; Stovalls try to establish a poultry farm while Brack maintains job as traveling salesman.

1923-1944 Moves back to Denver Street house in Lynchburg, except for intermittent summers in Amherst County; a son dies, two more sons are born; Queena becomes active member of The Antiquarians, an antique club in Lynchburg.

1945 Moves to Wigwam, near Elon, Virginia, to care for elderly mother; remains permanently at Wigwam after mother's death.

1949 At urging of older brother, David Hugh Dillard, enrolls in art course at Randolph-Macon Woman's College taught by Pierre Daura; Stovall's first painting, "Hog Killing," is part of student exhibition at R-MWC; Daura recommends that she take no more lessons, but continue to paint on her own.

1950 New Jersey artist, Grant Reynard, views Stovall's first paintings; Reynard begins seeking a New York gallery to exhibit her work.

1951-1955 Sells "Come, Butter, Come" to Oglebay Institute in Wheeling, West Virginia; Antoinette Kraushaar, owner of Kraushaar Gallery in New York City, accepts twenty paintings on consignment over five-year period, four of which sell.

1952 Exhibition of Stovall's paintings sponsored by Lynchburg Art Center.

1953 December 25: Brack Stovall, Sr., dies.

1956 First one-woman show, at Lynchburg Art Center; meets dignitaries in art world, such as Leslie Cheek, then Director of the Virginia Museum of Fine Arts in Richmond.

1957 "Swing Low, Sweet Chariot" becomes part of traveling exhibition sponsored by the Springfield Museum of Fine Arts, in Massachusetts.

1958 "Baptizing in Pedlar River" (now known as "Baptizing—Pedlar River") chosen for exhibition by Mead Atlanta Paper Company, Atlanta, Georgia.

1959 "Baptizing—Pedlar River" purchased by the Virginia Museum (Richmond) during the 17th Annual Virginia Artists Exhibition.

1963 "End of the Line" awarded certificate of distinction by the Virginia Museum during the 21st Annual Virginia Artists exhibition; Stovall travels with her brother David Hugh Dillard and his family in Europe for three months; Queena's health begins to show signs of deterioration.

1964 Grant Reynard's collection, including Stovall's "Full Litter," is exhibited at Montclair Art Museum, Leonia, New Jersey.

1965 Exhibition of thirty-one Stovalls at Randolph-Macon Woman's College; "Swing Low, Sweet Chariot" purchased by R-MWC.

1966 Commissioned as a "Kentucky Colonel."

1968 Completes "Compn'y Comin'," last painting produced by Queena Stovall's hand alone.

1972 Introduced to and interviewed by Louis C. and Agnes Halsey Jones of the New York State Historical Association and Cooperstown Graduate Program in Upstate New York.

1974-1975 Forty-one paintings exhibited at the Dillard Fine Arts Museum (at Lynchburg College); the Abby Aldrich Rockefeller Folk Art Collection, Williamsburg, Virginia; and the Fenimore House Museum, Cooperstown, New York; increasing problems with eyesight and heart.

1977 Seventeen Stovall paintings exhibited in the Dillard Gallery of the Lynchburg Fine Arts Center.

1978 "Swing Low, Sweet Chariot" exhibited at Museum of American Folk Art, New York City; folklorist/filmmaker, Jack O'Field, makes film about Stovall for public television (televised December 1981).

1980 June 27: Queena Stovall dies in her bedroom at the Wigwam; Stovall auction of
 Wigwam furnishings held in October.

1981 Exhibition of twenty-two Stovalls at Greenville County Museum, Greenville, South
 Carolina.

1983-1984 "Swing Low, Sweet Chariot" and "Baptizing—Pedlar River" exhibited in the IBM
 Gallery of Science and Art, New York City; "Swing Low" exhibited at Virginia
 Museum as part of Virginia Women's History Project.

Appendix B

Repeated Elements in Stovall's Paintings

Furnishings and Other Household Goods

Table

"Basket Maker"
"Lawdy, Lawdy, What'll I Do?"
"End of the Line" (painted green)

Framed Stitched Picture

"Come, Butter, Come"
"Basket Maker"
"Saturday Night Bath"
"End of the Line"

Dresser, Mirror, Pin Cushion

"Basket Maker" (mirror cracked)
"Lawdy, Lawdy, What'll I Do?" (only cracked mirror)
"Family Prayers"

Calendar

"Basket Maker"
"Family Prayers"

Almanac

"Come, Butter, Come"
"Basket Maker"

Kerosene Table Lamp

"Come, Butter, Come"
"Saturday Night Bath"
"Family Prayers"

Kerosene Wall Lamp

"Aunt Alice, No. 1" and "Aunt Alice, No. 2"
"Saturday Night Bath"

Bucket and Ladle

> "Aunt Alice, No. 1" and "Aunt Alice, No. 2"
> "Saturday Night Bath"

Alarm Clock (curiously, hands are always between 7:00 and 8:00)

> "Come, Butter, Come"
> "Favorite Breakfast"
> "Saturday Night Bath"
> "Family Prayers"

Blue Enameled Pan

> "Come, Butter, Come"
> "Aunt Alice, No. 1" and "Aunt Alice, No. 2"

People and Animals

Old Woman

> "Peaches Are In" (two figures, both sitting in chairs)
> "Making Apple Butter" (sitting, with scarf)
> "Old Woman Driving Cow" (standing)
> "Cabin on Triple Oaks Farm" (standing)
> "March Fury" (standing, reversed)

Playful Child

> "Dressing Turkeys"(boy and girl)
> "Monday Morning" (boy, reversed)
> "The Baptizing" (girl pulling mother)
> "Baptizing—Pedlar River" (same as above)

Boy and Man in Camel-Colored Coats

> "The Baptizing"
> "Swing Low, Sweet Chariot"
> "Baptizing—Pedlar River" (order of figures reversed)

Cow (head turned, with rump facing viewer)

> "June Pasture"
> "Old Woman Driving Cow"
> "February, No. 1"
> "Herefords in the Snow"

Dog (white with spots)

> "Hog Killing"
> "Dressing Turkeys on the Farm"
> "Cutting Corn"
> "Fireside in Virginia"
> "Licking the Dasher"
> "Cutting Tobacco"

Appendix C

Stovall's Works Sorted by Ethnic Group

Key:

B	=	blacks
BW	=	blacks and whites
W	=	whites
X	=	no humans
U	=	unfinished painting
S	=	sketch

Completed Paintings	Size (rounded off)	Year	Month
B—Monday Morning(1)	19x25	1950	4
B—Sally Mae's Favorite Breakfast(2)	16x12	1950	9
B—Uncle William, No. 1(3)	18x14	1951	1
B—Basket Maker(4)	20x16	1951	1
B—Toting Water(5)	18x24	1951	2
B—The Baptizing(6)	23x32	1951	3
B—Aunt Alice, No. 1(7)	18x14	1951	4
B—Aunt Alice, No. 2(8)	18x14	1951	5
B—Uncle William, No. 2(9)	18x14	1951	5
B—Lawdy, Lawdy, What'll I Do?(10)	24x20	1952	11
B—Making Sorghum Molasses(11)	22x30	1952	11
B—Swing Low, Sweet Chariot(12)	28x40	1953	10
B—Saturday Evening(13)	20x16	1954	3
B—Sunday Morning(14)	20x16	1954	10
B—Baptizing—Pedlar River(15)	26x34	1957	10
B—Comp'ny Comin'(16)	24x20	1967	2
B—Joe Peeler(17)	12x16	1975	8
BW—Hog Killing(1)*	18x24	1949	12
BW—Cutting Out the Meat(2)*	18x24	1950	1
BW—Dressing Turkeys on the Farm(3)	20x26	1950	?2
BW—Come, Butter, Come(4)*	20x16	1950	6
BW—Peaches Are In(5)	20x26	1950	10
BW—Cutting Tobacco(6)	22x30	1951	10

BW—Smoking Dark-Fired Tobacco(7)	22x30	1951	10
BW—Uncle Nathan and the Little Black Mare(8)*	22x30	1953	2
BW—Getting in the Winter's Wood(9)	22x30	1955	12
BW—Making Apple Cider(10)	16x20	1958	2
BW—End of the Line(11)	32x44	1960	12
W—Brack and the Pickwick Papers(1)	20x16	1950	1
W—Cutting Corn at the Foot of Tobacco Row Mt.(2)	20x30	1950	10
W—Feeding Time(3)	19x24	1950	11
W—Fireside in Virginia(4)	18x24	1950	12
W—Making Apple Butter(5)	22x30	1951	1
W—Old Woman Driving Cow(6)	18x24	1951	2
W—Milking Time(7)	16x20	1951	3
W—Blackberry Picking(8)	17x23	1950	7
W—Saturday Night Bath(9)	17x23	1951	4
W—Licking the Dasher(10)	16x20	1951	6
W—Family Prayers (11)	18x24	1951	11
W—Cabin on Triple Oaks Farm(12)	20x30	1955	3
W—March Fury(13)	20x26	1955	9
W—Full Litter(14)	20x16	1956	11
W—Queena Cutting Brack's Hair(15)	20x16	1958	2

No Humans

X—June Pasture(1)	18x24	1950	8
X—Empty Pen(2)	15x11	1950	2
X—February, No. 1(3)	18x24	1955	2
X—Hillside Pasture(4)	18x26	1958	11
X—Herefords in the Snow(5)	19x24	1963	2

Unfinished Paintings or Sketches

U/B— Will It Ever Rain (1)	18x24	1963	8
S—Three Old Maids (sketch on paper)(2)**		1953	?9
S—Country Doctor (sketch on canvas)(3)**		1975	?

**Percentages of Blacks and Whites in 49 Paintings,
Including 48 Completed and 1 Uncompleted Work**

36% All black subjects
32% All white subjects
22% Both blacks and whites
10% No human subjects

Total Number and Percentages of Black and White Subjects

159 Black subjects (56%)
125 White subjects (44%)
284 Total subjects in 49 paintings

*Note that while these paintings may have both black and white people as subjects, blacks play a central or predominate role.
**Because I cannot be certain of the total number of figures in the sketches, nor of their racial identities, I have not included the sketches in the percentages of black and white figures.

Notes

Preface

1. Robert T. Teske, "What is Folk Art," *El Palacio* 88 (1982-83), pp. 34-38.

2. Lawrence W. Levine, *Black Culture and Black Consciousness* (New York: Oxford University Press, 1977), p. xiii.

Chapter 1

1. Taped interview with Queena Stovall, Elon, Virginia, July 1978.

2. Taped interview with Queena Stovall, Elon, Virginia, 14 November 1972.

3. Taped interview with Queena Stovall, Elon, Virginia, July 1978.

4. Taped interview with Lucille Watson, Lynchburg, Virginia, 20 November 1982. Mrs. Watson explained that "there were several of the Dillard families in those days and we always designated her [Queena's] mother as 'Mrs. Dozen Dillard'."

5. Edward King, *The Great South* (Hartford, Conn.: American Publishing Co., 1875; reprint ed., Baton Rouge: Louisiana State University Press, 1972), p. 554.

6. Ibid., pp. 580, 554. Indeed, Queena would have had ample opportunity to observe blacks during these times, since the black population was considerable, making up forty percent of Virginia's population by the 1870s. See J. Morgan Kousser, *The Shaping of Southern Politics* (New Haven: Yale University Press, 1974), p. 171.

7. See Shirley Abbott, "Southern Women and the Indispensable Myth," *American Heritage,* December 1982, pp. 83-91, and *Womenfolks* (New York: Ticknor and Fields, 1983); Catherine Clinton, *The Plantation Mistress: Woman's World in the Old South* (New York: Pantheon Books, 1982), p. 91; the novels of Ellen Glasgow, particularly *Barren Ground* (Garden City, N.Y.: Doubleday, Page and Co., 1925; reprint ed., New York: Hill and Wang, 1980) and *Virginia* (Garden City, N.Y.: Doubleday, Page and Co., 1913); and Frederick Law Olmsted, *The Cotton Kingdom* (New York: Mason Brothers, 1861; reprint ed., New York: Alfred A. Knopf, 1953).

8. Taped interview with Lucille Watson, Lynchburg, Virginia, 20 November 1982.

9. King, *The Great South,* pp. 555, 557.

10. Taped interview with Lucille Watson, Lynchburg, Virginia, 20 November 1982.

11. Martha Woodroof Hiden, *Woodroof Family,* n.d., Jones Memorial Library, Lynchburg, Virginia, pp. 1-11. (Typewritten.)

12. This plantation may be "Brookfield" where Queena was born.

13. John Bennett Boddie, *Historical Southern Families,* vol. 23 (Redwood City, Calif.: Pacific Coast Publishers, 1960), 5:8-11.

14. Taped interview with Queena Stovall, Elon, Virginia, 24 May 1980. Genealogical records indicate that several women in the Woodroof family attended college.

15. The phrase "southern lady" was used by Anne Firor Scott in her treatise comparing cultural definitions (ideal) of southern women's behavior with their actual behavior (real). See *Southern Lady* (Chicago: The University of Chicago Press, 1970). Interview with Queena Stovall, Elon, Virginia, 25 May 1980.

16. Thomas Nelson Page, *Social Life in Old Virginia* (New York: Charles Scribner's Sons, 1897), pp. 38-42.

17. Taped interview with Queena Stovall, Elon, Virginia, July 1978.

18. Taped interview with Queena Stovall, Elon, Virginia, 25 May 1980.

19. Taped interview with Judy Fairfax, Lynchburg, Virginia, 20 June 1981.

20. Evidently, family money and property had not been legally willed at the time of James Dillard's swift, unexpected death from a heart attack.

21. Taped interview with Queena Stovall, Elon, Virginia, July 1978.

22. Taped interview with Queena Stovall, Elon, Virginia, 25 May 1980.

23. Taped interview with Queena Stovall, Elon, Virginia, 24 May 1980.

24. Scott, *Southern Lady,* p. 35.

25. Taped interview with Queena Stovall, Elon, Virginia, 25 May 1980.

26. Ibid.

27. *Lynchburg* (Va.) *News,* 29 September 1974; and taped interview with Queena Stovall, Elon, Virginia, 24 May 1980.

28. Taped interview with Queena Stovall, Elon, Virginia, 24 May 1980.

29. Kurt C. Dewhurst, Marsha McDowell, and Betty McDowell, *Artists in Aprons: Folk Art by American Women* (New York: E.P. Dutton in association with the Museum of American Folk Art, 1979), pp. 78, 123-125.

30. Taped interview with Robert K. Stovall, Lynchburg, Virginia, 9 March 1983.

31. Interview with Queena Stovall, Elon, Virginia, 24 May 1980.

32. While reading Queena's letters and other personal papers, I was continually struck by the high caliber of her grammar, spelling, and vocabulary, indicating a conscientious attitude toward school.

33. Taped interview with Queena Stovall, Elon, Virginia, 25 May 1980.

34. According to Anne Firor Scott, an "area of constant concern was education." Southern women "felt deeply deprived because their opportunities for learning were so limited." (See *Southern Lady,* p. 46).

35. Taped interview with Queena Stovall, Elon, Virginia, 25 May 1980.

36. Taped interview with Queena Stovall, Elon, Virginia, July 1978.

37. Stovall Family Papers (SFP), Lynchburg, Virginia.

38. Interview of Queena Stovall, Elon, Virginia, 24 May 1980.

39. See Scott, *Southern Lady,* p. 42, and Clinton, *Plantation Mistress,* p. 85, for a discussion of parental attitudes toward unmarried adult daughters. Since unmarried daughters usually remained at home, their continued support often became an economic burden.

40. SFP, Lynchburg, Virginia.

41. Taped interview with Queena Stovall, Elon, Virginia, 25 May 1980. Brack appears in nine, possibly ten, of Queena's paintings. His love for reading is the subject of her painting "Brack and the Pickwick Papers."

42. Louise Daura to Queena Stovall, 4 January 1954. SFP, Lynchburg, Virginia. All correspondence cited hereafter is contained in the Stovall Family Papers unless indicated otherwise.

43. See Scott, *Southern Lady,* Chapter 1 and p. 46 for a discussion of the definition of the social ideal in southern society based on patriarchal attitudes and marriage.

44. Brack Stovall to Queena Stovall, 26 September 1911.

45. Brack Stovall to Queena Stovall, 28 March 1915 and 10 April 1915.

46. Taped interview with Queena Stovall, Elon, Virginia, July 1978.

47. Taped interview with Queena Stovall, Elon, Virginia, 25 May 1980.

48. Scott, *Southern Lady,* p. 27.

49. United Loan and Trust Company to J.B. Stovall, 10 September 1913.

50. Taped interview with Queena Stovall, Elon, Virginia, July 1978.

51. Brack Stovall to Queena Stovall, 10 September 1913.

52. Brack Stovall to Queena Stovall, 23 May 1915.

53. Brack Stovall to Queena Stovall, 24 April 1915.

54. According to Sanborn maps from 1902 and 1907, and a 1910 map of the city of Lynchburg, by G. William Baist, black schools and churches begin to appear in the Federal Hill neighborhood during this period. Besides the advantages of proximity to her son, the changing ethnic composition of Federal Hill may have been a factor in Ella's decision to move to Denver Street.

55. Taped interview with Queena Stovall, Elon, Virginia, 24 May 1980.

56. Brack Stovall to Queena Stovall, 5 October 1913.

57. Brack Stovall to Queena Stovall, 16 August 1914.

58. Brack Stovall to Queena Stovall, 7 April 1915.

59. Brack Stovall to Queena Stovall, 5 October 1913.

60. Brack Stovall to Queena Stovall, 30 May 1915.

61. Taped interview with Hobart Lewis, Elon, Virginia, 26 July 1981.

62. Brack Stovall to Queena Stovall, 23 May 1915.

63. Brack Stovall to Queena Stovall, 24 April 1915.

64. Brack Stovall to Queena Stovall, 18 April 1915.

65. Ibid.

66. Brack Stovall to Queena Stovall, 3 April 1915.

67. Brack Stovall to Queena Stovall, 4 April 1915. Eventually, Brack's attitude mellowed when it became practical for Queena and the Dillards to pool resources for the care of Ella and other elderly family members.

68. Taped interview with Judy Fairfax, Elon, Virginia, 15 June 1980.

69. Interview with Judy Fairfax, Elon, Virginia, 26 July 1980.

70. George Bowles, *Pages from the Virginia Story* (Charlottesville, Va.: Maiden Lane Press, 1979), p. 15.

71. Interview with Narcissa Kelley, Marin County, California, 5 January 1982.

72. Interview with Mary White Lewis and Annie Laurie Bunts, Elon, Virginia, 15 June 1980.

73. Queena Stovall to Annie Laurie Stovall, 9 November 1933.

74. Queena Stovall to Annie Laurie Stovall, 26 December 1934.

75. Queena Stovall to Annie Laurie Stovall, 17 August 1935. This letter was written during a summer that Queena spent at her mother's farm near Pedlar Mills, in Amherst County.

76. *Rivermont Presbyterian News,* Vol. 10, No. 7, 1974, SFP, Lynchburg, Virginia.

77. Taped interview with Queena Stovall, Elon, Virginia, July 1978.

78. Taped interview with Kathleen Massie, Madison Heights, Virginia, 5 February 1983.

79. Interview with Narcissa Kelley, Marin County, California, 5 January 1982. Other inoffensive preoccupations surfaced over the years revealing Queena's interest in using her imagination. In 1979, I witnessed Queena laying her hands on the pregnant abdomen of a granddaughter, with the intention of intuiting the sex of the unborn child.

80. Queena wrote to her daughter in 1931, "The breakfast room has been papered and things look real nice. Also got a new gas range with a thermometer." (Queena Stovall to Annie Laurie Stovall, 19 September 1931.)

81. Queena Stovall to Annie Laurie Stovall, 26 December 1934. That the room's contents were cherished is illustrated by Queena's concern that "there will be anything left in there from the crowd of children that are in & out."

82. Taped interview with Lucille Watson, Lynchburg, Virginia, 20 November 1982.

83. Interview with Robert K. Stovall, Lynchburg, Virginia, 16 June 1980.

84. Queena Stovall to Annie Laurie Stovall, 17 January 1935.

85. Queena Stovall to Annie Laurie Stovall, 23 July 1935.

86. Ibid.

87. Queena Stovall to Annie Laurie Stovall, 17 August 1935. Queena, acutely aware of the give-and-take system between employers and their servants, was not willing to sacrifice available help with her heavy burden of chores because of one aggravating instance. It was not worth the additional work it would cause for Queena. A legacy for these trade-offs had existed among plantation mistresses who—responsible for the welfare and "good" behavior of their husbands' slaves—constantly weighed the advantages with the disadvantages of the workers' help. Plantation mistresses, ironically, became "slaves of slaves"; Queena's lot was better, but she still experienced a mixture of advantages and disadvantages. See Clinton, *Plantation Mistress,* pp. 17-19.

88. Queena Stovall to Annie Laurie Stovall, 6 September 1935.

89. The name "Wigwam" comes from the layout of the original structure, a square building with four rooms divided by a hallway. According to the local populace, the Wigwam was the first single-floor dwelling in Amherst County.

90. Taped interview with Queena Stovall, Elon, Virginia, July 1978.

91. Taped interview with Queena Stovall, Elon, Virginia, July 1978.

92. Louis C. Jones and Agnes Halsey Jones, *Queena Stovall: Artist of the Blue Ridge Piedmont* (Cooperstown, N.Y.: New York State Historical Association, 1974), p. 8. The spelling of "Davey" varies in this quotation because I have remained loyal to the NYSHA catalogue text; the Stovall family, however, prefers "-ey" to "ie."

93. Interview with Queena Stovall, Elon, Virginia, 21 January 1979. See appendix A for a list of major exhibitions that have included works by Queena Stovall.

94. Taped interview with Robert K. Stovall, Elon, Virginia, 9 March 1983.

95. Twelve of Stovall's canvases lack a month designation. It is possible that they were painted in July or August, but the Stovall family remembers the majority of these canvases were done in the winter and spring of the year.

96. Personal communication with Robert K. Stovall, 23 June 1983.

97. Grant Reynard to Queena Stovall, 16 December 1950.

98. Taped interviews with Robert K. Stovall, Elon and Lynchburg, Virginia, 25 May 1980 and 9 March 1983.

99. Grant Reynard to Queena Stovall, 16 December 1950.

100. Grant Reynard to Queena Stovall, 11 June 1951. As a professional artist, Reynard's view of marketing art was, of course, related to the income produced by it. Though his intentions were entirely honorable his perspective on publicizing Stovall's paintings was biased toward a mass audience. For instance, he wrote to Stovall, "I have a notion that your work would make a wonderful feature for LIFE magazine." (Grant Reynard to Queena Stovall, 29 May 1951.) Reynard's "notion" never materialized, but it is tempting to ponder the effect such visibility would have had on Stovall's career.

101. Grant Reynard to Queena Stovall, 11 June 1951.

102. Ibid.

103. She also turned to her good friends, Pierre Daura and his wife Louise, for counsel regarding the New York City gallery. Louise responded with reassuring words: "we feel you couldn't have a better gallery. Also we feel Miss Kraushaar is right in her promotion ideas." (Louise Daura to Queena Stovall, 27 September 1951.)

104. Antoinette Kraushaar to Queena Stovall, 23 July 1951 and 29 April 1953.

105. Grant Reynard to Queena Stovall, 11 June 1951.

106. Both Reynard and Kraushaar appear to have shared a disenchantment for the so-called "folk art" made popular by Sidney Janis, Otto Kallir (discoverer of Grandma Moses), and other promoters of "primitive," "naive," and "self-taught" painters in the 1940s. See Sidney Janis, *They Taught Themselves* (New York: Dial Press, 1942), and Otto Kallir, ed., *My Life's History* (New York: Harper and Row, 1952).

107. Antoinette Kraushaar to Queena Stovall, 3 November 1954; and interview with Robert Stovall, Lynchburg, Virginia, 19 November 1982.

108. The Kraushaar sales added up to nearly $800 after commission fees. (Antoinette Kraushaar to Queena Stovall, 19 July 1951 and 3 November 1954.) This was a stupefying amount compared to a $13 Social Security check.

109. *Lynchburg* (Va.) *News,* 9 November 1952.

110. *Lynchburg* (Va.) *News,* 30 September 1951.

111. *Presenting the Works of Queena Stovall* (Lynchburg, Va.: The Lynchburg Art Center, 1956).

112. Taped interview with Queena Stovall, Elon, Virginia, 14 November 1972.

113. *Lynchburg* (Va.) *News,* 15 April 1956.

114. Checklist for the 1957 Virginia Artists Exhibition, (Richmond, Va.: Virginia Museum of Fine Arts), SFP, Lynchburg, Virginia.

115. Muriel B. Christison to Queena Stovall, 25 April 1957.

116. Louise Daura to Queena Stovall, 27 April 1957. Over the years Stovall and her work would draw the interest of highly placed organizations in Lynchburg. For example, in the early 1970s the local chapter of the Junior League coordinated an exhibition of her paintings as part of a reception at the Miller-Claytor House, an historic house of local repute. See *Lynchburg* (Va.) *News,* 4 March 1972.

117. *Lynchburg* (Va.) *News,* 7 May 1958.

118. Checklist for the 1959 Virginia Artists Exhibition (Richmond, Va.: Virginia Museum of Fine Arts), SFP, Lynchburg, Virginia.

119. Queena sold "Baptizing—Pedlar River" for $450, the same price charged by Kraushaar for the first baptism scene painted in 1951.

120. *Lynchburg* (Va.) *News,* 11 April 1959. As part of The Virginia Museum collection, "Baptizing—Pedlar River" has been exhibited in several shows at that museum (for instance, in 1961 in their "Treasures in America" exhibition) and others. See *Richmond* (Va.) *Times-Dispatch,* 19 February 1961.

121. *Lynchburg* (Va.) *News,* 11 April 1959.

122. *Richmond* (Va.) *Times-Dispatch,* 24 February 1963.

123. *Lynchburg* (Va.) *Daily Advance,* 11 February 1965.

124. *Lynchburg* (Va.) *Daily Advance,* 27 July 1966. Stovall allowed that she was one of the few women in the Colonels seemingly aware of her role as a southern woman reaching beyond cultural myths.

125. As a young boy, he filled his father's shoes during the long absences, helping Queena in ways she never forgot.

126. The Joneses' work is particularly important because it produced one of the earliest known tape recorded interviews with Stovall about her life and work.

127. Openings for the 1974-75 exhibition were attended in customary Stovall fashion—by a large group of family and friends. An entire section of the Williamsburg Inn was reserved for the Stovall entourage attending the Abby Aldrich Rockefeller Folk Art Collection opening. Despite the distance, many of the same group went to the opening in Cooperstown a few months later. Members of the NYSHA staff recall Stovall's visit to the exhibition opening with fondness. Besides the entourage, Queena brought along an impressive collection of homemade baked goods, carried from her Wigwam kitchen, especially for the reception. (Personal communication with NYSHA staff, 1 May 1983)

128. The Dillard Museum is named after Queena's brother David Hugh Dillard who donated money for the building.

129. Taped interview with Queena Stovall, Elon, Virginia, July 1978.

130. Mary White Lewis to Claudine Weatherford, 18 July 1980.

131. Telephone interview with Robert K. Stovall, 14 December 1983.

Chapter 2

1. Jones and Jones, *Queena Stovall*, p. 5.

2. Taped interview with Queena Stovall, Elon, Virginia, 28 May 1974. All information from this interview is from a transcription in the New York State Historical Association Folk Art Archives (NYSHAFA).

3. *Norfolk Virginian-Pilot*, 19 January 1975.

4. Ibid.

5. *Cooperstown* (N.Y.) *Freeman's Journal*, 30 April 1975.

6. *Norfolk Virginian-Pilot*, 19 January 1975.

7. Taped interview with Queena Stovall, Elon, Virginia, 28 May 1974.

8. *Norfolk Virginian-Pilot*, 19 January 1975.

9. Jones and Jones, *Queena Stovall*, p. 9.

10. Letter to Mary F. Williams from Queena Stovall, 28 December 1966, Randolph-Macon Woman's College Art Department Archives (R-MWCAD), Lynchburg, Virginia.

11. Taped interview with Queena Stovall, Elon, Virginia, 28 May 1974, New York State Historical Association Folk Art Archives (NYSHAFA), Cooperstown, New York.

12. *Amherst New-Era Progress,* 22 December 1977.

13. In addition to "Brack and the Pickwick Papers" discussed above, Brack appears in "Hog Killing," "Cutting Out the Meat," "Dressing Turkeys on the Farm," "Feeding Time," "Fireside in Virginia," "Milking Time," "Full Litter" and "Queena Cutting Brack's Hair." Given the similarity of the walking figure in "Making Apple Cider," Stovall may have had her husband in mind for this painting too.

14. Taped interview with James Davis, Agricola, Virginia, 2 April 1983. Unless stated otherwise, all further narrative by Davis in this chapter is from the same interview.

15. Taped interview with Queena Stovall, Elon, Virginia, 21 January 1979.

16. Interview with Queena Stovall, Elon, Virginia, 21 January 1979.

17. McDaniel also appears in "Cutting Out the Meat," "Dressing Turkeys," "Peaches Are In," "Swing Low, Sweet Chariot," and "Making Apple Cider."

18. Jones and Jones, *Queena Stovall*, p. 21.

19. Taped interview with Sally Mae McDaniel, Lynchburg, Virginia, 30 March 1983. Unless stated otherwise, all further narrative by McDaniel in this chapter is from the same interview.

20. Taped interview with James Johnson, Lynchburg, Virginia, 22 June 1983. Unless otherwise stated, all further narrative by Johnson in this chapter is from the same interview.

21. Taped interview with Melvin Bailess, Lynchburg, Virginia, 23 June 1983. Unless otherwise stated, all further narrative by Bailess in this chapter is from the same interview.

22. Taped interview with Queena Stovall, Elon, Virginia, 28 May 1974.

23. Taped interview with Queena Stovall, Elon, Virginia, July 1978.

24. Taped interview with Queena Stovall, Elon, Virginia, July 1978.

25. Taped interview with Queena Stovall, Lynchburg, Virginia, 11 November 1972.

26. Taped interview with Queena Stovall, Elon, Virginia, July 1978.

27. Mark A. Davis, *Queena Stovall* (Lynchburg, Va.: Virginia Arts, 1980), p. 4 SFP, Lynchburg, Virginia.

28. Taped interview with Queena Stovall, Elon, Virginia, July 1978.

29. It would be intriguing, I think, to study the vocabularies of other self-taught artists during different stages of their artistic development to determine more precisely how their vocabularies evolve, and how that process affects their work.

30. I am indebted to two colleagues with fine art backgrounds, V. Spike Peterson and Aimee L. Ay, who brought this point to my attention.

31. Taped interview with Queena Stovall, Elon, Virginia, 28 May 1974.

32. See my article, " 'In My Mind's Eye': The Genre Painting of Queena Stovall," *Folklore and Folklife in Virginia* 3 (1984): 7-30.

33. Taped interview with Melvin Bailess, Lynchburg, Virginia, 23 June 1983.

34. Since Stovall applied paint in a thin manner, the scars from initial placement of these figures remains visible.

35. Eventually, Stovall asked her son Jim for help. He suggested additional details, such as, stubble in the corn field. In the end, Stovall decided that the painting was unsalvageable and gave it to Jim. He dabbled with the mountains before he too gave up. Because of the joint effort "Cutting Corn" is not considered a true Queena Stovall and, therefore, not included in exhibitions of her work.

36. Jones and Jones, *Queena Stovall*, p. 10.

37. Taped interview with Allen Dempsey, Washington, D.C., 14 April 1983. Unless otherwise stated, all further narrative by Dempsey in this chapter is from the same interview.

38. Mary E. Case to Claudine Weatherford, 18 December 1980.

39. Taped interview with Queena Stovall, Elon, Virginia, July 1978.

40. Mary S. Ellet, "A Kind of Magic: The Paintings of Queena Stovall" (Student Paper, Randolph-Macon Woman's College, Lynchburg, Va., 14 April 1971), p. 16.

41. Taped interview with Queena Stovall, Elon, Virginia, 28 May 1974.

42. Taped interview with Lucille Watson, Lynchburg, Virginia, 20 November 1982.

43. Abbott, *Womenfolks,* p. 96.

44. Brack Stovall to Queena Stovall, 14 April 1915.

45. Taped interview with Queena Stovall, Elon, Virginia, 21 January 1979.

46. Taped interview with Julia Hunt, Amherst, Virginia, 7 March 1983. Unless otherwise stated, all further narrative by Hunt in this chapter is from the same interview.

47. Taped interview with Florine Slaughter, Lynchburg, Virginia, 6 February 1983. Unless otherwise stated, all further narrative by Slaughter in this chapter is from the same interview.

48. Taped interview with Florine Slaughter, Lynchburg, Virginia, 6 March 1983.

49. See Henry Glassie, *Pattern in the Material Folk Culture of the Eastern United States* (Philadelphia: University of Pennsylvania Press, 1968), p. 117, for statements regarding "old Negro ladies still wear[ing] headkerchiefs which hide the brow." Glassie considers headkerchiefs a retention from African culture.

50. *Norfolk Virginian-Pilot,* 19 January 1975.

51. Taped interview with Queena Stovall, Elon, Virginia, 21 January 1979.

52. *Norfolk Virginian-Pilot,* 19 January 1975.

Chapter 3

1. Charles J. Milton to Queena Stovall, 8 January 1951. Besides encouragement, Queena's brother David Hugh Dillard lent his business prowess to the initial sales of the paintings. In the same letter Milton wrote, "I discussed with Mr. Dillard the purchase price for one of your paintings." Further, Queena was advised by Grant Reynard to "let him [Dillard] handle these boys about the money end of things." (Grant Reynard to Queena Stovall, 18 January 1951.)

2. Charles J. Milton to Queena Stovall, 14 February 1951.

3. Grant Reynard to Queena Stovall, 18 January 1951.

4. Taped interview with Margaret Stovall, Lynchburg, Virginia, 8 March 1983.

5. Taped interview with Annie Laurie Bunts, Elon, Virginia, 15 June 1980.

6. Besides the portrayals of Brack and Sally Mae McDaniel, Stovall had enlisted her daughters Narcissa and Judy and her grandson, "Chug" (James Adams), to pose for paintings.

7. Interview with Robert K. Stovall, Lynchburg, Virginia, 13 April 1983.

8. Jones and Jones, *Queena Stovall*, p. 19.

9. Ibid., p. 23.

10. The availability of popular publications is revealed in one of Stovall's early works, "Brack and the Pickwick Papers"—a *Saturday Evening Post* sits on Brack's footstool.

11. Frederick Douglass, *Life and Times of Frederick Douglass* (Hartford, Conn.: Park Publishing Co., 1881; reprint ed., New York: Collier Books, 1962), p. 42.

12. Glasgow, *Barren Ground*, p. 59.

13. R.H. Early, *Campbell Chronicles and Family Sketches* (Lynchburg, Va.: J.P. Bell Company, 1927), pp. 263-64.

14. Although "Swing Low" was completed in October 1953, Stovall said that it took her three years to paint it.

15. *Cooperstown* (N.Y.) *Freeman's Journal*, 30 April 1975.

16. Taped interview with Queena Stovall, Elon, Virginia, July 1978.

17. Taped interview with Queena Stovall, Elon, Virginia, 14 November 1972.

18. Taped interview with Queena Stovall, Elon, Virginia, July 1978.

19. Taped interview with Queena Stovall, Elon, Virginia, 3 November 1972.

20. Ibid.

21. For additional information on the techniques of naive painting, see Jane Kallir, *Grandma Moses: The Artist Behind the Myth* (New York: Clarkson N. Potter, 1982). I have never seen any penciled figures on Stovall's canvases indicating outlines filled in by paint. Since her paint was applied thinly—"I don't put on heavy paint"—at least some penciled lines are likely to be apparent if present. (Taped interview with Queena Stovall, Elon, Virginia, July 1978.)

22. Taped interview with Queena Stovall, Elon, Virginia, July 1978.

23. Jones and Jones, *Queena Stovall*, p. 5.

24. Taped interview with Queena Stovall, Elon, Virginia, July 1978.

25. Taped interview with Kathleen Massie, Madison Heights, Virginia, 5 February 1983.

26. Taped interview with Queena Stovall, Elon, Virginia, July 1978.

27. Stovall evidently painted second versions of certain pictures for a variety of reasons. "Baptizing—Pedlar River" was painted for a brother who admired the first version. The painting did not go to the brother, but rather to the collection of the Virginia Museum in Richmond. And regarding the impetus to duplicate "Aunt Alice," Bobby Stovall, Queena's son, stated it is not unlikely that the second version was painted on request: "If someone would ask Queena to do another, she would," he said. (Telephone interview with Robert K. Stovall, Lynchburg, Virginia, 13 April 1983.)

28. Taped interview with Sally Mae McDaniel, Lynchburg, Virginia, 30 March 1983.

29. Interview with Judy Fairfax, Lynchburg, Virginia, 30 March 1983.

30. Jones and Jones, *Queena Stovall*, p.14.

31. Brack Stovall to Queena Stovall, 4 April 1915.

32. Taped interview with Hannah Escoe, Amherst, Virginia, 2 February 1983. Unless otherwise stated, all further narrative by Escoe in this chapter is from the same interview.

33. Jones and Jones, *Queena Stovall,* p. 15.

34. Taped interviews with Allen Dempsey, Washington, D.C., 14 May 1983, and with Julia Hunt, Amherst, Virginia, 7 March 1983. Unless otherwise stated, all further narrative by Dempsey and Hunt in this chapter is from the same interviews.

35. Taped interview with Florine Slaughter, Lynchburg, Virginia, 6 March 1983.

36. Taped interview with Carlena Robertson, Pleasant View, Virginia, 9 March 1983.

37. Taped interview with Perkins Flippin, Lynchburg, Virginia, 12 March 1983.

38. Jones and Jones, *Queena Stovall,* p. 23.

39. The hint of irreverence in this painting and a few others presents an intriguing avenue for further investigation. A proper, genteel woman, Stovall may have used her paintings as an outlet for mildly indelicate expressions normally shared only with family members. For instance, in "Fireside in Virginia" Stovall pokes gentle fun at her husband for napping while "Mary Massey [who] always had real fine legs... [is] liftin' her dress to warm her legs." (Jones and Jones, *Queena Stovall,* p. 14). Perhaps painting provided an acceptable mode to express circumstances not usually referred to in public. Similarly, John Richardson refers to the increasing bawdiness in Picasso's work produced later in life in "The Catch in the Late Picasso," in *The New York Review of Books* (19 July 1984), pp. 21-28.

40. Judy Connell, "Queena Stovall: Eminent in American Folk Art," in *Lynchburg* (June 1979), p. 31.

Chapter 4

1. Louise Daura to Queena Stovall, 4 January 1954.

2. Taped interview with Queena Stovall, Elon, Virginia, 28 May 1974. During this same interview Stovall was asked if not knowing the people would hinder her ability to paint a picture of Cooperstown, New York. She answered with characteristic wit: "No, I don't think so, but they would all turn out to look like people from Lynchburg."

3. Queena Stovall to Mary F. Williams, 28 December 1966, R-MWCAD, Lynchburg, Virginia.

4. Rosalie Basten to Mary F. Williams, 8 February 1976, R-MWCAD, Lynchburg, Virginia. Apparently, Basten was asked by Williams to talk with Stovall about the inspiration for "Swing Low."

5. Queena Stovall to Mary F. Williams, 28 December 1966, R-MWCAD, Lynchburg, Virginia.

6. Rosalie Basten to Mary F. Williams, 8 February 1976, R-MWCAD, Lynchburg, Virginia.

7. Taped interview with Margaret Stovall, Lynchburg, Virginia, 8 March 1983. Unless otherwise stated, all further narrative by Margaret Stovall in this chapter is from the same interview.

8. Jones and Jones, *Queena Stovall,* p. 16.

9. See Charles Williams, "The Conversion Ritual in a Rural Black Baptist Church," in *Holding on to the Land and the Lord: Kinship, Ritual, Land Tenure, and Social Policy in the Rural South,* ed. Robert L. Hall and Carol B. Stack (Athens, Ga.: University of Georgia Press, 1982),

pp. 69-79, and also Bruce T. Grindal, "The Religious Interpretation of Experience in a Rural Black Community," in the same book, pp. 89-101. These two articles offer vivid descriptions, along with analysis and interpretation, of the conversion process in rural black churches.

10. Taped interview with Julia Hunt, Amherst, Virginia, 7 March 1983. Unless otherwise stated, all further narrative by Hunt in this chapter is from the same interview.

11. The custom of taking a dinner break may be part of a tradition which accommodated participants coming from long distances before concentrated populations existed in rural Virginia. A letter from a Virginia woman, dated 1880, stated, "All the negroes in the country appeared to be on their way to [the funeral]. . . . All were provided with ample picnic-baskets." (Emily M. Harris, *The New Virginians* [London: William Blackwood and Sons, 1880] 2: 235.)

12. Williams, "Conversion Ritual," p. 76.

13. Taped interview with Florine Slaughter, Lynchburg, Virginia, 6 March 1983. Unless otherwise stated, all further narrative by Slaughter in this chapter is from the same interview.

14. Williams provides an account of the serious attitude expected from children by their parents and grandparents. He wrote that the conversion process was "probably the most frightening experience of my childhood." ("Conversion Ritual," p. 71.)

15. Williams notes that "religion in many small black communities is . . . a strong means of social control." ("Conversion Ritual," p. 73.)

16. Ibid., p. 70.

17. Taped interview with Hannah Escoe, Amherst, Virginia, 2 February 1983. Unless otherwise stated, all further narrative by Escoe in this chapter is from the same interview.

18. Taped interview with James Johnson, Lynchburg, Virginia, 22 June 1983. Unless otherwise stated, all further narrative by Johnson in this chapter is from the same interview.

19. Taped interview with Beatrice Braxton, Washington, D.C., 14 May 1983. Unless otherwise stated, all further narrative by Braxton in this chapter is from the same interview.

20. Taped interview with Teeny Winston, Pleasant View, Virginia, 8 February 1983. Unless otherwise stated, all further narrative by Winston in this chapter is from the same interview.

21. Williams, "Conversion Ritual," p. 70.

22. Grinda, "Religious Interpretation," p. 100.

23. Historically, an open coffin at the grave site may have been more common. In slavery times, blacks often had no church of their own in which to hold services, and, therefore, the coffin had to be opened at the grave in order to honor the custom of viewing the remains. See Erskine Clarke, *Wrestlin' Jacob: A Portrait of Religion in the Old South* (Atlanta: John Knox Press, 1979), p. 33.

24. Taped interview with Ora Johnson, Lynchburg, Virginia, 22 June 1983. Unless otherwise stated, all further narrative by Johnson in this chapter is from the same interview.

25. Mary F. Williams, *Catalogue of the Collection of American Art at Randolph-Macon Woman's College* (Charlottesville, Va.: University Press of Virginia, 1977), p. 154. Because the heart is now considered "old fashion," knowledge of its origin and meaning has become

obscured for many of the blacks in Amherst County. Only two of the people I interviewed could elaborate on the meaning of the heart insignia beyond the fact that hearts identified male members of the family of the deceased. James Johnson said, "If your mother died you wore a heart"; Beatrice Braxton agreed that black hearts were worn "just like it were your mother."

26. Heart-shaped flower arrangements, or at least the underlying form, have been photographed in Alabama by William Christenberry. See William Christenberry, *Southern Photographs* (Millerton, N.Y.: Aperture, Inc., 1983).

27. Christopher Crocker, "The Southern Way of Death," in *The Not So Solid South,* ed. J. Kenneth Morland (Athens: University of Georgia Press, 1971), pp. 122-23.

28. Taped interview with Queena Stovall, Elon, Virginia, 31 May 1974. All information from this interview is from a transcription in NYSHAFA.

29. Taped interview with Lucille Watson, Lynchburg, Virginia, 20 November 1982. Unless otherwise stated, all further narrative by Watson in this chapter is from the same interview.

30. Crocker, "Southern Way of Death," pp. 123-24.

31. Queena Stovall to Mary F. Williams, 28 December 1966, R-MWCAD, Lynchburg, Virginia.

32. Taped interview with Ora Johnson, Lynchburg, Virginia, 22 June 1983.

33. Albert J. Raboteau, *Slave Religion* (New York: Oxford University Press, 1978), p. 231.

34. While surveying the literature by and about Glasgow, Welty, and O'Connor I was impressed by their similarity to Stovall: for instance, both Welty and O'Connor oil painted; for Welty, "the detail tells everything"; Glasgow "drew her Negro characters from people she had known," and the enduring (fictional) locale for her major work, *Barren Ground,* is Pedlar Mills, the location of Ella Dillard's family farm; and similar to the descriptions of so-called folk artists, O'Connor's reviews of books were called "straightforward, nonacademic . . . and professedly innocent of theory."

35. Taped interview with Queena Stovall, Elon, Virginia, July 1978.

36. Taped interview with Queena Stovall, Elon, Virginia, 28 May 1974.

37. Robert Coles, *Flannery O'Connor's South* (Baton Rouge: Louisiana State University Press, 1980), p. 63.

38. Coles, *Flannery,* p. 60.

39. Taped interview with Lucille Watson, Lynchburg, Virginia, 20 November 1982. Unless otherwise stated, all further narrative by Watson in this chapter is from the same interview.

40. Williams, *Catalogue of the Collection,* p. 154.

41. Queena Stovall to Mary F. Williams, 17 October 1966, R-MWCAD, Lynchburg, Virginia. Stovall dealt with sensitive situations with thoughtfulness and respect. Stovall's daughter recalled that those portrayed in "Swing Low" wanted to know " 'who is that in the coffin?' So mother said, 'well, that's nobody from around here. He was shipped in from Pittsburgh.' " Stovall explained, "If they'd thought it was somebody [they knew] it would have been bad." (Taped interview with Queena Stovall and Annie Laurie Bunts, Elon, Virginia, 21 January 1979.) Although she shared a misunderstanding of so-called black "superstitions" with other Southern whites, Stovall did not wish to foster apprehension, or to deride the customary interpretations made by her black friends.

42. Queena Stovall to Mary F. Williams, 28 December 1966, R-MWCAD, Lynchburg, Virginia.

43. Taped interview with Queena Stovall, Elon, Virginia, July 1978.

44. Rosalie Basten to Mary F. Williams, 8 February 1976, R-MWCAD, Lynchburg, Virginia.

45. E. Stanly Godbold, Jr., *Ellen Glasgow and the Woman Within* (Baton Rouge: Louisiana State University Press, 1972), p. 243.

46. Peggy Whitman Prenshaw, ed., *Conversations with Eudora Welty* (Jackson, Miss.: University Press of Mississippi, 1984), p. 134.

47. Prenshaw, *Conversations,* p. 137.

48. Godbold, *Ellen Glasgow,* p. 143.

49. Prenshaw, *Conversations,* p. 137.

50. Taped interview with Queena Stovall, Elon, Virginia, 31 May 1974.

51. Interview with Robert K. Stovall, Lynchburg, Virginia, 2 February 1984.

Chapter 5

1. Taped interview with Queena Stovall, Elon, Virginia, July 1978.

2. Ellett, "A Kind of Magic," p. 25.

3. Ibid.

4. "Joe Peeler," completed in 1975, is not considered a "pure Stovall" because portions of the painting were modified by Bobby Stovall at his mother's request.

5. Taped interview with Queena Stovall, Elon, Virginia, July 1978.

6. Taped interview with Margaret Stovall, Lynchburg, Virginia, 8 March 1983. Unless otherwise stated, all further narrative by Margaret Stovall in this chapter is from the same interview.

7. Jones and Jones, *Queena Stovall,* p. 32.

8. Ibid.

9. Louise Daura to Queena Stovall, 18 May 1959.

10. Taped interview with James Davis, Agricola, Virginia, 2 April 1983. Unless otherwise stated, all further narrative by Davis in this chapter is from the same interview.

11. Taped interview with Queena Stovall, Elon, Virginia, 31 May 1974.

12. Telephone interview with Mrs. Maitland Ivey, Lynchburg, Virginia, 20 June 1983. Unless otherwise stated, all further narrative by Ivey in this chapter is from the same interview.

13. Taped interview with Mary White Lewis, Elon, Virginia, 25 May 1980.

14. Taped interview with Queena Stovall, Elon, Virginia, July 1978.

15. Taped interview with Queena Stovall, Elon, Virginia, 25 May 1980.

16. Taped interview with Lucille Watson, Lynchburg, Virginia, 20 November 1982.

17. Taped interview with Narcissa Stuart, Elon, Virginia, 21 January 1979.

18. Taped interview with David H. Stovall, Elon, Virginia, 26 July 1980. Unless otherwise stated, all further narrative by David Stovall in this chapter is from the same interview.

19. Interview with Robert K. Stovall, Lynchburg, Virginia, 23 June 1983.

20. Guy Friddell, "A Compassionate Eye and a Talented Hand," *Commonwealth,* May 1980, p. 36.

21. Taped interview with Robert K. Stovall, Lynchburg, Virginia, 9 March 1983.

22. *Richmond* (Va.) *Times-Dispatch,* 7 May 1978. Stovall had been thinking about this scene for many years. The first time she mentioned the idea was just before starting "Swing Low." When her daughters balked at the idea of a funeral scene because of its sadness, Stovall lightheartedly threatened to do an "old maids" portrait of them instead. Not surprisingly, the daughters relented and gave their approval for "Swing Low."

23. Ibid.

24. Taped interview with Queena Stovall, Elon, Virginia, 28 May 1974.

25. Taped interview with Queena Stovall, Elon, Virginia, July 1978. In fact, Stovall's sight may well have improved by wearing glasses, but she resented wearing them all the time: "You might say it's purely a matter of vanity," she said. "I just hate to go peeping through those old glasses." (Taped interview with Queena Stovall, Elon, Virginia, 25 May 1980.)

26. Brown vs. Board of Education of Topeka, 347 U.S. 483 (1954).

27. Taped interview with Annie Laurie Bunts, Lynchburg, Virginia, 20 June 1981.

28. Dorothy Walters, *Flannery O'Connor* (Boston: Twayne Publishers, 1973), pp. 134-35.

29. Taped interview with Queena Stovall, Elon, Virginia, 14 November 1972.

30. Ibid.

31. Taped interview with Queena Stovall, Elon, Virginia, July 1978.

32. *Lynchburg* (Va.) *News,* 19 October 1980.

33. Ibid.

34. Taped interview with Judy Fairfax, Lynchburg, Virginia, 20 June 1981.

35. *Lynchburg* (Va.) *News,* 19 October 1980.

Chapter 6

1. Most of Stovall's paintings are located in Virginia, West Virginia, Tennessee, and Florida. Eight privately owned paintings, however, are located outside of the South: three on Long Island, two in Delaware, one in New Jersey, one in California, and another one in Washington, D.C. Of these eight works, three were bought by individuals who formerly lived in central Virginia and, therefore, found Stovall's pictures appealing for personal reasons.

2. *Lynchburg* (Va.) *News,* 7 May 1958.

3. Bess F. Devine to Queena Stovall, probably May 1958.

4. Louise Daura to Queena Stovall, 18 May 1959.

5. Taped interview with James Davis, Agricola, Virginia, 2 April 1983. Unless otherwise stated, all further narrative by Davis in this chapter is from the same interview.

6. John L. Stone to Queena Stovall, 21 December 1966.

7. Taped interview with Hobart Lewis, Elon, Virginia, 31 July 1981.

8. Taped interview with Hobart Lewis, 14 June 1980 and 26 July 1981.

9. Taped interview with Queena Stovall, Elon, Virginia, 24 May 1980.

10. Louise Daura to Queena Stovall, 15 February 1961.

11. Taped interview with James Johnson, Lynchburg, Virginia, 22 June 1983.

12. Taped interview with Melvin Bailess, Lynchburg, Virginia, 23 June 1983.

13. Williams, *Catalogue of the Collection,* p. 3.

14. Ibid.

15. Ibid., p. 17. Both Louise Jordan Smith and Georgia Morgan prepared the way for women in the Lynchburg area with artistic aspirations. Smith and Morgan, described in the Randolph-Macon catalogue as "strong-willed" and "strong-minded," seem to have been allowed a degree of freedom beyond the normal expectations of Southern women. Subsequently, several other female painters, educated at Randolph-Macon, achieved professional status and have works in the R-MWC Collection. I think the fact that these women had become celebrated as artists in the Lynchburg area helped Stovall's transformation from mother to artist in the eyes of the members of her community.

16. The reader might recall that the first leg of Queena Stovall's 1974-75 exhibition was held at the Dillard Fine Arts Building before traveling to Williamsburg and Cooperstown.

17. S. Allen Chambers, Jr., *Lynchburg, An Architectural History* (Charlottesville, Va.: University Press of Virginia, published for the Sarah Winston Henry Branch of the Association for the Preservation of Virginia Antiquities, 1981), p. 369.

18. Williams, *Catalogue of the Collection,* p. 129.

19. Reaffirming David Hugh Dillard's support of the arts, one of the galleries at the Center is named after him. Before acquiring paintings by Queena Stovall, Dillard collected paintings by academically trained artists which he displayed in the sumptuous rooms of his mansion.

20. Taped interview with Margaret Stovall, Lynchburg, Virginia, 8 March 1983.

21. Mary White had planned to buy "Saturday Night Bath" from the Kraushaar Gallery, but by the time she and her husband made their decision the painting had sold.

22. About her rendition Stovall said, "She's a nice person but ... she has big, heavy legs. I first got 'em real good—I made 'em like her. After she knew I had her that way in the painting I just had to soften them down a bit." (Taped interview with Queena Stovall, Elon, Virginia, 31 May 1974.)

23. Taped interview with Annie Laurie Bunts, Elon, Virginia, 21 January 1979.

24. Taped interview with Sally Mae McDaniel, Lynchburg, Virginia, 30 March 1983.

25. Taped interview with Teeny Winston, Pleasant View, Virginia, 9 March 1983.

26. Taped interview with Queena Stovall, Elon, Virginia, July 1978.

27. Mary F. Williams wrote to Queena Stovall, "I lent the color slide to Gene Campbell Studios so that Mr. Hutcherson's order for a color print could be filled." (5 April 1967.)

28. Taped interview with Hobart Lewis, Elon, Virginia, 21 August 1981.

29. This material was gathered in a confidential interview.

30. Telephone interview with Mary F. Williams, Lynchburg, Virginia, 4 February 1983. A precedent for white artists portraying black employees had been set by a Randolph-Macon graduate, Harriet Fitzgerald. Fitzgerald portrayed "Mrs. Maria Graves, faithful servant of Randolph-Macon from its opening," entitling the portrait "Aunt Maria." Additional insight into blacks' attitudes about being portrayed by whites comes from "one of Harriet's Negro friends who said, 'I rruther just sit for Miss Harriet than clean and wash clothes for someone else.'" (Williams, *Catalogue of the Collection,* p. 86.)

31. *Norfolk* (Va.) *Virginian-Pilot,* 19 January 1975.

32. Telephone interview with Bobbie Ferguson, Lynchburg, Virginia, 13 November 1984.

33. Ibid.

34. This single-page flier—widely distributed in various public places throughout the city— was brought to my attention by one of the staff at the Lynchburg YWCA.

35. Bob Spivey to Nancy Mathews, Skip Kughn, and Muriel Casey, 3 December 1980, R-MWCAD, Lynchburg, Virginia.

36. It would be worthwhile, I think, to explore the relationship between Stovall's art and the mentally disabled in her community: for example, how might Stovall's themes, or the rural themes of other painters, be used in art therapy?

37. Bobby, especially, feels a close bond to his mother's artistic heritage. He said proudly, "Mama gave me her paints, box of brushes, [and] her easel." (Personal communication, 1 March 1983.)

38. *Charlotte* (N.C.) *Observer,* 9 January 1984.

39. Telephone interview with Robert K. Stovall, Lynchburg, Virginia, 2 February 1984.

40. *Stanly* (Albemarle, N.C.) *News and Press,* 13 January 1984.

41. Though most were sold, a few paintings were given away; for example, Stovall gave David Hugh Dillard three of the pictures about hogs as tokens of her gratitude.

42. Taped interview with Perkins Flippin, Lynchburg, Virginia, 12 March 1983.

43. Louis B. Basten to Louis C. Jones, 1 October 1974, NYSHAFA, Cooperstown, New York.

44. Louis C. Jones to Louis B. Basten, 10 February 1975, NYSHAFA, Cooperstown, New York.

45. Ibid.

46. Louis C. Jones to Annie Laurie Bunts, 4 February 1976, NYSHAFA, Cooperstown, New York.

47. Interview with Robert K. Stovall, Lynchburg, Virginia, 19 November 1982.

48. Personal communication, Stovall family, 20 November 1982.

49. Robert S. Barbour to Louis C. Jones, 25 August 1975, NYSHAFA, Cooperstown, New York.

50. Alfred Percy to Queena Stovall, 8 April 1954.

51. Alfred Percy to Queena Stovall and Annie Laurie Bunts, 26 January 1961.

52. Interview with Teeny Winston, Pleasant View, 9 March 1983.

53. SFP, Lynchburg, Virginia.

54. Epps T. Perrow to Queena Stovall, 30 April 1956.

55. See Richard McLanathan, *The American Tradition in the Arts* (New York: Harcourt Brace Jovanovich, 1968), pp. 311-23; James Thomas Flexner, *That Wilder Image* (Boston: Little, Brown and Co., 1962); and Barbara Novak, *American Painting of the Nineteenth Century: Realism, Idealism, and the American Experience* (New York: Harper and Row, 1979) for discussions on this period of art in the United States.

56. McLanathan, *American Tradition*, p. 311.

Chapter 7

1. For references exemplifying both long-established and contemporary viewpoints on the definition of American folk art, see three publications by Simon J. Bronner: *A Critical Bibliography of American Folk Art*, Folklore Publications Group Monograph Series, vol. 3 (Bloomington: Indiana University, 1978); *American Folk Art: A Guide to Sources* (New York: Garland Publishing, 1984); and "The Idea of the Folk Artifact," in *American Material Culture and Folklife: A Prologue and Dialogue* (Ann Arbor: UMI Research Press, 1985), pp. 3-39. See also two publications by John Michael Vlach, "American Folk Art: Questions and Quandaries," *Winterthur Portfolio* 15, no. 4 (1980): 345-55, and "Quaker Tradition and the Paintings of Edward Hicks: A Strategy for the Study of Folk Art," *Journal of American Folklife* 94, no. 372 (1981): 145-65. Also see Robert T. Teske, "What is Folk Art?" *El Palacio* 88 (1982-83): 34-38.

2. Pierre Daura to Martha Adams, 13 July 1950.

3. *Lynchburg* (Va.) *News*, 30 September 1951.

4. *Lynchburg* (Va.) *News*, 29 September 1974.

5. *Presenting the Works,* unpaginated.

6. *Lynchburg* (Va.) *News*, 17 April 1956.

7. Grant Reynard to Queena Stovall, 16 December 1950.

8. 30 September 1951.

9. *Presenting the Works*, unpaginated.

10. Grant Reynard to Queena Stovall, 16 December 1950.

11. *New York Herald Tribune*, 28 October 1951.

12. *Lynchburg* (Va.) *Daily Advance*, 11 April 1959.

13. *Richmond* (Va.) *Times-Dispatch*, 19 February 1961.

14. Sherman Lee, "The Art Museum as a Wilderness Area," *Museum News* 62, no. 3 (1984): 59.

15. *Lynchburg* (Va.) *News*, 7 February 1965.

16. Williams, *Catalogue of the Collection*, p. 154.

17. Ellett, "A Kind of Magic," p.1.

18. Ibid.

19. Nani Yale, "The American Folk Art Tradition and Queena Stovall" (Senior Thesis, Randolph-Macon Woman's College, 1979), pp. 28-29.

20. Nani Yale, "Tradition of American Folk Art and Queena Stovall" (checklist for the 68th Annual Exhibition at R-MWC, Lynchburg, Va., 1979), R-MWCAD, Lynchburg, Virginia.

21. Charlotte Emans, "Queena Stovall: An Analysis of Her Life and Paintings" (Student Paper, New York University, New York, 1982), p. 17.

22. Friddell, "Compassionate Eye," p. 35.

23. Jones and Jones, *Queena Stovall*, p. 4.

24. Draft of prospectus for 1974 exhibition, NYSHAFA, Cooperstown, New York.

25. *Richmond* (Va.) *Times-Dispatch*, 12 January 1975.

26. *Newport News* (Va.) *Times-Herald*, 23 January 1975.

27. *Binghamton* (N.Y.) *Evening Press*, 22 January 1976.

28. *Binghamton* (N.Y.) *Evening Press*, 29 April 1975.

29. Louis C. Jones, "Genre in American Folk Art," in *Papers on American Art*, ed. John C. Milley (Maple Shade, N.J.: Published for the Friends of Independence National Historical Park, 1976), p. 60.

30. *Lynchburg* (Va.) *News*, 29 September 1974.

31. *Norfolk* (Va.) *Virginian-Pilot*, 19 January 1975.

32. *Amherst* (Va.) *New Era-Progress*, 7 October 1976.

33. *Lynchburg* (Va.) *News*, 21 April 1979.

34. *Amherst* (Va.) *New Era-Progress*, 22 December 1977.

35. *Amherst* (Va.) *New Era-Progress*, 24 August 1978.

36. Connell, "Queena Stovall," p. 30.

37. Advertising brochure for Leggett's Department Store, SFP, Lynchburg, Virginia.

38. *Norfolk* (Va.) *Virginian-Pilot*, 16 March 1981.

39. 29 June 1980.

40. Elaine Eff to Nancy Mowll, 6 March 1978, R-MWCAD, Lynchburg, Virginia.

41. Kurt Dewhurst et al., *Artists in Aprons*, pp. 139-141.

42. Kurt Dewhurst, Marsha MacDowell, and Betty MacDowell, *Religious Folk Art in America: Reflections of Faith* (New York: E.P. Dutton in association with the Museum of American Folk Art, 1983), p. ix.

43. Simon Bronner, "Investigating Identity and Expression in Folk Art," *Winterthur Portfolio* 16, no. 1 (1981): 80.

44. Mrs. Cassell D. Holt, "Folk Artist Queena Stovall," *Southern Accents*, Summer 1980, pp. 72-77.

45. Personal communication, Robert T. Teske, 1 June 1983.

46. See Kenneth L. Ames, *Beyond Necessity: Art in the Folk Tradition* (New York: W.W. Norton and Co., 1977) for a critical discussion of the use of the term "folk art."

47. Taped interview with Queena Stovall, Elon, Virginia, 25 May 1980.

48. *Richmond* (Va.) *News Leader*, 22 January 1975.

49. Personal communication with Sue Stephenson, 24 May 1980.

50. Jones and Jones, *Queena Stovall*, p. 5.

51. Taped interview with Queena Stovall, Elon, Virginia, July 1978.

52. Pierre Daura to Martha Adams, 13 July 1950.

53. Grant Reynard to Queena Stovall, 16 December 1950.

54. *Lynchburg* (Va.) *News*, 30 September 1951.

55. *Lynchburg* (Va.) *News*, 13 April 1956.

56. *Richmond* (Va.) *Times-Dispatch*, 2 March 1959.

57. Grant Reynard to Queena Stovall, 25 August 1964. Flattered by the proposal, Stovall wrote back immediately and offered "Swing Low, Sweet Chariot" as her part of the exchange. Though Reynard was deeply touched by Stovall's offer, he declined: "it is too big for me ... [and] my family wouldn't like the sadness of the subject to be frank with you." (Grant Reynard to Queena Stovall, 3 September 1964). Subsequently, Reynard and Stovall settled on "Full Litter."

58. Timothy Foote, *The World of Bruegel, c. 1525–1569* (New York: Time-Life Books, 1968), pp. 8, 168.

59. Ellet, "A Kind of Magic," p. 5.

60. Taped interview with Queena Stovall, Elon, Virginia, 28 May 1974.

61. Queena Stovall to Mr. C. (?) Allaben, probably Winter 1956.

62. Queena Stovall to Pierre Daura, 18 February 1965.

63. Taped interview with Queena Stovall, Elon, Virginia, July 1978.

64. Pierre Daura to Queena Stovall, 9 January 1961.

65. Pierre Daura to Queena Stovall, 16 June 1963.

66. Ibid.

67. *Binghamton* (N.Y.) *Evening Press*, 29 April 1975. For other discussions on the self-taught nature of artists, see Jane Livingston and John Beardsley, *Black Folk Art in America: 1930–1980* (Jackson: University of Mississippi Press and Center for the Study of Southern Culture for the Corcoran Gallery, 1982); and Jane Kallir, *The Folk Art Tradition: Naive Painting in Europe and the United States* (New York: Viking Press, 1982).

68. Teske, "What Is Folk Art," pp. 37-38.

69. James Thomas Flexner, "The Cult of the Primitives," *American Heritage*, February 1955, pp. 39-40, and Jean Lipman, *American Primitive Painting* (New York: Oxford University Press, 1942). See also Ann Uhry Abrams, "A New Light on Benjamin West's Pennsylvania Instruction," *Winterthur Portfolio* 17, no. 4 (Winter 1982): 243-57.

70. Jones and Jones, *Queena Stovall*, p. 4.

71. Ibid., pp. 4-5.

72. Ibid., p. 5.

73. Yale, "American Folk Art Tradition," p. 25.

74. Hermann Warner Williams, *Mirror to the American Past: A Survey of American Genre Painting, 1750-1900* (Greenwich, Conn.: New York Graphic Society, 1973), p. 68.

75. Ibid., p. 146.

76. Personal communication with Stovall family, July 1980.

77. Taped interview with Melvin Bailess, Lynchburg, Virginia, 23 June 1983.

78. Peggy A. Bulger, "Defining Folk Arts for the Working Folklorist," *Kentucky Folklore Record* 26, no. 1-2 (1980): 64.

79. Taped interview with Queena Stovall, Elon, Virginia, July 1978.

80. Interview with Queena Stovall, Elon, Virginia, 25 May 1980.

81. Queena Stovall to C. (?) Allaben, Jr., undated, but probably January, 1956.

82. Louvre Frame Company to Mrs. J.B. Stovall, 3 April 1956.

83. C. (?) Allaben, Jr. to Queena Stovall, 17 January 1956.

84. Taped interview with Queena Stovall, Elon, Virginia, July 1978.

85. To the contrary, Grandma Moses, who produced a total of over 1600 works of art, was considered by many to be swayed by the temptations of market demands.

86. Nancy St. Clair Talley to Queena Stovall, 17 April 1959.

Bibliography

Primary Sources

Interviews

Note: All interviews were conducted by the author, except for the following: 3, 11, and 14 November 1972 by Louis C. and Agnes Halsey Jones; 28 and 31 May 1974 by Robert Sieber; and July 1978 by Jack O'Field.

Adams, James D. Rome, Georgia: 24 March 1985.

Bailess, Melvin. Lynchburg, Virginia: 23 June 1983.

Braxton, Beatrice. Washington, D.C.: 14 May 1983.

Bunts, Annie Laurie. Elon, Virginia: 21 January 1979, 15 June 1980. Lynchburg, Virginia: 20 June 1981.

Burton, Selvy. Pleasant View, Virginia: 8 February 1983.

Davis, James. Agricola, Virginia: 2 April 1983.

Dempsey, Allen. Washington, D.C.: 14 May 1983.

Escoe, Hannah. Amherst, Virginia: 2 February 1983.

Fairfax, Judy. Elon, Virginia: 15 June 1980, 26 July 1980. Lynchburg, Virginia: 20 June 1981, 30 March 1983.

Ferguson, Bobbie. Lynchburg, Virginia: 13 November 1984.

Flippin, Perkins. Lynchburg, Virginia: 12 March 1983.

Goode, Margie. Lynchburg, Virginia: 22 June 1983.

Hunt, Julia. Amherst, Virginia: 7 March 1983.

Ivey, Mrs. Maitland. Lynchburg, Virginia: 20 June 1983.

Johnson, James. Lynchburg, Virginia: 22 June 1983.

Johnson, Ora. Lynchburg, Virginia: 22 June 1983.

Kelley, Narcissa. Marin County, California: 5 January 1982.

Lewis, Hobart. Elon, Virginia: 14 June 1980, 26 July 1981, 31 July 1981, 21 August 1981, 9 October 1981.

Lewis, Mary White. Elon, Virginia, 25 May and 15 June 1980, 20 June 1981.

Massie, Aaron. Elon, Virginia: 31 July 1981.

Massie, Kathleen. Madison Heights, Virginia: 5 Feburary 1983.

McDaniel, Sally Mae. Lynchburg, Virginia: 30 March 1983.

Robertson, Carlena. Pleasant View, Virginia: 9 March 1983.

Slaughter, Florine. Lynchburg, Virginia: 6 February 1983, 6 March 1983.

Stovall, Barbara. Virginia Beach, Virginia: 6 November 1982.

Stovall, David H. Elon, Virginia: 26 July 1980.
Stovall, James. Newport News, Virginia: 6 November 1982.
Stovall, Margaret. Lynchburg, Virginia: 8 March 1983.
Stovall, Queena. Elon, Virginia: 3, 11, and 14 November 1972, 28 and 31 May 1974, July 1978, 21 January 1979, 24 and 25 May 1980, 15 June 1980.
Stovall, Robert K. Elon, Virginia: 25 May 1980, 16 June 1980. Lynchburg, Virginia: 19 November 1982, 9 March 1983, 13 April 1983, 23 June 1983, 14 December 1983, 2 February 1984.
Stuart, Narcissa. Elon, Virginia: 21 January 1979.
Trevillian, Archie and Francis. Lynchburg, Virginia: 3 February 1983.
Watson, Lucille. Lynchburg, Virginia: 20 November 1982.
Williams, Mary F. Lynchburg, Virginia: 4 February 1983.
Winston, Julia Ivey. Lynchburg, Virginia: 20 June 1983.
Winston, Teeny. Pleasant View, Virginia: 8 February 1983, 9 March 1983.

Manuscript Collections

Cooperstown, New York. Folk Art Archives, New York State Historical Association (NYSHAFA).
Lynchburg, Virginia. Art Department, Randolph-Macon Woman's College (R-MWCAD).
Lynchburg, Virginia. Stovall Family Papers (SFP).

Secondary Sources

Books and Articles

Abbott, Shirley. "Southern Women and the Indispensable Myth." *American Heritage,* December 1982, pp. 83-91.
————. *Womenfolks.* New York: Ticknor and Fields, 1983.
Abrams, Ann Uhry. "A New Light on Benjamin West's Pennsylvania Instruction." *Winterthur Portfolio,* 17, no. 4 (1982): 243-57.
Ames, Kenneth L. *Beyond Necessity: Art in the Folk Tradition.* New York: W.W. Norton and Co., 1977.
Boddie, John Bennett. *Historical Southern Families.* 23 vols. Redwood City, Calif.: Pacific Coast Publishers, 1960.
Bowles, George. *Pages from the Virginia Story.* Charlottesville, Va.: Maiden Lane Press, 1979.
Bronner, Simon. *American Folk Art: A Guide to Sources.* New York: Garland Publishing, 1984.
————. *A Critical Bibliography of American Folk Art.* Folklore Publications Group Monograph Series, vol. 3. Bloomington: Indiana University, 1978.
————. "The Idea of the Folk Artifact." In *American Material Culture and Folklife: A Prologue and Dialogue,* pp. 3-39. Ann Arbor: UMI Research Press, 1985.
————. "Investigating Identity and Expression in Folk Art." *Winterthur Portfolio,* 16, no. 1 (1981): 65-83.
Bulger, Peggy A. "Defining Folk Arts for the Working Folklorist." *Kentucky Folklore Record,* 26, nos. 1-2 (1980): 62-66.
Chambers, S. Allen, Jr. *Lynchburg, An Architectural History.* Charlottesville: University Press of Virginia, published for the Sarah Winston Henry Branch of the Association for the Preservation of Virginia Antiquities, 1981.
Christenberry, William. *Southern Photographs.* Millerton, N.Y.: Aperture, Inc. 1983.
Clarke, Erskine. *Wrestlin' Jacob: A Portrait of Religion in the Old South.* Atlanta: John Knox Press, 1979.
Clinton, Catherine. *The Plantation Mistress: Woman's World in the Old South.* New York: Pantheon Books, 1982.

Coles, Robert. *Flannery O'Connor's South.* Baton Rouge: Louisiana State University Press, 1980.

Connell, Judy. "Queena Stovall: Eminent in American Folk Art." *Lynchburg,* June 1979, pp. 30-33.

Crocker, Christopher. "The Southern Way of Death." In *The Not So Solid South,* pp. 114-29. Edited by J. Kenneth Morland. Athens, Ga.: University of Georgia Press, 1971.

Dewhurst, C. Kurt; MacDowell, Marsha; and MacDowell, Betty. *Artists in Aprons: Folk Art by American Women.* New York: E.P. Dutton in association with the Museum of American Folk Art, 1979.

_____. *Religious Folk Art in America: Reflection of Faith.* New York: E.P. Dutton in association with the Museum of American Folk Art, 1983.

Douglass, Frederick. *Life and Times of Frederick Douglass.* Hartford, Conn.: Park Publishing Co., 1881; reprint ed., New York: Collier Books, 1962.

Early, R.H.. *Campbell Chronicles and Family Sketches.* Lynchburg, Va.: J.P. Bell Company, 1927.

Ellet, Mary S. "A Kind of Magic: The Paintings of Queena Stovall." Student Paper, Randolph-Macon Woman's College, Lynchburg, Virginia, 14 April 1971.

Emans, Charlotte. "Queena Stovall: An Analysis of Her Life and Paintings." Student Paper, New York University, New York, N.Y., 1982.

Flexner, James Thomas. "The Cult of the Primitives." *American Heritage,* February 1955, pp. 38-47.

_____. *That Wilder Image.* Boston: Little, Brown and Co., 1962.

Foote, Timothy. *The World of Bruegel, c. 1525-1569.* New York: Time-Life Books, 1968.

Friddell, Guy. "A Compassionate Eye and a Talented Hand." *Commonwealth,* May 1980, pp. 30-37.

Glasgow, Ellen. *Barren Ground.* Garden City, N.J.: Doubleday, Page and Co., 1925; reprint ed., New York: Hill and Wang, 1980.

_____. *Virginia.* Garden City, N.J.: Doubleday, Page and Co., 1913.

Glassie, Henry. *Pattern in the Material Folk Culture of the Eastern United States.* Philadelphia: University of Pennsylvania Press, 1968.

Godbold, E. Stanly, Jr. *Ellen Glasgow and the Woman Within.* Baton Rouge: Louisiana State University Press, 1972.

Grindal, Bruce T. "The Religious Interpretation of Experience in a Rural Black Community." In *Holding on to the Land and the Lord: Kinship, Ritual, Land Tenure, and Social Policy in the Rural South,* pp. 89-101. Edited by Robert L. Hall and Carol B. Stack. Athens, Ga.: University of Georgia Press, 1982.

Harris, Emily M. *The New Virginians.* London: William Blackwood and Sons, 1880.

Hiden, Martha Woodroof. *Woodroof Family.* Jones Memorial Library, Lynchburg, Virginia, n. d. (Typewritten).

Holt, Mrs. Cassell D. "Folk Artist Queena Stovall." *Southern Accents,* Summer 1980, pp. 72-77.

Janis, Sidney. *They Taught Themselves.* New York: Dial Press, 1942.

Johnston, Ruby F. *The Development of Negro Religion.* New York: Philosophical Library, 1954.

Jones, Louis C. "Genre in American Folk Art." In *Papers on American Art,* pp. 41-60. Edited by John C. Milley. Maple Shade, N.J.: Published for the Friends of Independence National Historical Park, 1976.

Jones, Louis C., and Jones, Agnes Halsey. *Queena Stovall: Artist of the Blue Ridge Piedmont.* Cooperstown, N.Y.: New York State Historical Association, 1974.

Kallir, Jane. *The Folk Art Tradition: Naive Painting in Europe and the United States.* New York: Viking Press, 1982.

_____. *Grandma Moses: The Artist Behind the Myth.* New York: Clarkson N. Potter, 1982.

Kallir, Otto, ed. *My Life's History.* New York: Harper and Row, 1952.

King, Edward. *The Great South.* Hartford, Conn.: American Publishing Co., 1875; reprint ed., Baton Rouge: Louisiana State University Press, 1972.

Kousser, J. Morgan. *The Shaping of Southern Politics.* New Haven: Yale University Press, 1974.

Lee, Sherman. "The Art Museum as a Wilderness Area." *Museum News* 62, no. 3 (1984): 57-59.

Levine, Lawrence W. *Black Culture and Black Consciousness.* New York: Oxford University Press, 1977.

Lipman, Jean. *American Primitive Painting.* New York: Oxford University Press, 1942.

Livingston, Jane, and Beardsley, John. *Black Folk Art in America: 1930-1980.* Jackson: University of Mississippi Press and Center for the Study of Southern Culture for the Corcoran Gallery, 1982.

McLanathan, Richard. *The American Tradition in the Arts.* New York: Harcourt Brace Jovanovich, 1968.

Novak, Barbara. *American Painting of the Nineteenth Century: Realism, Idealism, and the American Experience.* New York: Harper and Row, 1979.

Olmsted, Frederick Law. *The Cotton Kingdom.* New York: Mason Brothers, 1861; reprint ed., New York: Alfred A. Knopf, 1953.

Page, Thomas Nelson. *Social Life in Old Virginia.* New York: Charles Scribner's Sons, 1897.

Prenshaw, Peggy Whitman, ed. *Conversations with Eudora Welty.* Jackson, Miss.: University Press of Mississippi, 1984.

Presenting the Works of Queena Stovall. Lynchburg, Va.: Lynchburg Art Center, 1956.

Raboteau, Albert J. *Slave Religion.* New York: Oxford University Press, 1978.

Richardson, John. "The Catch in the Late Picasso." *The New York Review of Books,* 19 July 1984, pp. 21-28.

Scott, Anne Firor. *The Southern Lady.* Chicago: University of Chicago Press, 1970.

Teske, Robert T. "What is Folk Art?" *El Palacio* 88 (1982-83): 34-38.

Vlach, John Michael. "American Folk Art: Questions and Quandaries." *Winterthur Portfolio* 15, no. 4 (1980): 345-55.

————. "Quaker Tradition and the Paintings of Edward Hicks: A Strategy for the Study of Folk Art." *Journal of American Folklife* 94, no. 372 (1981): 145-65.

Walters, Dorothy. *Flannery O'Connor.* Boston: Twayne Publishers, 1973.

Weatherford, Claudine. " 'In My Mind's Eye': The Genre Painting of Queena Stovall." *Folklore and Folklife in Virginia* 3 (1984): 7-29.

Williams, Charles. "The Conversion Ritual in a Rural Black Baptist Church." In *Holding on to the Land and the Lord: Kinship, Ritual, Land Tenure, and Social Policy in the Rural South,* pp. 69-79. Edited by Robert L. Hall and Carol B. Stack. Athens, Ga.: The University of Georgia Press, 1982.

Williams, Hermann Warner. *Mirror to the American Past: A Survey of American Genre Painting, 1750-1900.* Greenwich, Conn.: New York Graphic Society, 1973.

Williams, Mary F., ed. *Catalogue of the Collection of American Art at Randolph-Macon Woman's College.* Charlottesville, Va.: University Press of Virginia, 1977.

Yale, Nani. "The American Folk Art Tradition and Queena Stovall." Senior thesis, Randolph-Macon Woman's College, Lynchburg, Virginia, 1979.

Newspapers

Amherst (Va.) *New Era Progress,* 7 October 1976; 22 December 1977; 24 August 1978.

Charlotte (N.C.) *Observer,* 9 January 1984.

Daily Advance (Lynchburg, Va.), 11 April 1959; 11 February 1965; 27 July 1966.

Evening Press (Binghamton, N.Y.), 29 April 1975; 22 January 1976.

Freeman's Journal (Cooperstown, N.Y.), 30 April 1975.

New York Herald Tribune, 28 October 1951.

News (Lynchburg, Va.), 30 September 1951; 9 November 1952; 13, 15, 17 April 1956; 7 May
 1958; 11 April 1959; 19 February 1961; 7 February 1965; 4 March 1972; 29 September 1974;
 21 April 1979; 19 October 1980.

Richmond News Leader (Va.), 22 January 1975.

Richmond Times-Dispatch (Va.), 2 March 1959, 19 February 1961; 24 February 1963; 12 January
 1975; 7 May 1978.

Stanly News and Press (Albermarle, N.C.), 13 January 1984.

Times-Herald (Newport News, Va.), 23 January 1975.

Virginian-Pilot (Norfolk, Va.), 19 January 1975; 16 March 1981.

Washington (D.C.) *Post,* 29 June 1980.

Index